MARKED FOR LIFE

Tattooing Through the Golden Age

Worthing Road, Horsham, West Sussex, RH12 1TD

Copyright Notice

Author's Pen

This book is dedicated to Scarlett and Charlie Fuller, *ma raison d'etre*.

Other works by the same author

Tattoo Clip Art: Thousands of Exclusive Ready-To-Use Designs, by Danny Fuller, published by ILEX; 1st edition (6 April 2009)
ISBN-10: 1905814453
ISBN-13: 978-1905814459

Tattoo Clip Art: Thousands of Exclusive Ready-To-Use Designs, by Danny Fuller, paperback – 1 Aug. 2011, published by ILEX; 1st edition (1 Aug. 2011)
ISBN-10: 1907579834
ISBN-13: 978-1907579837

Foreword

Tattooing as a way of marking oneself, has been around for many, many years. Probably since man first stumbled over, cut open his knee and forever after walked around with grit healed into the wound.

Ancient Greek and Roman records date back to at least the 5th century BCE, but these civilisations used tattooing to penalise slaves, criminals and prisoners of war. Decorative tattooing was rare and in Egypt and Syria the tattooing of religious symbols was mainly practised.

Tattooing was first carried out using hand tools: sharpened bamboo sticks or different types of thorns. Dyes used were traditionally made from ash or crushed charcoal. Common designs would be those of animals or nature.

Tattooing first became popular in the UK during the 17th century. According to existing records, it was sailors from Captain Cook's crew who first chose to get tattoos as mementos of their journeys to the great tattoo countries and continents of Japan, China and the Pacific Islands. At this time tattooing became so ubiquitous that they were even referred to in court cases. In January 1739, the London Evening Post reported the conviction of a fifteen-year-old thief whose trial found him to have a particularly garish tattoo across his chest, 'On his breast, marked with Indian ink was the portraiture of a man at length with a sword drawn in one hand and a pistol discharging balls from the muzzle in the other, with a label from the man's mouth, "God damn you!"'

The story carries on dramatically, 'This the rogue would have concealed, but a discovery being made thereof, he was ordered to show his breast to the court who were all shocked at so uncommon a sight in so young a ruffian.'

It is not hard to imagine that the court took a very dim view of the young thief during sentencing. And so it was for the next two hundred years or so that tattooing was mainly considered to be a pastime of the darker elements of our society. Although there was the odd dalliance by members of Royalty and the Aristocracy. King Edward VII and Lady Randolph Churchill being of particular note.

Tattooing became more popular with the invention of an electric tattoo machine on 8th December 1891, which was invented by a New York tattoo artist named Samuel O'Reilly. Even O'Reilly would be the first to admit that his machine was actually an adaptation of a machine invented by Thomas Edison, the *Electric Pen*.

A major leap in the popularity of tattooing was the introduction of coloured

inks, such as red, green, yellow and sometimes purple made from natural ingredients found in nature.

Formal interest in the art of the tattoo became prominent to various degrees throughout the 1900s with the 1970s seeing a dramatic redefinition as the practice shifted from a form of deviance to an accepted form of expression.

But it was during the 1980s that interest in tattoos really began to accelerate, although it was still limited to the warmer summer months. These and the 1990s are considered to be tattooing's *Golden Age*. Tattoo studios, originally only found in seaside towns, garrison towns and London and other major cities, gradually began to appear in areas all over the UK because of the growing demand. To aspire to be a *tattooer* was an extremely rare and unusual career choice at this time and becoming one was not a guarantee of future wealth and security by any means. One of the main reasons being the fact that tattoo equipment was extremely hard to acquire. Every artist at this time inevitably had to make their own, so this workload dissuaded everyone but the most determined individuals. In the early 1980s tattoo equipment started to be offered for sale by small time manufacturers, but you had to be lucky to find an advertisement for it.

This humble start was enough to spark an interest in and give dedicated individuals a chance to take-up and practise the craft. This rising number of the new breed of tattoo artists offering their skills amongst the population thus guaranteed the growth of tattooing as an art form, with more styles becoming available and more complex designs never seen before being offered in a full range of colours.

By the 1990s, organisations had sprung up offering annual large scale trade shows, conventions or expos, aimed at furthering the development of the trade and providing a common meeting place for sharing knowledge.

It is thanks to these groundbreaking forerunners of the modern tattoo artist that tattooing has continued to grow through its Golden Age into the worldwide phenomenon it has become today.

This is the story of what it was like to be a tattooist during the formative Golden Age and the story of one particular artist who had the drive and determination to weather the early storms and take his part in that revolution.

Lal Hardy, London 2022

Acknowledgements

Some well-deserved thanks ...

For their help and inspiration with writing this book, Lesley Hart (Author's Pen), Simon Cottrell, Ben Morris, Lal Hardy, Yvette Court, Scarlett Fuller, Steve Fuller.

For their help in getting me started in the tattoo game, Ronnie Starr, Eddie Fretwell, Paul Thorpe, Rob Robinson, Ian Frost, Brent Eggleton, Dave How.

For their help in keeping me in the tattoo game, John Sargeson, Ian of Reading, Tony Titherage, John Williams, Lionel Titchener, Lou Robbins, Danny Harkin, Jack Saleses.

For being my good friends and support in the tattoo game, 'Woody' Woodford, Mick 'J' Jackson, Dave Lyeach, Karl Thornton Rice, Gordon Couser, 'Phil', Aaron Soffe, Shaun Butling.

For their work helping me with most of my shops over the years, Rob Massey, Shaun Purnell, Wayne Hemmings, Nick Paxton.

For being lifelong friends of mine and putting up with me for all those years, Paul Miller, Richard Bell, Dean Drewe, Lyndon Pugh, Stephen Russell, Mark Verrall, Gary Baker, Stewart McCall, Jason Sumpter, Celia Hemmings, Ian Taylor, Bill King and Jerry Dark.

Without just one of you all of this might not have been possible.

Contents

Introduction

I have made my living as a professional tattoo artist for over forty years.

Tattooing certainly was a unique and unusual career choice to make back in the late 1970s when I first got interested in the subject.

My particular story started with a homemade needle and Indian ink job I did at home one night in my bedroom when I was about fifteen years old. God knows what made me do it and at the time I pretty much instantly regretted it. It was awful. Rather than just do a simple cross or my initials like most people would, I tried to be all arty and do a castle with a bat flying round it! It took me ages. After it was done, I realised it might be seen by my mum and dad who were extremely old school and would not have been amused in the slightest by my amateur tattoo attempt!

Regret it? I might have done at the time, but little did I realise that one silly teenage rush of blood would go on to shape the rest of my life. It was the first step on what was to be – in my eyes – an adventure. One so varied and fantastic, so rich and rewarding that as I sit here now looking back, I can't believe I was actually lucky enough to have experienced it.

Don't get me wrong, tattooing isn't an easy career that's for certain. There were very few tattooers to be found in the 1970s. It was also extremely hard to get into. I had no one to help me and I faced many obstacles in my early days. At the time I got interested in it, tattooing was more of an underground activity. It is a bizarre way to make a living and it is definitely not a career for the squeamish!

First of all, and without a doubt, getting tattooed involves a certain amount of pain and the smallest mark from a tattoo machine will last your entire life, so there is very little room for error. It's not like a ruined haircut where your hair will eventually grow back.

When you become a tattooist, you are on your own. You are not part of a team. You have to learn the hard way and quickly if you want to make a living.

It takes a certain kind of person – a rebel if you like – to be a tattooist. Someone with huge strength of character, someone who can keep calm and do a job where no two days are the same. Someone who has the ability and the imagination to deal with the unexpected, the people they will meet and the requirements those people will have.

They will need to be a people person, that's for sure. Over the years, I've met and sat with thousands of people for extended periods, good and bad but mainly good. Fortunately, I have made many, many friends since I became a tattooist. All of whom were drawn to me and the indelible service I learnt to provide.

Tattoos build people's character. It's a fact. There is something about wanting to be tattooed that is an inexplicably fundamental part of human nature. People are often drawn to it without actually knowing the true reason why.

Do you know the real reason why you got your Tattoo?

It's as if a kind of primordial connection with our ancient ancestors still exists, dating right back to when homo-sapiens first began to develop the first signs of intelligence. It is not a modern fad, or a desire to be trendy, it is an ancient and symbolic ritual that a certain type of person gets drawn to.

After all this time, I still don't have an accurate explanation of what it was that made me want to dive wholeheartedly into this ancient art form. Once I had sat down and experienced the thrill of getting my first few tattoos, I began to feel a growing desire to explore this strange ritual more deeply. A desire that I felt build up inside me and which I couldn't ignore. It all sounds a bit heavy I know, but the way it took over my thoughts and eventually my life proves it was obviously meant to be. Perhaps one of my ancestors from long, long ago was somehow reaching out to me to follow in their footsteps? Or, was it just that once I first noticed and began to take an interest in those indelible marks made on the skin that I felt a subconscious connection with the whole process? One which would lead me to devote the rest of my life to exploring and trying to fully understand the secrets of the art of the tattoo.

Whatever it was, I can honestly say with my hand on my heart that I have never once regretted my decision to take – what at the time seemed to so many – such an unusual path in life. I do feel truly blessed that I possessed the courage to make the leap of faith that so few at the time could or would.

This is my story, of how I went about it all. From a nervous, nothing special, extremely shy ex-public schoolboy, to a seasoned pro who took his chosen trade to its limits. The characters I met, the places I went and what it was like to be a tattoo artist through the 1980s, 90s and beyond. Tattooing's truly golden age.

I really hope you enjoy the ride. My good times, bad times, ups and downs and the fascinating tale of what you can do with your life if you're prepared to step out of the box and follow your dreams.

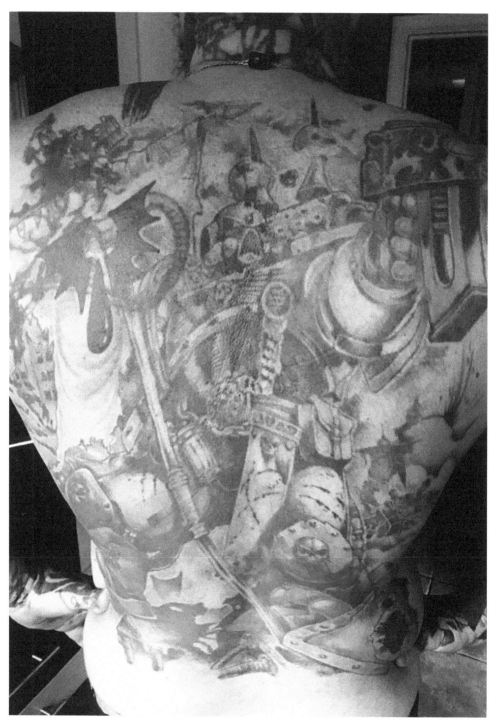

Various black and grey work, circa 1990s

Chapter 1: *A brief description of my life before my real life began*

I was born on Friday 15th of January 1960. Friday's child is giving, so they say. Well that certainly turned out to be true.

My mother, Dorothy Minnie Fuller – they don't make names like that any more – was forty-four and my father; Ernest Steven William Fuller, was forty-eight. They were considered to be quite old at the time. I had two older brothers, Lee aged sixteen and Steve aged fifteen, so it doesn't take a genius to figure out that somehow, I wasn't planned. A Guinness baby as they called it.

Both my parents went through the Second World War. My Dad was in the Merchant Navy for many years and used to do regular trips across the Atlantic Ocean, transporting prisoners to Canada and bringing back much needed supplies to the UK. The German U-Boats took a dreadful toll on the kind of supply convoys he was part of, sinking a devastating number of ships. He was very lucky to survive. My Mum joined the fire service in London where she lived and did her bit during the Blitz. Most notably driving a fire engine up the steps of Kennington Police Station in a blind panic during one particular air raid.

Nice one Mum!

The war was an awful time for most Londoners obviously, but for my mum and dad, who knew how to make the most of any situation – even bad ones – it didn't turn out too bad. Firstly, it was how they met. My dad was billeted at my mum's house, with her mum, four sisters and younger brother. Secondly, they found the time to get married and thirdly, my dad used to bring back a lot of stuff that he wasn't really supposed to from his trips across the Atlantic. Stuff that because of rationing, was unavailable over here in the UK at the time. Fruit, shoes, clothes and pretty much anything else he could fit in a trunk and get onshore past the watchful eyes of Customs and Excise. My mum would then sell this on the so-called Black Market for lots of money.

You see, during the war you still worked and you still got your wages, but due to the heavy rationing of everything there wasn't a lot you could buy with the money you had left over. Everyone had a ration book and everything you bought was marked off in there for the week and once you had used up all your ration allowance you couldn't get anything more until the next week. This meant that a lot of people usually had quite a bit of spare cash they couldn't readily use for anything. So, for example, if someone had some oranges or bananas for sale, which weren't being imported at this time, people would pay well over the usual price to get them.

My parents managed to do quite well with their Black Market shenanigans, the whole operation ran quite smoothly, but I do remember dad telling me of one time he got caught bringing two crates of oranges into port by the customs officials. After being detained and locked in an office to await an imminent dressing down and punishment that were sure to come, he decided the only way out was to get rid of the evidence. Being a tiny office with the exits – the door and window – both locked, he decided that the only thing to save himself was to eat the evidence.

By the time the customs official returned, twenty-four oranges, skin, pips and all had mysteriously disappeared! Seeing my dad's green face and swollen tummy the official – who was obviously no fool – took it in good heart and said something to my dad along the lines of,

'I hope you're alright for toilet paper where you live?' and he let him go on his way. From that day hence, I never saw my dad eat an orange as long as he lived.

I think this must have been where my out of the box thinking originated, because my parents always worked for themselves and very rarely took on a normal job working for anybody else.

Fortunately for me and my brothers, when the war ended they had both survived and had put away enough savings to purchase their first house in Sydenham, South London. Outright. How's that for entrepreneuring?

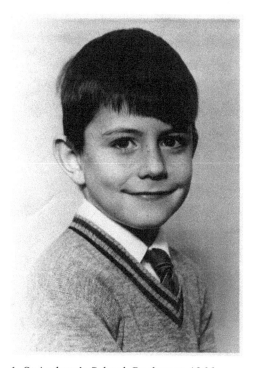

1. St Andrew's School, Rochester, 1966

As I said, they weren't the kind of people to work for others. I suppose their wartime experiences had instilled a strong sense of self preservation and acting on their own initiative. They had a number of reasonably successful ventures and at the time I was born they were running a cafe in Lewisham, South London.

They did this for a number of years, I can vaguely remember putting a sixpence my dad gave me into the one-armed bandit they had in there, as fruit machines were called in those days. Seeing the bells and cherries spin round and round and hearing the tinkle of a couple of coins as they fell out for a small win. According to my dad – on my second pull of the arm – after the reels had stopped spinning and there was no tinkle

of coins, I wailed with disappointment! Yes, I think I may have been a difficult child.

The next business was some self-park garages in Rochester, Kent. There were no multistorey car parks in those days and people would rent a garage to park their cars in while they took the train to work. I can remember our house there very well because we were high up on a hill and had an amazing view over the River Medway. My dad must have loved this because you could see all the ships and boats sailing in and out. This business seemed to pay well enough and after a few years they had enough money put by to invest in a new business: an eight-bedroom guest house in Crawley, West Sussex.

Crawley was a new town then, one of the towns built as an overspill from London. It wasn't a holiday destination, but it had a large industrial estate and you would get people travelling down to work who needed a place to stay during the week, so there was plenty of trade to be had.

The guest house was called, Pine Lodge and it was on Brighton Road, not far from the town centre. It was a nice big place with three quarters of an acre of land at the back, which was great for dad's German Shepherd dog, Jackie. When we went to view the place the big green, iron, spiral fire escape attached to one side, had a long rope tied to it and it was used as an improvised swing with a great big knot for you to sit on. Of course, at seven years old this seemed like a great idea to me and I remember the current owner encouraging me to get on and pushing me enthusiastically back and forth until – eventually misjudging the angle as I swung back – my head smashed against one of the iron steps! The next thing I remember is waking up in hospital with a Tom and Jerry style bandage around my throbbing head. Twelve stitches and an embarrassing bald patch later, we were headed back to Rochester.

At the time I hoped that was the last I'd see of Crawley but it obviously didn't put my parents off, because despite my protests, a couple of months later we were all packed up and, on our way, to take over the running of Pine Lodge.

When I was much older, I remember reminiscing with my mum about when we went to see the guest house and my accident with the fire escape swing. She told me how – after I hit my head – dad had lost it with the owner a bit and threatened him with similar injuries to mine due to his carelessness if something wasn't done. My dad was ex-Navy and an ex-Boxer and a very scary character when he lost his temper. So the owner decided to drop the asking price by a fair margin to save any retribution from this volatile ex-Navy man.

It was nice to know that my self-sacrifice helped them get a better price on the business of their dreams, but I never saw any reward for it and I think even at that young age I was determined to stay out of any further business negotiations they had.

So, I was seven years old when we moved to Crawley in 1967. I went to Southgate Primary School just up the road from our house. Pretty standard stuff is all I remember about this time. Nothing of note happened, but I do remember developing a phobia against small rodents after putting my hand into the cage of the class hamster and fast as lightning pulling it out again with the little fucker hanging from my finger with its teeth sunk deep into my flesh. I didn't tell my dad about this or he probably would have beaten Freddie Starr to the newspaper headlines of the day!

I also remember taking my first disco dancing class at age ten or eleven, despite being awfully shy with that sort of thing. Looking back on it now, I think it was just a ploy so that the organiser, my teacher Mr Winchester, could get a free grope with Miss Reeves from Class 2B. They seemed to spend most of the lesson grinding away at each other to Marvin Gaye's *Heard it through the Grapevine*. I still get a vision of them whenever I hear that song. It's funny how things stick in your mind when you're a kid.

I didn't see very much of my older brothers at this time because they both still lived in London and didn't come to visit us very often, apart from Christmas-time, so I was like an only child really. My parents were a lot older than all my friend's parents and this could be a bit embarrassing at times, when people would ask, 'Is that your Grandad?' When they came to get me from school.

My dad would sometimes kick a football about with me in our garden, but they always seemed to be busy with stuff around the guest house so I was left alone a lot of the time to amuse myself. As you may know, young boys around the age of ten or eleven experiment a lot, especially with tools and suchlike. I can remember once, sawing through a metal drainpipe with my dad's hacksaw to see if it would really cut metal and putting a hole in the tin bath with a pickaxe because it looked really sharp and various other silly stuff that boys do. Being very old fashioned as they were in those days, both my parents were very strict disciplinarians and weren't averse to hitting me whenever I did anything they regarded as stupid. My dad especially would grab hold of me, point to a room and shout, 'Get in there!' and as I passed by him, he would smack me very hard on the back of my head, I would often see stars. The shock would always make me cry, but in those days, it brought no respite. I was very scared of my dad when I was young.

Finding some matches in the kitchen drawer and setting light to a pile of newspapers inside our garden shed didn't go down too well either. Luckily, my dad was out at the time. Well, that's why I did it! After the Fire Brigade had been called by my mum and a pile of charred wood was all that was left at the top of our garden, you can imagine the pasting I got for that when he got home.

I can't say that I had a blissful childhood because of moments like these.

I find it very hard to understand how kids were often treated in the 60s, I never hit my kids when they were growing up, because I remember the sheer terror I felt when my dad went off on one. I'm not saying he was a bad man at heart, but I suppose because of his unfortunate upbringing – he was sent away to sea when he was thirteen by his mum and dad who he never saw again. He didn't really talk about it, so I'm not sure why. But, he never got shown any love and as a result was unable to show it in ways you might think were normal nowadays.

My mum also had a rough time as a child. Her dad died from diabetes when she was very young and her mother, Minnie Dancy – another corker of a name! – was left to bring up six kids on her own and was a complete tyrant. I hated Grandma. Whenever I was forced to visit her, she certainly didn't have any time or patience for naughty little boys. I remember on the rare occasions we went to visit her and if she was in a fairly good mood, she would say I could go and help myself to a sweet from her sweet tin, which was located under the dining room dresser. Don't get too excited though … her sweet tin consisted entirely of ancient Fox's Glacier Mints and various other boiled sweets, all stuck together in one lump. Mmm, mouth-watering.

I didn't have the best childhood, but it wasn't the worst. I wasn't allowed to go to my friends' houses very often and my parents didn't like me having friends round the house. So, I would have to make my own amusement at home. I developed an interest in the little Airfix plastic soldiers and would spend whatever pocket money I got on them and Humbrol enamel paints.

I spent hours painting the British redcoats with all their white cross belts and black shakos, I even tried to paint tartan patterns on the Highlanders' kilts! This is when I developed a love of hobbies. Anything to do with arts and crafts I would have a go at. I found I had an endless supply of patience and could sit there painting for hours on end, something that was to benefit me in my later life. My mum wasn't so keen on me spending endless hours sat at the dining room table. In her mind, boys should be outside in the garden playing in the fresh air. She had this annoying thing about always making me clear everything away before I went to bed, which was a total bind for me. Consequently, I would have to get it all out again in the morning when I wanted to start again.

When I eventually bought my own house, I made sure I had a man cave so I could leave everything just where it was and didn't have to keep clearing up every time I stopped for the day.

Come to think of it, that might have been one of the contributing causes to the end of my first marriage! Hey-ho, but you've really GOT to have a man cave.

If I misbehaved my mum would often threaten to send me away to borstal, basically a young offenders institute. A bit harsh I thought, but as I was getting older and so were my parents, the strain of looking after a growing adolescent must have begun to take its toll on them.

My brothers – I learnt – had already been a bit of a handful when they were teenagers and had put my parents through quite a bit of stress to say the least. My brother, Steve, had stolen my dad's car one night when he was fifteen and written it off halfway down Lewisham High Street in a head on. God knows what my dad did to him for that but I know my dad cried in court at his hearing. That must have been difficult. My other brother Lee – the eldest one – worked at a garage and one night he and Steve decided it would be a good idea to rob the safe with all the takings in it. Lee had somehow got hold of the key and when the robbery was discovered the next morning it didn't take Sherlock Holmes to recognise that it had been an inside job, because the safe hadn't been damaged at all. And the keys were missing!

The police soon came knocking on our door and as my brothers were no longer juveniles they were arrested and ended up spending three months on remand at Pentonville Prison. I think they only received a suspended sentence due to time served on remand and the amount stolen was very small. But this put a big strain on the family and neither of my brothers returned home to live with us when they were released. Until I was a lot older and much to my disappointment, they found their own accommodation and I rarely saw them after that.

So, when I was heading towards my teenage years my parents must have half expected me to follow the same pattern of behaviour and I could feel a bit of distance coming between us.

The final straw came when I and a couple of friends had been caught over on a building site in Southgate West. One of my friends had thrown some stones and smashed a couple of windows, the police had been called and they took me home, gave my mum and dad a lecture for not supervising me properly and left my punishment up to them. I hadn't even thrown any stones but it was no good, after the, 'Get in there!' and a smack round the back of the head treatment, I could tell they were really pissed off with me.

This would have been the school summer holidays of 1971. I was due to leave my primary school and go on to secondary school in the next term. I was looking forward to going to the same school where most of my friends were going, Thomas Bennet secondary in Tilgate.

To cut a long story short, I think my parents had finally had enough of raising boys at home, so they changed their minds and decided they would be sending me off

to boarding school. In those days pretty much the same as borstal, if you were unlucky enough to be sent to one. The discipline was draconian!

They looked at a few, but it was decided that I was to go to Forest Grange Preparatory School. Probably the cheapest! Only seven miles away, near Horsham. I could have cycled there. But my parents were determined to, in their words, 'Give me a good education.'

In my words, 'Get rid of me.'

Don't worry, I shan't go into lengthy detail about my school days because I find that one of the most boring parts of any autobiography but there are a few memorable moments, both good and bad. I also think it would be interesting to relate how public schools were run in those days compared to comprehensive schools which most kids attended.

Read on and be warned, it's fairly shocking!

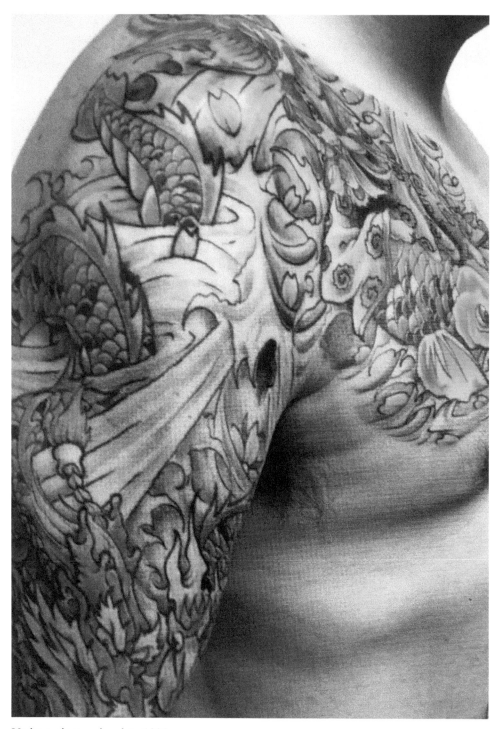

Various pieces, circa late 1990s

Chapter 2: *Public school days*

You have to understand that when you're eleven years old you don't really have a clue as to what is going on around you. Other than when it's time to eat and when it's time for bed and when it's your birthday or Christmas. The happenings of the world just don't seem to concern you. I knew I was going to a new school, not the one I had hoped to and I wasn't going to know anyone there. I knew we were spending a lot of time fitting me out with a new uniform, underwear, shoes, sports kit, pyjamas, blazers and overcoat, which would be packed up into a large trunk that would be going along with me. But it was just another school, wasn't it?

Well, I was in for a shock on my first day. It was a very old and stuffy place. The hallways and classrooms smelt damp and musty and all the teachers were old males and mostly very scary looking. The only female staff members were the headmasters' secretary and the Matron.

Mum and Dad drove me there on the first day of term and after unloading my trunk and putting it in reception and after a few tears I waved goodbye and was led off to my classroom. After surviving the first day of lessons and not feeling too traumatised with my new surroundings, I got on the bus with the other boys which I assumed would take me home.

When the teacher on duty took a headcount there was one boy too many, me.

'What do you think you're doing Fuller!? Get off this bus now. This is the day boys' bus. Report to the headmaster's office immediately!' They never seemed to speak; it was always a shout.

Completely bemused, I got out of my seat and got off the bus to screams of laughter and cat calls off all the other boys.

'New bug! New bug! Fuller is a new bug.'

I burst into tears at all of this which made things even worse.

You learn not to cry at public school and you learnt not to cry pretty quickly if you didn't want to get bullied for the foreseeable future. But this time I cried like never before. I wasn't going home. Like I said earlier, you don't fully understand what's happening to you at that age. It hadn't sunk in that I wasn't a day boy; I was a boarder, Ahh, that was why I had a great big trunk full of clothes with me!

I wasn't going home for at least the next month!

What's more I found myself being escorted to the headmasters' office by a prefect to be accused of *trying to escape* and as I was forced to bend over his desk, receiving four strokes of the cane on my arse!

You probably get a rough idea of how I felt at this point on my first day at my new school but believe me it was a low point in my life. I didn't know what I was doing. All the kids, well the day boys at least, were laughing at me, and my backside was so sore I couldn't sit down properly. Yes, when they gave you *the whack* as we called it – much too freely in my opinion – it hurt. It was really meant to teach you a lesson, they didn't hold anything back.

Funnily enough a little while later my spirits were soon lifted, word had got round that new boy, Fuller had got *the whack* on his first day at school. So I was treated like a mini-celeb by some of the other boys who admired my pluck.

What a bizarre first day at my new school.

Public school was very difficult for anyone in those days. It was a very unsympathetic environment. You were stuck there for weeks on end without contact with your parents and couldn't go back to the sanctuary of home each night like normal schoolkids. There was nobody you could really count on to help if you got yourself in a sticky situation. You were very much on your own.

I think this realisation definitely helped me in my post-school years and sharpened up my outlook on things, eventually giving me the confidence to live my life under my rules and trust my judgement on the decisions I was to make. Even now, once I make a decision I very rarely regret it and I go all out to achieve it.

There were all sorts of boys there. Boys from every country, Black boys, Asian boys, upper class boys who spoke *posh* and normal boys like me whose parents were fairly well off and could afford to send them away to get a decent education. At that age there weren't really class divides, but some of the posher boys were a bit up themselves.

There was an awful lot of bullying though, mainly at night in the dormitories after lights out. We were sent to bed very early in those days. During the summer it would still be sunny for ages so it was difficult to get to sleep. There would be a lot of piss taking and teasing but if you were caught talking after lights out by one of the masters on duty, the dormitory light would suddenly come on and he would call out the names of those he had heard talking. Line you up outside in the hallway to receive a couple of vicious strokes of whatever weapon he carried, be it a cane, hairbrush or tennis shoe. This made it even harder to get to sleep, as your backside would now be on fire for the next hour or more.

We used to take turns to sit peering down the hallway from our dormitory door as a sentry, keeping *caveat* as we called it, there was a lot of Latin going on in those days, but we would still often get caught talking. The boy who had been keeping caveat receiving an extra stroke for his troubles. This must seem pretty harsh

to *normal* kids sitting comfortably at home, but it was just the way it was in those days. It was like being in the army and although I hated it most of the time, as I looked back on it as a grown up, I did find it character building.

It's also very hard living with other boys 24/7 and there were often scuffles and fights. This was considered normal by the teachers who often turned a blind eye to the odd black eye or bruise. But if they actually caught two boys fighting, they would take their names and they would be made to go to the gym on a Sunday after chapel, don PE gear and a pair of boxing gloves and fight it out under the Marquis of Queensbury rules in a makeshift boxing ring in front of a small audience. It was a good way to learn how to fight and stick up for yourself and no one really got hurt. Although there were quite often a few bruises and tears. I must admit I quite enjoyed the bouts that I had. It was also a good way of ensuring you weren't the subject of further bullying once you had won a few. Funnily enough, the boxing coach was also a priest, Father Thompson. All in the good Lord's name, eh?

I wasn't a great academic pupil but I did love the sports, we played rugby, hockey and cricket. No soccer though. I played for the school in all three disciplines and got my full colours for rugby and cricket. Public schools were seen as a forerunner to joining the armed forces, a lot of the boys went on to Sandhurst officer school. So, there were lots of outdoor activities such as assault courses, cross country running, rock climbing and canoeing which I also really enjoyed.

Unfortunately, the outward-bound activities were run by our Australian chemistry teacher, Peter Smith, a nice enough guy but it turned out he had a dark secret, he was a paedophile! A few years after I had moved on to my next public school, I heard that he had been caught interfering with one of the boys at a weekend away camp and had been doing so for years, he had been arrested. I never really trusted this guy. It's funny how you can get a sixth sense about someone. He used to do some weird things. When he used to be the master on night duty, while on his rounds, he would come into our senior dormitory and show us porno magazines such as Mayfair and Playboy and didn't mind us talking after lights out. Also, when we used to get changed into our swimming gear in the hut to go swimming or canoeing on the lake, he would do so as well and he would always be the first one to get his clothes off and would soon be standing there, stark bollock naked in front of everyone. Very strange behaviour from an adult when you're a thirteen-year-old boy. We would all be struggling to get our trunks on and holding a towel round ourselves so no one could see anything, but he'd be in no rush to put his on. It used to be very embarrassing.

I thought nothing of it at the time, but many years later I realised this was a form of grooming. By standing there naked in front of everyone he could see if any

of the boys were looking at him and so he would have an idea who he might be able to approach at another time. That sent a shudder down my spine. It gave me another reason to be annoyed at my parents for sending me to such a place where things like that along with corporal punishment, could so easily happen.

He served quite a few years in prison for his crimes, so I'm sure he got his just desserts. Good.

Then, in the Autumn of 1973, after passing my *Common Entrance* exam, but only just. I went on to Seaford College in Petworth, Sussex. A much bigger school but run with the same rules. Mind numbing discipline and corporal punishment.

I looked it up on an internet search a while back: When was corporal punishment abolished in Public Schools? and it turns out it went on until 1983, so for quite a few years after I had left school.

Corporal punishment: punishment of a physical nature, such as caning, flogging or beating was without a doubt one of the worst parts of my schooling. Most masters, as they were called at public school, seemed to enjoy it. You would be sent to the office for the most ridiculous offence. Then they would make you wait outside, shitting yourself at the punishment to come and knowing what was about to happen. Once you were called inside you would get a dressing down at full volume and then be forced to bend over against their desk while the sadistic bastard swished his cane through the air. I'll never forget that noise. Then they gave your backside four to six vicious strokes with the cane depending on the severity of the crime. This could be anything from having shirt buttons undone, no tie on, or talking after lights out.

At Seaford College the age range was thirteen, the 4th year, up to eighteen, the 6th year. So, you had another dimension here because in the 6th year you could become a prefect, which gave you the right to treat the younger boys appallingly. On the whole the biggest bunch of cunts I've ever encountered. You had to call them, sir. Yep, you had to call an eighteen-year-old, sir! So, you can imagine what that did to their egos. They couldn't give you *the whack* but they could give out Prefects Detentions (PDs) which consisted of writing out lines for half an hour's duration in your very limited free time. I was not a great fan of being told what to do by someone who was only a few years older than me. Particularly, when I knew, due to my many boxing bouts at Forest Grange, that I could probably wipe the floor with them. But there wasn't much you could do. You had to bite the bullet, because if you laid a finger on them that would automatically be six lashes with the cane.

Suffice to say I spent many hours of my free time at Seaford College writing out PDs.

Very hard times during my teenage years, but it wasn't all bad. I did get used to

the discipline and this also set me up for my adult life because whenever I got knocked back, I didn't make too much fuss. I just took it on the chin, kept calm and carried on. Being a public schoolboy makes you mentally tougher than the average kid in my opinion, because you can't go crying to mum and dad when there's a problem. You have to handle it yourself. So I am very grateful for that side of it. Also, I did have some very good mates at school because we used to stick together through thick and thin. You would never *grass anyone up* for anything, even if you didn't like them. It was just not the done-thing to tell tales.

I still keep in touch with a few old school mates. Fifty years on and to this day we still meet up at a pub or restaurant three or four times a year on Old Boys Nights. They all seem to have done very well in life. I'm the only tattoo artist in the group though. Do you think I stand out much?

Finally, my favourite story of my public-school days. Although it wasn't very funny at the time.

I'm pretty sure I can lay claim to being the only boy to be given *the whack* whilst playing a sports match representing his school. Yep, you read that right.

I must have been sixteen at the time and it would have been my last summer term. I was playing a home cricket match for the school against another school. The cricket pitch wasn't very far away from my dormitory building and we were batting at the time so I didn't have to be out on the field. A boy came running over and said, 'Fuller, your dad's on the phone.'

So, I rushed into the dormitory building and was on my way down the hall to the payphone. As I got there the Housemaster, a Kiwi, called Mr Hern came out of his office, saw I had left a trail of holes in the lino floor all the way down the corridor where I hadn't taken off my spiked cricket shoes in my excitement to see what my dad wanted. He instantly went ballistic, 'Fuller! Get in my office now!'

One giant bollocking and four vicious slashes of the cane later, I ran to the phone again, this time in my socks. But too late … my dad had hung up.

When I returned to the cricket pitch, completely pissed off, word had already got back to everyone and they were finding it extremely hard not to laugh. While I just stood there, they kept telling me to sit down. I can't blame them and looking back it was hilarious really. Who the hell gets caned while playing for his school? I was so fucked off with the place by then that as the ball sailed towards me, I just stepped to one side with my bat and deliberately got bowled out. So, I made myself get out for 0, a duck, and I didn't give a shit. I can't remember if we won or lost that match.

In a nutshell, that was my school days.

An emotional seesaw full of downs with a few ups. A lot of hard lessons learnt.

I did get quite a good education in the end though and passed most of my O Levels, because the emphasis was on working hard, we had school lessons on a Saturday morning! I never got enough to eat. I remember being hungry the whole time, I had never really spoken to a girl, I learnt to stick up for myself and not be a *Mummy's boy*, I never got homesick again. I learnt how to successfully tackle the emotional side of life, look on the bright side whenever possible and never give up on an idea without giving it my absolute best shot.

I must confess though, there was a time when I was older, after my kids had been born, that I went off my parents for a while for sending me away to such a place.

I could never have sent my kids off to the lion's den that public school was, especially at age eleven, with its bullying, harsh discipline, corporal punishment, awful food and especially the possible run in with an actual paedophile. I cared too much for mine at such a tender age, to let them be at the mercy of people who might pretend to but didn't particularly care about them one way or another. Abuse has many, many forms and it is pure luck how you come out of it at the end.

Another downside to going to public school for me was that it did make me very shy when I entered the outside world, because I didn't know how the other kids would take it when I told them that I'd been to boarding school. I didn't really know how to talk to girls and I didn't have any friends that lived locally. All my friends at school came from all over the place, many miles away. So that made things a bit difficult when I moved on to get an apprenticeship at a local factory on the Crawley Industrial Estate where a lot of the other apprentices already knew each other.

But I was sure my strength of character could pull me through and an even better thing was … I wouldn't have anyone watching my every move and treating me like I was a kid any more. I had left school and left all that bullshit behind me.

Oh, wait a minute … I had forgotten, I was going back to live with my parents. Fuck.

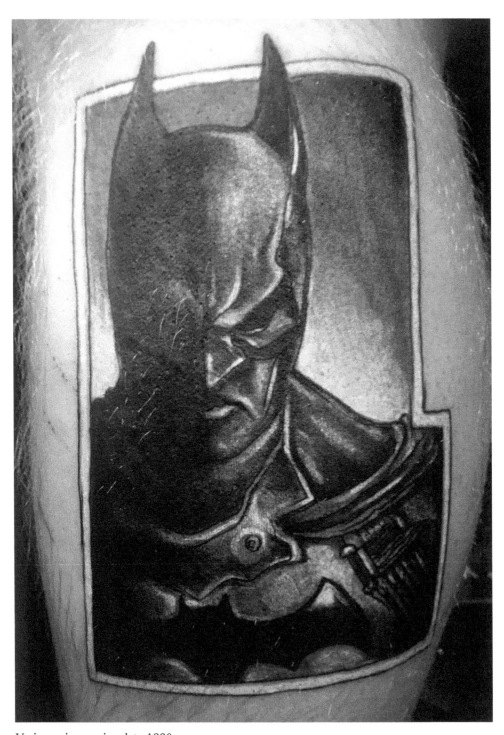

Various pieces, circa late 1990s

Chapter 3: *Back home*

I left Seaford College on Sunday 4th July 1976. The date, 4th July wasn't lost on me of course, it's Independence Day in the USA!

It was a great feeling to finally be free of the oppressive regime of public school. On my last day there was a final assembly, which my parents were allowed to attend with me. I remember my mum remarking how smart all the Masters looked with their hats and gowns on. Oh my God, if only she knew what they were really like, but I didn't bother to say anything. My mind was so full of what I was going to do with my newfound freedom.

There was one tragic incident that certainly put a downer on things though.

After assembly was over and the headmaster and the various housemasters had said their piece, we walked out of the main hall to be greeted by an alarming sight. Parked outside on the gravel drive there were a number of police cars with blue lights flashing and an ambulance and a fire engine. The headmaster and a few of the masters, with stern and shocked looks on their faces, were deep in conversation with a couple of police officers.

Apparently, there had been a tragic accident. One of the boys who was leaving had gone missing with a couple of other lads and taken his dad's car for a joyride. As he didn't have much of a clue how to drive, he'd obviously floored the accelerator and lost control, hitting one of the large trees on the long driveway up to the school and totalling the car.

He was killed in the collision and the two other boys were seriously injured. No seat belts of course.

As you can imagine, this had a profound effect on everyone present that day. It was just so tragic and unnecessary, very hard to get your head around when up until then the day had been so full of excitement and anticipation. It just goes to show you how fragile life can be. He hadn't even left the school to start his new life. He died in his school uniform.

His poor parents.

On our way home we drove past the scene of the crash, no one had been allowed to leave until the wreckage had been cleared away and the casualties taken to hospital. I was totally aghast at what was left, pieces of car, glass, deep ruts in the grass and deep gash marks on the tree. It was a harrowing scene and I can still remember it very clearly.

As he was in my year, I knew the boy very well and it did affect me, and

obviously a lot of others, quite badly for a number of years after.

So, we all arrived back at Pine Lodge a bit later than anticipated. I got changed out of my school uniform for the last time and my mum, dad and I went for an, albeit muted, celebration dinner at The Crown pub at Turners Hill near Crawley. I remember they used to do the best gammon steak and chips I've ever had, so that helped to lighten the mood a little. Sunday may seem a strange day to leave school but that's public school for you.

The conversation in The Crown was based around what I was now going to do with my life. We had talked about it a lot before I left school but following in my parents' footsteps it was decided that I wouldn't be taking part in any further education. Thank God. I'd had enough of schools and teachers to last me a couple of lifetimes!

When I left school, I didn't really have a clue about what I was going to do with my life. I quite fancied joining the Army. A few of my schoolmates had gone on to do this. I was sure I had the fitness and handling the discipline shouldn't be a problem after what I'd been used to.

But my parents had decided that getting an apprenticeship was the only way to go. Apparently, I would be applying for Engineering Apprenticeships at a couple of local factories on the Crawley Industrial Estate and whether I was accepted would depend on my O Level results. I needed to get passes in at least English and Mathematics, so as long as they were okay I would have a decent job and be set up for the foreseeable future.

This sounded great to me, I would be earning money. My dad also informed me that they had found an interim job for me at a factory that made wooden art easels. I started the next day, Monday morning. Bang went my idea of a long rest, painting my soldiers before I moved on to the next stage of my life! I didn't really mind though because again, I would be earning money which would make me feel totally grown up.

I did feel sorry for those of my old schoolmates who had to go back to school the next term and carry on their education and be totally broke. Although being in the sixth form, life got a hell of a lot easier. You weren't subject to such harsh discipline and you had the chance to be a prefect and boss around all the younger kids. I might have enjoyed that but I'm not a bully by nature.

The idea of getting an apprenticeship seemed good at the time because once I qualified, I would have a full-time job as a qualified at whatever it was I qualified in. I had no idea how factories worked or what they even did. Comprehensive schools prepared kids for the outside world a whole lot better than public schools did. My

experience of public school was that it was very limited in its connection with the running of the world as a whole. I hadn't done any metalwork or woodwork or touched on any of the things I would encounter in my adult life. The whole emphasis had been on academic and sporting pursuits and for me, doing fucking prefects' detentions.

Monday 5th July, off I went to start my first job: making easels on Crawley Industrial Estate. My Mum had made my packed lunch; two peanut butter and marmite rolls, the same lunch she would make for me for the next four years or so. When my mum knew you liked something it was set in stone, bless her!

I was properly nervous about starting that day but the people were pretty nice and it was mostly older women who worked there, so I think having a young lad about the place cheered things up a bit. When they asked about where I went to school, I just said that I'd only recently moved to the area and they wouldn't know it, which seemed to satisfy the queries. I stuck to this story for the next few years. Whenever I was asked, because there was a bit of a rumour going round at the time that if you went to public-school you were gay. Far from it, I was dying to get the chance to get myself a girlfriend.

The work was very easy, just drilling holes in hundreds of small pieces of wood and other non-taxing jobs like that. The time passed quickly because there was no one bossing me about and I began to feel a lot more grown up. I even copied one of the older guys there and bought some tobacco and rolling paper and started to smoke. Pay day was on a Thursday and my first wage packet was just over eighteen pounds. That might not seem a lot nowadays but I went straight into town after work and bought myself a Levi jacket and some other bits. I was made up. I was earning money.

My parents were very old fashioned and hadn't changed much while I was away, the initial furore of my return home soon died down and my home life began to go through a period of drudgery. I spent most of my time in my room playing the vinyl records I had bought with my wages: Showaddywaddy, Bay City Rollers, The Sweet etc. Yes, I know, hilarious when I look back but these bands were all the rage in the late 70s.

Not long later I got my O Level results back and I had passed enough of them to get me into an apprenticeship with a large local electronics firm called, Mullard's Electric Limited. I had really wanted to get a job at British Caledonian Airways where you could get free flights if you were staff, but it was not to be.

I went for my interview which went well, I found out they were something to do with the Ministry of Defence and made parts for guided missiles. Guided missiles! That sounded good to me. Maybe I'd get a chance to let one off?

I signed the contract for my apprenticeship as a trainee Electrical Technician.

Big mistake, I should have gone for the mechanical side where you got to work on lathes and milling machines and do welding and metalwork. The electrical side was all electronic circuits and equations, mathematics and stuff like that. To me it might as well have been written in Greek, I was way out of my depth and struggled the whole time I was there.

The first year of my apprenticeship was done at the ITC: The Industrial Training Centre at Crawley College. This turned out to be a great laugh, all the other boys were about the same age as me and I fitted in quite well. I had always longed to mix and make friends. I used the old, I've just moved down here from London ploy to avoid having to tell anyone I was an ex-public schoolboy.

There was one huge downside though, I had to spend one day a week in a classroom on *day release*. Oh my God, a classroom doing maths and electrical science! I had vowed to myself never to go anywhere near a fucking classroom ever again in my life. But as part of my contract, I had to. Because of my good O Level passes I was put in the top tier. Again, it might as well have been Greek to me, I had no idea or interest whatsoever in the stuff they were trying to teach. Each year I failed the exams miserably and went down a tier until by my last year I was down in the bottom group and it still seemed just as difficult as it had before.

My attendance was very poor as well, I'd rather be anywhere else than the classroom. I had to go to the management offices a few times and be told I'd have to do a lot better or I could find myself out of a job. That didn't go down very well with my parents who got a couple of letters telling them the problem. My dad was still giving me the odd slap if I misbehaved and at this time, I was approaching seventeen. Yep, seventeen and still getting walloped.

After the last warning letter, my dad tried the, *get in there!* smack round the back of the head trick, and by this time I'd had enough. As I passed him to go into the room he was pointing at, I ducked and he hit his hand on the door frame. So, he went to kick me and I caught his foot and tipped him onto his arse.

'Oh, so you think you're a man now do you?'

'Stop it, Dad,' I replied

'Okay, outside. We'll see about that.' He grabbed me and we went out wrestling into the garden with mum screaming behind us. I couldn't believe I was actually in a physical struggle with my dad, until he hit me hard on the side of my head with his fist!

Well, that was that. I immediately saw red. I shouted at the top of my voice. All the years of bullying and abuse had come to this. He had actually punched me in the face! I hit him twice with two corkers right back where he'd hit me and over he went

backwards into the rose bed on top of two of the large thorny bushes. He was trying to get up but was scratching himself to pieces and screaming out in pain.

'Help him, Dan!' said mum and was trying to help pull him up.

As far as I was concerned, he could sleep there that night. I felt awful that I'd had a fight with my dad but proud that I'd stood up for myself at last. As far as I was concerned, he had started it and he got what he deserved.

We eventually got him out of the tangle but the look on his face as he got up said it all: he'd lost. He could see by the look on my face that if he tried any more, he would get the same again, so without a word he turned and stormed back into the house.

I shouted out, 'Sorry.' but we were never the same again.

He would have been about sixty-five at that time and was still very fit and strong due to his Navy and sporting days but of course I was seventeen and fresh out of school and probably had as much ring time as he had. It was a foregone conclusion. I was quite upset for a while after this experience and it was pretty tense round the house for a fair while. Things got better, but by that time I had got my own car and was going out a lot to discos, as the clubs were called then. I had a girlfriend and I had a taste for beer. I was also smoking at this time, but I never smoked in front of my parents because they would not have approved and would still tell me off fairly regularly. But there was no more hitting me round the back of my head.

It may seem that I didn't think too much of my parents but as I said before, they were quite old when they had me and already had two teenage boys when I was born. So, it must have been a bit of a strain having a new baby when you think your parenting days are almost finished.

One good thing I do remember my dad doing for me, was lending me some money to buy my first car: a 1963 green Austin Mini 850. I was seventeen, just old enough to start learning to drive. They were good at pushing me to get going with things like that. I paid for some lessons, £3.50 an hour! And when my eldest brother Lee came down to visit us at the guest house in Crawley from London every other weekend, he would get the train down on the Saturday. On the Sunday, we would all get into my Mini, my dad would sit in the passenger seat, as I was a learner and I would drive Lee back to his flat in Forest Hill, South London. It was a fair old way and I would absolutely love driving up to London and back. There wasn't much traffic then – especially on a Sunday – so thanks to dad I got lots of practise and managed to pass my driving test on the first attempt in August 1977. Nice one Dad.

Other than that though, we weren't a very close family. I can never remember my mum or dad telling me they loved me. It just wasn't their way. I'm sure they did

though. Mum certainly did as she got a lot older but they were never the emotional type. I was a lot like that until my first child was born when I couldn't help the feelings of love and emotions babies brought about. It wasn't until they were in their seventies and had retired that they relaxed a bit and began to treat me more like a proper grown up, even though I had started my tattoo studio by then and had been working for myself for a number of years.

They certainly didn't understand why I wanted to become a tattooist, but more of that later.

I really enjoyed my year at the ITC, it was such a laugh. The boys were all very down to earth and I made a lot of friends. There was even a boy there from Forest Grange, Ian Taylor, who I am still friends with today, fifty years! Being at Crawley College was great, there were a lot of girls there, hairdressers and the like. I was very shy – and I still am, believe it or not – when it comes to chatting up girls, but I had a few girlfriends during this time and life was good.

My main friend at this time was a guy called, Dick Butland. He was a great big fella who used to smoke like a chimney and drove a tiny Austin Healey Frog Eye Sprite sports car. I made him laugh one dinnertime in the canteen and we took to each other instantly, which was great from my point of view because he really was a big bloke and used to work as a bouncer at some of the discos. So, wherever he was working I would get in for nothing even though I was underage. People didn't seem so bothered about underage drinking or drinking and driving in those days, but because of that I do think there was a lot more violence in the pubs and clubs than there is now. There always

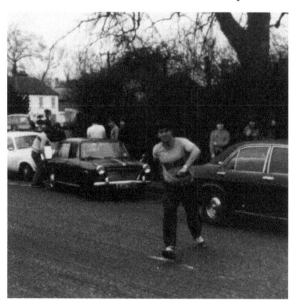

2. Burgess Hill Barkers on tour!

seemed to be a punch-up wherever I was most Friday and Saturday nights in either the pub or the disco and especially at the Grubstop burger van at Crawley Railway station car park, which would be open after the discos shut. Different gangs of lads would congregate and there would very often be free for all's going on all over the place. It was always fists though and sometimes glasses, but you never saw knives being used which was good.

It was all part of growing up in the 1970s and I managed to get

through it all pretty much unscathed. There were a couple of times I was *started on* but I found it easy to deal with because most kids think they can have a row but when it comes down to it, they don't really have any experience. One or two good hits in the boat race will discourage the toughest nut.

Another lad that I got on really well with at the ITC was another apprentice at Mullard's. Graham Somerville or Grudge as he was nicknamed, was a little older than me but we both loved a laugh and had some hilarious times. He was from Burgess Hill; not too far away from me. He got me into soul music which I really took to and is still my favourite kind of music along with jazz funk. He was part of what in those days was called a Soul Tribe, The Burgess Hill Barkers, it was a group of boys and girls who would get together and go to the soul all-dayers or all-nighters, which were literally that. Disco's that would take place either all day or all night where you would have live bands and DJs playing the whole time and there would be tribes from all over the UK. They would have names like, Magnum Force from London, The Eastbourne Earls, The Brixton Frontline, Brighton Southern Atmosphere and The Paddington Soul Patrol.

This was a most enjoyable time, we'd get together on the weekends and go out together all over the place. Brighton mainly, but also London and other places. There would be anything from a handful of us up to twenty or more. We all loved dancing and were mainly there for the music, but it was great to feel part of a group. I was from Crawley then but I was welcomed nevertheless, especially when I did the first sky dive off the balcony at The Top Rank at one all-dayer – a la Quadrophenia! Everyone wanted to have a go after that, some not as successfully as our attempt. Eventually the DJ Robbie Vincent – my hero from The Radio London Soul Show – had to stop the music and plead with everyone to stop it as people were getting hurt. Ha ha. After that wherever we were and if there was a balcony, it would be a Burgess Hill Barkers' trademark to do the sky dive.

The main soul weekender of the year was not that far away, at Caister Holiday Camp in East Anglia. It would be packed and would go on from Friday night to Monday morning. Three days of dancing and boozing. We always had a brilliant time and the chalets we were in would be a complete train wreck at the end of it; they were definitely the highlight of that period of my life.

Back at work at the factory, life was not so much fun. It was a joke really. You had to do three or four months in each department to learn how the place worked: goods inwards, wiring, quality assurance, the drawing office. I couldn't give a fuck really. Each department was supposed to give you work to do so you could learn how they operated, but as no one there really knew how to go about the teaching part I'd

usually be left alone and have fuck all to do while they all got busy with whatever it was they were doing. Time dragged by. The days were mind numbingly boring to me. I would find any excuse to go off and skive, usually sitting on the toilet and reading. My legs would go numb! You'd get half an hour for lunch, which would fly by and then it was back to trying to make yourself look busy until it was time to go home.

I can't remember any highlights that come to mind during this particular period at the factory, but I do remember getting the chance now and again to make myself a bit of a nuisance with some of the young girls in the offices when I was asked to take a message up. So there were a few good days.

Everything happens for a reason though, even at the most miserable of times. It was during this time that I first noticed a tattoo on somebody.

I was at the washroom sink one morning washing my hands and a lad came to the sink next to me, he was a skinhead and as he rolled up his sleeves to wash his hands, I noticed he had a freshly shaved patch on his forearm. I could see he had some kind of design in the shaved patch. Obviously, a new tattoo.

'What's happened there?' I asked.

'Just had a tattoo done last week,' he told me and held it up so I could see. I was amazed. It had started to scab over and some parts had already healed. The scabby parts were very blurry and you couldn't make out much, but the parts that had healed were clear and shiny and you could see all the colours and the lines. Now I was totally amazed. I think it was an actual jaw dropping moment for me. As a complete layman as far as tattoos were concerned – and because he'd had his arm shaved – his white skin made it look even more attractive.

I had already had a brief go at tattooing myself just after I left school, with a needle and Indian Ink but that had turned out disastrously and I'd never really shown anybody. I did show this guy though, 'Look here's my tattoo.' I said as I rolled up my sleeve.

He burst out laughing, just as I expected.

'You should get that covered over.'

'Can they do that?' I said.

'Yeah, easy,' he said. 'We've got a two-week summer shutdown coming up, we get the two weeks' pay in advance and I'm going up to get another one on the other arm. Why don't you come up with me? It's a studio in Fulham in London. The guy's really good.'

'Sounds good, I'll let you know.' I said.

I was dying to get my shitty homemade tatt covered up because it hadn't quite turned out to be the masterpiece I was hoping for, but my parents still hadn't seen it

and I was really worried that if I got something bigger – a proper professional one – they would see it and I'd be for the high jump. I still lived at home under their rules and their rules were very strict. Too fucking strict.

I couldn't really think about much else in the next few weeks. I really, really wanted to get a proper colourful tattoo done over my homemade crap. I'd seen the guy, Paul, a few times since and his tattoo had healed by now and I thought it looked awesome. I got him to show me every time we bumped into each other. This feeling was growing inside me; it was very powerful and it was not going away. The more I thought about it, the stronger the feeling became. But I was so scared of my parents' reaction.

Dad and I had not had our showdown by the rose beds at this point!

Finally, in the week before the factory shutdown – when I had the two weeks wages in my pocket – I decided, fuck it, I was going to go for it. The desire had become too strong. I just had to get my tattoo covered with a brand new, lovely, full colour professional job. I'd just have to be extra careful not to let my parents see it. I told Paul I was up for it and we arranged to meet at Crawley train station the next week and go up to London to get tattooed. I was going to do it. It was one of the most exciting and most daring things in my life so far. The feeling was that strong.

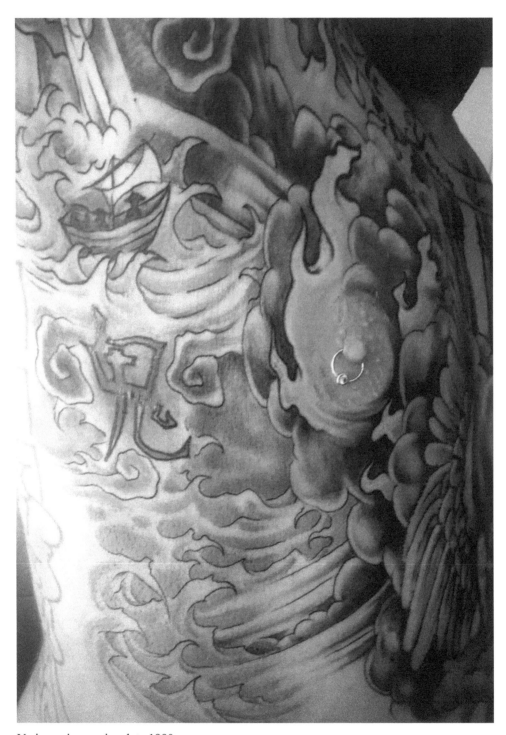

Various pieces, circa late 1990s

Chapter 4: *Going for it*

I remember the day Paul the skinhead and I arranged to go up to London to get tattooed was a Tuesday. As it was summertime, he reckoned the tattoo studio would be quieter during the week than on the weekend. In the late 1970s right up to the end of the century, you couldn't book a time or date in advance to get a tattoo.

Tattoo studios were a one-man operation; there was no one sitting at a reception desk as you walked in. A lot of studios didn't even have a phone and there were certainly no mobile phones in those days. The guy had enough to do without answering the phone, taking deposits and booking people in.

So, it was a case of first come, first served. Most tattoo studios would open around 11 or 12 o'clock, no one was going to get there for a tattoo at 7 am! The tattooist certainly wasn't going to get up that early, they were free-living party animals remember? Ha ha, well that's the image they gave off.

Summertime was the busiest time of year so it was best to get to the studio a couple of hours before it opened so you could guarantee you'd be first in the queue. The studio we were going to was on Fulham Broadway, in the basement beneath an antique shop. The guy's name was Terry Maclaren, the studio didn't have a name, like most studios do today: Blissful Gallows, Fallen Heroes, Vibrant Lotus Blossom … ffs! Just a sign outside with, Tattoo Studio written on it.

I know I didn't sleep much the night before; I was just too excited. I had no idea of what I was going to get done and I wasn't sure of how it all worked. Paul told me that all the designs were on sheets on the wall with the price by each design and you picked the one you wanted.

'What sort of designs are there?' I asked.

'All sorts, he's got hundreds of them.'

I was buzzing with anticipation like never before. Being a Crawley boy, the fact we were going up to London for the day also added to the sheer excitement of the whole adventure. I'd spent my younger days in South London but had left when I was seven and my parents moved to Rochester and I'd only had the odd day out in the smoke. So London was *the big scary one* to me.

It was quite a journey to Fulham from Crawley, by the time we got to the studio it was around lunchtime. We walked in through the door of the antique shop and the old guy who owned the shop could obviously tell we weren't there to buy antiques. He told us that Terry was in and downstairs.

As we went downstairs the smell of the place hit me, it smelt of antiseptic.

Rather nice, I thought. I could hear the tattoo machine buzzing away and I felt goosebumps forming on my skin. I was here, how fucking exciting was this?

The studio itself was nice and bright and as I said, it smelt very clean. They used to use Listerine mouthwash in the spray bottles to clean your skin in those days, so the air was full of it. The room was fairly small and the walls were covered from floor to ceiling in varnished tongue and groove, like a sauna. They were covered in sheets of multi coloured tattoo designs. To me it looked fantastic. I'd never been anywhere like it.

The trouble was, there were a few people already there before us and the tattooist was already working away at a design on a bloke's arm.

'What are you after lads? Oh, hello mate,' he recognised Paul because he'd been up a few weeks before.

'I'm up for another one and my mate wants a home-made one covered up,' Paul told him.

'Well, I'm going to be a while, cos I've got this one to finish and there's a couple more before you. Give us a bit of room; shoot over to the pub for a while and then come back in a couple of hours and I should be done.'

So off we went to the pub down the road. I must admit I was a bit disappointed, as I would have loved to have stayed there and watched what was going on, but the tattooist himself made me a bit nervous.

He was in his thirties, I'd have said. He wasn't a big bloke but he was sitting there in a t-shirt and his arms were completely covered with tattoos, which made them look twice as big as they were. You couldn't see any of his skin. As I found out later, these were called sleeves. He also had what looked like the ends of bird's wings sticking out of the neck of his shirt. To me they looked the coolest thing, but they also made him look very intimidating and I was going to do whatever he said, for sure.

There's something magical about the human skin as a canvas. When you see a design on flat, bright white paper it looks nice – but it looks sort of clinical and contrived. When you see the same design on skin it has a glow to it, a softness that is unique. It seems to belong there. The curves of the body and the muscles moving beneath it make it come alive. When you look at a sleeve where there is hardly any skin colour remaining, it can't be compared to anything else and a full bodysuit looks even better. Almost surreal.

I had a tailor's mannequin in a display cabinet in one of my studios, which I had sprayed with a near full bodysuit of colourful Japanese style tattoos, it looked lovely but it didn't look anything like the real thing. Photos of tattoos, no matter how professional the quality, don't come close to seeing a tattoo on skin in real life. If you

can appreciate this you can begin to understand the lure that tattoos have on a lot of people.

As it turned out, I am one of those people. When I saw my first tattooists' sleeves that day as he sat in his chair, it had an effect on me that I would only come to appreciate much later on when I had sleeves of my own and I was that guy sitting in the chair.

We finished our pints and headed back to the studio, the excitement rising in me again, but when we got downstairs, he was still busy and there were still a couple of others waiting. Terry told us to come back again a bit later and off we went again. I had managed to get a quick glance at some of the designs on the wall and saw a really nice-looking tiger that I fancied having.

Rinse and repeat, we went back and forth from the studio to the pub a few more times, but each time we got back to the studio there was someone in the chair. Eventually it all got a bit much for Paul because we must have drunk five or six pints and he decided he couldn't wait any longer and would come back another day. I, however, was still in a high state of excitement and although I was feeling a little worse for wear, I was determined to get my tattoo done after waiting all bloody day.

Paul headed off to the Tube station and I went back to the studio for one last try, by now it must have been about five o'clock. I struggled down the stairs and as I got to the bottom, I could see that Terry was just finishing a piece on a guy and there was no one else there. Yes! It would be my turn next.

'Hello mate,' he said. 'you still here?'

'Am I still okay to get mine done?' I asked.

'Yeah, won't be long. Sit down over there.'

At last, I could sit down, watch what was going on and have a proper look at all the designs on the wall.

I watched the guy in the chair being tattooed, he looked quite calm and collected and was happily chatting away with Terry. He wasn't writhing around in agony or grimacing with pain and I couldn't see any blood dripping.

Well, I'd been told all

3. Crawley Studio 1984 – look no gloves!

4. My first tattoo – a swallow

sorts of stories of how painful it was to be tattooed.

I hadn't given much thought to the pain factor until then. I just thought if it was that bad then people wouldn't have them done and there would be loads of people walking about sporting half-finished tattoos. I'd played rugby at school and had my backside caned more times than I could count, so it couldn't be as bad as that surely?

Terry gave his customer's arm a final wash down. He sellotaped a pile of tissues over his work as a temporary dressing, the guy paid up and vanished up the stairs.

Finally! It was my turn. I was going to get a tattoo!

He washed his hands in the sink but left all the inks and the machine as it was. No latex gloves or new needles and colours for each customer in those days, but of course I knew nothing about tattooing then, so it mattered not.

'Right then, what you after mate?'

'I want to get this covered over,' I said pulling up my t-shirt sleeve. 'maybe with that tiger?'

'Oh Christ. I haven't got time to do that now, it's a bit big and a bit late.'

Shit.

'Oh, well what can I have?'

'How about a little bird here? A swallow.' he said pointing to my other arm.

'See how you like it first.'

Well, it wasn't quite what I had in mind but like I said, looking at the bloke I wasn't about to argue and I was determined to get tattooed now. I'd been here all day.

'You can come back in a couple of weeks and I'll cover that other shit up for you then.'

Convinced, I sat down in the chair. He got a purple transfer out of a nearby drawer, sprayed something on my arm and laid the transfer of the swallow at the top of my arm on my triceps. When he lifted the transfer off there was a perfect purple outline of a swallow left behind.

44

Amazing!

He fired the machine up and I watched – totally enthralled – as he started to draw over the lines. At first the black ink went everywhere and the purple lines of the swallow disappeared in a tidal wave of black ink. He did a few more lines, employing the well-known secret art of a tattooists' *x-ray vision*, all I could see was a great big black smudge. He stopped the machine, sprayed my arm again and wiped everything away with a tissue. And lo and behold there it was: the perfect outline of a swallow, sitting there at the top of my arm. As neat as anything. I'd hardly felt a thing. He wiped it again to get the rest of the black ink off and the lines he'd drawn on still stayed there. I was absolutely gobsmacked.

'How was it?' he asked

'Brilliant,' I said. 'Is that it?'

'No, I've got to colour it in.'

Duh! Of course. I'd forgotten about that.

He took the needles out of the machine and put some other ones in and started to colour my swallow in: purple, red, blue and finally white. I was hypnotised by the whole process and watched his every move like a hawk, concentrating extra hard as he did it. After he did the white – the final colour – he gave my arm a good spray with that lovely smelling cooling liquid – Listerine and a bit of soap – to clean it all up and lifted a mirror up to show me the result. It was absolutely magic; he was wiping my arm and the swallow stayed there. I *actually* had a proper tattoo on my arm.

The whole thing probably took about fifteen minutes and the time had passed as quick as a flash. I realised I was done and a feeling of disappointment swept over me, because I felt as if I could have sat there for another hour at least.

'There you go mate, that's £6.50.' He put a tissue over my swallow and wrapped Sellotape around my arm to stop the tissue falling off.

'Come back in a couple of weeks and I'll sort that other one out for you.'

And that was it. I'd had my first proper tattoo done and I'd been very brave.

What a day it had been: we'd waited about five hours, had at least five pints, Paul had gone home but I'd stayed 'til the end and accomplished – sort of – what I'd set out to do. On the train on the way home I felt like a million dollars.

There was one funny incident on the way home, the train was pretty full as it was rush hour and there was a very straight looking, middle aged lady sitting opposite me. I couldn't resist having a look at my tattoo, mainly to make sure it hadn't rubbed off! I had a jumper on so I pulled the neck down, so I could get to the swallow, which was at the top of my arm. The tissue that covered it had a fair amount of blood on it by now; especially as I had been drinking and I was struggling with the Sellotape which

he had wrapped under my armpit and stuck to my hairs. It hurt, so I was grimacing a bit. Suddenly I felt someone watching me and I looked up to see the lady sitting opposite staring at me with a look of absolute horror on her face. I think she thought I'd been shot or something.

'Tattoo.' I blurted, with a great big grin on my face. She let out a gasp, jumped up and hurried off down the carriage.

I managed to keep my new tattoo hidden from my parents. They had no idea what I'd been up to on my day out in London. It's strange how fate steps in – but looking back – if I'd managed to get my homemade tattoo covered on my first attempt, I might not have gone up to get tattooed again and therefore I wouldn't have got into the tattoo scene in the way I eventually did. I might just have stopped there and been done with it. But I think that day was such a milestone in my life – and for me it had been such a daring adventure – that I would definitely have gone on to get more ink as time went by. The day might not have gone exactly as I planned and in the end, I hadn't managed to get rid of my embarrassing teenage effort, but as they say: everything happens for a reason.

Sometimes things are destined beyond your control. I'm a firm believer in fate. I'm not a great believer in luck because unless you win the lottery or are a successful gambler then you have to make your own way in life and luck only plays a very small part in that. I know this because I've played a lot of poker over the years and if you're not a lucky person then you're going to lose more than you win. You have to recognise when little crumbs of opportunity get thrown at you and pick them up and see where they lead you.

A couple of weeks later, just before my two-week's break at the factory was over, I took the train back up to Fulham Broadway and finally got my homemade tattoo covered over. I didn't get the tiger that I had originally planned, because I was told that some of the lines would probably still show through; so I had a beautiful horse's head done instead. It took a lot longer than the swallow did, about an hour and a half, and was a bit more painful because part of the mane went into my armpit – wahey! He did praise me on how well I took the pain though, so that helped to make my day.

I was sitting there under the needle for a lot longer than the last time and I had no problem with the first-timer nerves and I hadn't had five pints! So, I was able to take a lot more notice of what he was doing. I had to rest my hand on a towel on his leg and I watched as he put a purple transfer of the design I was having on my arm so he could follow the lines and – I supposed – so he didn't have to waste precious time drawing the design on every time. Very clever, I thought to myself. It looked like it made things a lot easier. He did the outline first, then as he progressed with the tattoo,

he shaded some areas with black ink and finally went on to colour in the rest of the head with brown and lastly coloured in the mane with light grey highlighted with yellow.

It truly was fascinating to me, sitting there watching this horse's head grow on my arm from nothing. He was very good and I had to admire his technique because he made it look so easy. One thing I couldn't work out though, was how he operated the actual tattoo machine. Each time he brought it near my skin to work on a new area, whether it was the outline or the colouring in, it seemed to magically burst into life and the needle started to move up and down ready to pierce my skin.

Was there a tiny micro switch on the machine itself that he pressed? I couldn't see one. How was that tattoo machine bursting into life every time it got near my skin? Was he using the power of his fucking mind? That's all I could think of, because I couldn't see any movement on his part that made that damn thing work. Of course, I daren't ask, he had sleeves!

It was only after a few more visits that I rumbled the mystery that had eluded me for so long. His machine suddenly started to play up and misfire one time, so he stamped his foot on the floor a few times until it burst back into life, I looked down to where his foot was and then I saw it: a foot switch, AHA!

Genius or what? You didn't need to start the machine up with your hands, it was done with a foot switch. That way both your hands were free to do the important things like holding the skin steady and actually guiding the tattoo machine.

I was starting to really get into all of this and the thought entered my mind: how cool it would be to actually have a go myself.

The main reason I began to think like this was because of the tattoo designs that were to be had at this time. I found them so attractive. They had an outline around them and the inside was fully coloured in just like in a colouring book. They actually were miniature cartoons because of the outlines around them. For years – since school – I had been really keen to get into art in some way. But I found it such a difficult subject. I'd tried oil painting, pen and ink, pencil drawing, watercolours and all the other kinds of art. You name it, I'd had a go at it but found it all so difficult. I really didn't want to draw or paint landscapes, trees, cats and dogs or bowls of fucking fruit! Sooo boring. But looking at those tattoo designs covering his studio walls, I reckoned I might be able to have a go at reproducing some of my own. They looked like the kind of thing I could really get into.

You had: skulls, daggers, roses, eagles, panther's heads, swallows, sailing ships, native American Indian heads, hearts, scrolls, flowers, basic female heads, dragons, dice, anchors, peacocks, red devils, cupids, Geisha girls, hula girls, bulldogs,

tigers, wolves and all were coloured in, in bright colours. They were calling out to me to have a go and try to make up some of my own.

So, on my next payday, I went out and bought myself a sketch pad and some felt tips.

My journey had begun.

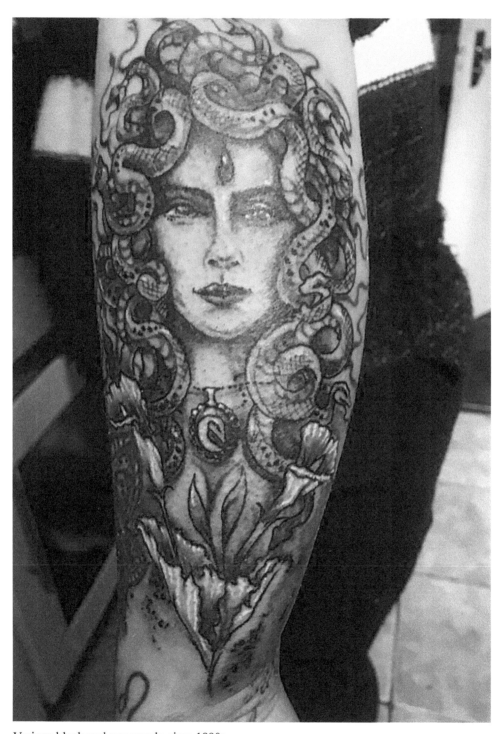

Various black and grey work, circa 1990s

Chapter 5: *Time for a change*

By now, it was coming up to the end of 1979. I only had a few months of my apprenticeship to go and then I would be qualified and full time at the factory. I had chosen to go into the drawing office, of course. Purely because I liked the look of the big adjustable drawing tables with the sexy lamps on. So, when I qualified, I would become what was called a draughtsman.

This sounded good when I first went into the drawing office but unfortunately, it was a Ministry of Defence firm, manufacturing military equipment such as missile guidance systems and night vision goggles. As there was no war going on, there was no demand for the stuff they made, so they weren't actually making or designing anything new. I was supposed to help design the layouts for printed circuit boards and anything else the design department came up with but the only work was changing the odd dimension on a drawing.

To do this you had to get a job sheet written out with the serial number of the drawing to be changed and go down to the stores, log the drawing out and bring it back to your desk. Then rub out, for instance, one dimension and then change it to a different dimension, which took literally thirty seconds and then fill out the completed job sheet and take the drawing back to the stores.

It was about as boring as work could be. Any decent jobs were immediately snapped up by the guys who had been in the drawing office longer than me. I was at the bottom of the barrel and it didn't look like I was going to be able to climb out anytime soon.

Another major problem was my supervisor, he was a miserable bastard of the highest order and reminded me of my teachers at public school. He really didn't like young people and took a special dislike to me because of my general free spirit after having been at public school for all those years. There was no work to be had but he didn't like it if you went over to one of the other guy's desks and stood there talking, you had to *look* as if you were busy which meant sitting at your own desk. He'd be sitting in his glass partitioned office and staring at you over the rim of his glasses; giving you the evil eye until you went back to your desk and sat back down.

He also hated seeing my tattoos and told me to roll my shirt sleeves down so he didn't have to look at, *such an abomination*. What an arsehole he was.

This all came together to make my working life pretty miserable and I started to actually hate going to work. It was only payday every Thursday which kept me going. I spent most of my time drawing my tattoo designs on sheets of paper, which

certainly made me look busy. Some of the younger lads were pretty impressed with what I was drawing which made me feel good.

I decided I wanted to get the hell out as soon as I could and do something else. This sure wasn't the life for me. One of my friends worked at Crawley Swimming Pool as a lifeguard. I really fancied doing something like that, walking around in shorts and flip flops blowing your whistle now and again and getting to talk to all the lovely girls in their swimsuits. That was more like it.

I went for the interview but I didn't get the job. I supposed it was because they knew I had a good friend already working there: the two of us working together wouldn't be a good idea.

I even went up to Hendon with another friend to try to join the Metropolitan Police. I did well at the interview, thanks to my O Level results again, apart from when they asked me which part of the force I would like to join and I said, the Sweeney! This raised a few eyebrows, so they asked if I knew exactly what the Sweeney did? I said I wasn't sure but said I'd like to be like Dennis Waterman (Detective Sergeant Carter) one day.

A few weeks later I got a letter back which said I'd done well enough in the interview for them to offer me a place. But as I was still under contract with the factory for a few more months I would have to go back up to Hendon and redo the medical test. They gave me a new date for my next visit. Of course, by the time that date came along I had already made my mind up to take a very different path!

I was still going up to Fulham to get tattooed, I kept my new tatts to the top of my arm so it was easier to hide them from my parents, but as I got more into it, I was dying to have some done on my forearms to be able to show them off better. By now, I was seriously starting to think about the possibility of becoming a tattoo artist and I really wanted to get sleeves done, because, remember … they looked so cool.

I was also getting sick and tired of living under my parent's strict rules. I was nineteen years old, working full time and had my own car but they still treated me like a little kid. If I came home late after the disco on a weekend or having been out with my girlfriend, my dad would usually be sitting in the downstairs lounge, waiting up for me to give me a bollocking for coming in so late!

The final straw came one Saturday night when I returned back home around 2.30 am. Before I pulled into the guest house car park which was laid with gravel, I switched my engine and my headlights off so I could coast in. That way I wouldn't illuminate mum and dad's bedroom which was at the front and wake them up. All of a sudden, a police car that I hadn't noticed came roaring into the car park behind me (Sweeney style!) with blue lights flashing and skidded to a stop on the gravel.

Oh, my God, that's done it.

I looked upwards and saw mum and dad's bedroom light come on.

As I just sat there resignedly, with my head in my hands, one of the coppers got out of his car – lights still flashing – and walked up to my window.

'What was that all about then son?' he asked.

I lifted my head, 'I'm a bit late and I didn't want to wake him.'

'Who?' he looked puzzled.

'Him!' I said, pointing to my dad who was, by now, silhouetted in the light of the open front door; standing there with a look of thunder on his face, in his pyjama top and Y-fronts.

'Right then, I'll leave you to it.' the copper said, with a wry grin on his face, as he got back in his car and pulled out of the car park.

Needless to say, I got a proper dressing down from my irate dad, but no smack round the head of course.

I got up to my room eventually and thought to myself, that was it. The last straw. I'm a grown man for goodness' sake and I'm not taking this shit anymore.

The next morning, I looked through the accommodation to rent section of their copy of The Crawley Observer and saw a vacant bedsit available to rent in nearby Three Bridges. I left the paper open on the kitchen table – to send a subtle message – and went off to have a look at it.

By the following night I was sitting in my own armchair, in my own little bedsit. It felt weird but I couldn't have been happier. I could sit there in a t-shirt, smoke a cigarette, drink a beer. Do whatever I liked, with no fat old fucker telling me I couldn't. I felt as free as a bird. I was in absolute heaven.

My parents were shocked and upset when I moved out, especially as it happened so quickly, I could never figure this out. They obviously resented me being at their house and the lifestyle I was living, which was really just what any normal man would be doing at that time in his life. But when I left, they went all weird and upset. Probably because it would just be the two of them stuck there together and they'd have no one to take things out on. I couldn't care less. Once I'd made my move, I was free to do what I wanted and it made the decision to try to become a tattoo artist a hell of a lot simpler. I wouldn't have to say anything to them about it as I knew they definitely would have tried to put the mockers on that idea.

Good riddance, I thought.

I did go back and visit my parents now and again, especially when I'd run out of money and had no food. But it was a turning point because they realised, I would be making my own decisions from now on.

And I had some serious decisions to make.

Oh yes.

Finally having a place of my own to live was fantastic, I felt free from the oppressive atmosphere at my parents' guest house. I could have my friends or girlfriend over whenever I wanted. They had to be out by ten o'clock though. I could come home whenever I liked, without having someone waiting up to interrogate me on where I'd been. I could also wear a t-shirt without worrying about my tatts being spotted; although I still had to wear a long sleeve shirt to work!

The best thing for me though was being able to have all my tattoo drawings out on my table. I spent a lot of time drawing and making up new designs with variations of my own.

I even designed a tattoo for myself: a cobra snake with a skull's head. I thought it looked pretty good, so I took it up to Fulham on my next visit and asked Terry if he could do it for me on the back of my arm. He said he liked it and he would. I watched him make up the transfer, which I hadn't seen him do before because he always had the designs ready in a labelled envelope.

He traced my design and then laid the tracing paper with my design on it on top of a purple sheet of Hectograph photocopying paper like all schools had at this time – the first photocopiers. As he drew over the lines on the tracing paper the purple ink was transferred to the back and once complete, he had a lined copy of my cobra that he could follow.

This – I thought – was very clever and made it all look fairly easy because you wouldn't have to draw the tattoo up each time someone wanted it done.

As he tattooed the cobra onto my arm we were chatting away as usual, mainly on the subject of tattoos. He was always very careful never to give any details away about the equipment or where he got his stuff from.

It was like getting blood from a stone.

Tattooists have always been very secretive about their trade. It was never *the done thing* to share any information about how you became a tattoo artist, where you got the equipment and especially what type of colours were used. You could compare it to the magicians' Magic Circle, where you must never give away the secrets of how the tricks are done. Understandable really, but I dread to think how many poor assistants have actually been nearly sawn in half or been run through with razor sharp swords while sitting in a big wooden box!

I could imagine the cry, 'But it looked so simple when Mysto the Magician did it on stage at the Emporium last night!'

It was the same with old school tattooists. Tattoo equipment was almost impossible to get hold of in the early 1980s; there was nobody selling it to the general public. Most artists would make their own gear and use their own colours which they'd got from somewhere, mainly food colouring and Indian ink for the black. The needles would probably have been thin sewing needles … Ouch! I've been tattooed by these types of needles and they hurt like fuck.

Old-time tattooists rarely communicated with each other, civilly that is. They were overly protective of their *territory*. They were scared of someone coming along and setting up down the road from them in competition and then taking all their business away. You see, up until the late 1990s, when it really started to become popular. Tattoos were not something indulged in by the masses, like they are nowadays. You just didn't see that many people walking about sporting tattoos. It was frowned upon by the establishment for some weird reason. Women very rarely had tattoos, as they might be labelled as a *loose woman*. Such a dinosaur attitude, but it did exist at the time. So as a result, there wasn't the abundance of business there is today.

It was also mainly a summertime trade. When the weather was warm and people were wearing t-shirts that showed off their tatts, it seemed to remind others that tattoos existed and spur some on to visit a tattoo studio and get their first one or get additional ones.

Understandably it was an incredibly difficult trade to get into, but by now I was absolutely determined to give it a go.

So, when my cobra was finished and after I paid my money, I decided to take the bull by the horns and tell Terry that I wanted to become a tattoo artist one day and I asked where I could get some equipment.

By the look on his face, you might think I'd just asked him if his wife was available for a date that night. He stiffened up, looked at me and said, 'Ain't got a clue mate.'

'What?'

'Don't know what you're on about. You'd better get going cos there's another geezer waiting.'

There wasn't, but I got the message. As I walked up the stairs, he shouted, 'You don't need to come back here no more!'

With fucking pleasure, I thought.

Well, to tell you the truth I was shocked; one minute all had been fine and we were chatting away like old pals and the next minute I'd been kicked out of his

studio and wasn't welcome any more. I'd spent quite a lot of money there by now and thought that was a hell of a way to treat me.

Obviously, he was worried about me starting up in competition, but I lived in Crawley which was at least thirty miles away. Well, bollocks to you, I thought. Maybe my cobra was so good it got him worried? Probably not but when I got home and looked at it, it really was a nice job and was one of my favourites for a long time.

I hadn't got very far tracking down any tattoo equipment for sale and was getting very frustrated. How the hell was I going to get anywhere at this rate? I was desperate to have a go with a tattoo machine. I thought of trying to make my own but I had no idea how to go about it.

Later on, once I knew a lot more about it, I did make some tattoo machines for myself and they worked very well but that was quite a way off in the future.

As we know, some things are just meant to be … Quite by chance, one weekend I went to a local car boot sale, not really my thing but I had nothing better to do. One guy had a stall with loads of biker stuff and bike parts and there was a big stack of old custom bike magazines for sale, mainly *Back Street Heroes*. I loved all the pictures of the choppers and would have loved to get one some day. I did have a Yamaha DT125 and loved riding that.

So, I bought them. There were some great bikes in there and the paint jobs and chrome work were fantastic. I liked to look through the classified section and see how much they were going for and dream of owning one of my own one day.

One of the magazines I looked through had a little advert that caught my eye. Well, when I say caught my eye, I mean: made me want to jump out of my chair and do a stark bollock naked lap around the car park outside!

TATTOO EQUIPMENT FOR SALE

Oh my God, was this for real?

I read it again about a hundred times, then checked the date of the magazine on the front cover. It was over a year old but hopefully the number was still valid. Please, please, please, please!

I rushed down to the phone box and rang the number.

It started to ring! I felt butterflies swarming in my stomach.

The name on the advert was: Ultra Tattoo Supplies in Bradford, West Yorkshire.

After a few rings, a guy answered, and in a broad northern accent said, 'Ultra, Ronnie Starr speaking.'

Oh my God, they were still going. I was really nervous. I mean really nervous. I didn't quite know what to say.

I told him I wanted to get a set of tattoo gear and that I wanted to start up as a

tattoo artist in my hometown, Crawley. He asked if I knew what I wanted to get and I said I didn't really know much about it and was a complete beginner.

He asked for my address and said he'd send me down a catalogue in a few days. I told him thanks and put the phone down.

That was the pivotal phone call of my life so far. If he really did send me a catalogue – I still thought it might be a wind up – then I would have my foot on the first step of the ladder. On the way to getting hold of my very own set of tattoo equipment. I had never been so excited. I felt on top of the world.

I still had to learn how to use it all of course but having had a few tattoos by now, I did feel that I had a basic idea of how to go about it.

After waiting what seemed like an eternity for my catalogue, it finally arrived. It was actually a couple of A4 sheets of photocopied paper stapled together, but no matter.

Everything that was available at the time was listed; I phoned Ronnie back up and asked him what he suggested and he said he could put me a basic kit together for around two hundred and fifty quid, which was the equivalent of around £1,500 in 1976. That was more money than I had at that time; about two hundred and forty-nine quid more than I had! I wasn't earning a lot at the factory, only about sixty quid a week and I had to pay twenty-five quid a week rent for my bedsit. So, I had to get my arse in gear and start to put together money. I found a part time evening job at a local petrol station, filling up cars. There was no self-service in those days. I did all the evening hours I could do and worked weekends as well. I sold my beloved Yamaha DT125 but winter was on its way so it didn't matter too much.

It took me about six weeks and finally I had enough put by to pay for my tattoo equipment.

I could have had it posted to me but I figured it would be better to drive all the way up to Bradford to collect it and then maybe I could get a few tips off of Ronnie on how to actually put it all together. I called Ronnie and arranged a date and time to drive up to the wild wild north of England and pick up my new kit. Fuck me, what a place for a young handsome southern boy with a soul boy wedge haircut to be visiting, but it was actually happening.

Was I nervous? Apprehensive? Who, me?

Was I wondering if I was doing the right thing? Would it just be another stupid idea that lasted a week or two? But most importantly was it going to be two-hundred and fifty quid down the drain? Was I scared?

I was absolutely petrified.

I'd arranged to drive up and pick the gear up on a Saturday morning, so I

thought it would be best to set off late and travel overnight to avoid any early morning traffic jams.

My best friend Paul Miller wanted to come up with me for the crack which was great. Of course, we decided to spend the evening in the pub, maybe for a bit of Dutch courage? I'm not sure. Actually yes it was, and well, it was Friday night.

Ultra Tattoo Supplies was based in Bradford, but where the hell was Bradford? I looked it up on the map, two-hundred and fifty miles north of Crawley. I hadn't driven that far in my life before but never mind. I wasn't going to let that put me off. No one said it would be easy and I am always a bit of a one for an adventure anyway.

I had been bitten hard by the tattoo bug and my fascination was growing by the day. I had to get this tattoo gear and see what it felt like to actually tattoo somebody.

We sat in the pub most of the evening and then set off after closing time. I hadn't meant to leave that late but once I'd told everyone where we were going and what for, that was all they wanted to talk about. A couple of my pals volunteered to be my guinea pigs when I got it all back home which amazed me, as I hadn't even held a machine yet. This was one of the things that really surprised me throughout my career: I was never – ever – short of volunteers to let me try out new machines, inks, needle set-ups or anything that was up and coming and I am very grateful to them for that. It sure saved me scribbling away on my own arms and legs like a lot of the old-timers had to.

We finally got on our way and I could hardly contain my excitement. I was absolutely buzzing. I was finally going to get my hands on a real, working tattoo machine and all I had to do was set it all up and I would be a tattoo artist in no time and I could finally tell the factory where to stick it.

It turned out to be a little harder than I thought.

The main reason Paul was eager to come with me was in the hope he could have a drive of my Volkswagen Beetle. It wasn't a fast car but it was quite a custom job and I had spent a lot of time painting, decking out the interior with fur and buttoned crushed velvet and it had two rear tyres the size of a Formula 1 race car. The wheels and tyres were so big in fact that when I brought the car back to my garage space at the bedsit after having them and the wheels fitted it wouldn't go back in; it was too wide! Class.

The fact that we'd been drinking in the pub most of the night didn't put us off driving up to Bradford.

Driving while intoxicated is unthinkable nowadays, but in those days the laws were a lot more relaxed. If you were stopped on suspicion, they would get you out of the car and make you try to walk in a straight line and also make you blow into

a breathalyser which was a small clear plastic bag containing some sort of crystals which would turn yellow or green depending on the amount of alcohol you had drunk. You could still be prosecuted, but the crystals weren't as sensitive as the breathalysers of today so you had to be pretty wankered to get done. Anyway, like most people said at the time, 'I actually drive better when I'm drunk!'

Yeah, right.

The trip went well and there was nothing on the motorway except a few lorries. We stopped at some services near Leicester; the staff in the shop were speaking with awfully funny accents. We were really far from home!

After filling up with good old three-star petrol, I let Paul have a drive. I was pretty tired after the late start and the beers so I didn't mind even though he wasn't insured, there was no traffic about.

No sooner had we got back onto the motorway there was suddenly blue lights flashing behind us – you've got to be fucking kidding me – not now.

Paul was driving my car uninsured, all one hundred yards of it! And we were both over the alcohol limit.

In the unlikely case of something like this actually happening though, we had decided on a clever plan.

If we were to get stopped, he would say he was me and I would say I was him. Brilliant. We had known each other for years and knew each other's date of birth and personal details. It was bound to work. Well, to cut a very long story short, we gave our false details and it didn't work. Of course, it fucking didn't. Coppers aren't stupid, even northern ones.

They put me in the cop car and Paul was kept in the Beetle but they were really suspicious for some reason, probably because we were the only car on the motorway. Amazingly not once did they attempt to breathalyse us. We must have reeked of beer. All the pints in the pub and Paul had shaken up a can and then opened it letting the contents burst out and fill up most of the passenger footwell. He was great like that!

So that was extremely fortunate to say the least.

I really didn't like being questioned and I daren't tell him I was on my way to buy a load of tattoo equipment, because of the stigma around tattooing at that time; I just didn't think it a good idea to mention it.

My copper said to me that if we didn't come up with a proper reason why we were on the motorway this late at night they'd take us to Leicester Police Station and we could sit in the cells until we came clean. I just had to get to Bradford tomorrow; it was too important an appointment to miss. So, I came clean. I told him who I really was.

They got us both out of the cars, but Paul was still adamantly claiming he was Danny Fuller, which afterwards we had a good laugh about, and this was where the copper finally lost his patience. He grabbed us both by the throat, 'Two fookin' Danny Fuller's? You're telling me there's two fookin' Danny Fuller's now, is it?'

He actually threatened to bang both our heads together and that was just for starters; he was a big chap and big northern chaps in police uniforms can be pretty persuasive.

Finally, after about an hour and a half stuck on the hard shoulder of the M1 – being grilled by Leicester Five-O – they just wrote us a ticket each and sent us on our way. The big cop did pull me aside as I was getting in my driver's seat.

'It's cat and mouse on junction (whatever it was) and the cat always wins.' Well, that certainly made us laugh the rest of the way up to Bradford. As far as we were concerned, we'd got away very lightly indeed.

When the summons for our traffic tickets eventually came, we both had to go back to court up in Leicester. Paul got done for driving without insurance and I got done for: aiding and abetting, counselling and procuring. I'll never forget that, what a bloody mouthful. We also got an endorsement on our licences and a £150 fine. Pretty steep for those days. We still laugh about it now though; it certainly was quite an adventure.

We finally arrived in Bradford around 7 am and began our search for Ultra Tattoo Supplies. It sure wasn't in the posh end of the city.

I was aware that there was a bit of a North-South divide in the UK with more of the poorer areas in some of the northern towns and cities, but we were quite taken aback by what we saw. We drove through some derelict streets! Not just the odd derelict house but actual streets with all the houses boarded up and looking like something from the Blitz. I imagine they were being demolished to build new and better houses for the people. At least I hoped so.

This was all very eye opening and depressing and we drove around in silence as we searched for the address.

I must admit to feeling a bit nervous as we drove deeper into this labyrinth. We didn't dare stop and ask anyone for directions as then they'd know we were southerners. But there weren't many people around and those that were, were dressed in Arab-type clothing and didn't seem to notice us; so it wasn't too bad.

When we eventually found the building, it turned out to be a *private shop*, a sex shop! I'd never seen one before. It was all shuttered up as we were a bit early. So, we just parked up nearby, locked the car doors, hunkered down and tried to look as inconspicuous as possible until someone came to open up.

Finally, about 10 am, a couple of guys came along, took the shutters down and opened the shop.

This was it! Go! Go! Go! We locked the car and approached the front door; I gingerly pushed the door open and off went the bell. A seedy looking guy with a fag in his mouth came out from the back with a big grin on his face.

'Oh, aye lads, what yer after?' He flopped down onto a stool in front of rows of hardcore porno mags and dildos of all sorts. Some looked as big as thermos flasks!

'Er … tattoo gear … Buy it!' I stammered; pretty overawed with the whole situation.

'Oh, you'll be wanting Ronnie. Go through door there, e's out the back.'

He's here, I thought. I was so excited, I almost ran. I pushed open the door and there he was: Ronnie Starr, sitting at a desk in this pokey little back room with damp patches on the walls and wallpaper hanging off in places. To me it was a mystical cave full of beautiful treasures.

The private shop may have been full of hardcore pornography but this was the room that gave me a hard on! There were shelves full of tattoo equipment; boxes of all sizes: lamps, spray bottles, sets of tattoo designs, outlines only – you had to colour them in yourself back then. Bottles of all the different coloured inks. I had arrived in heaven.

'You must be Danny; I've sorted you some bits out; did you bring the money?'

'Yep.'

'Gissit 'ere then. Yer stuff's in box over there.'

I gave him my money, then went over and picked the box up. It wasn't very heavy but I could see there was quite a bit of stuff in there.

After counting out the money he strode over and shook my hand, 'Best of luck with it.' and he went to go back to what he was doing.

'Are the instructions in there?' I asked.

He laughed, a great big belly laugh.

'Instructions?!' he said. 'No, you just get on with it.'

I looked puzzled, 'Can you just show me what's what? There's a lot of stuff here.'

'Oh, go on then, just quickly like.'

Then followed five minutes of, *all you ever need to know on how to be a tattooist*. I hoped Paul was listening because I sure didn't take it all in.

He finished his instructional lecture, then stopped and said, 'You're from Crawley you say?'

'Yes.'

'Me sister lives down there, I'm gonna be comin' down in a couple of weeks, gonna start a tattoo shop up. I'm sick of it up here, like.'

Did someone just hit me over the head with a sledgehammer?

'Crawley?!' I said.

'Yeah.'

'In Sussex?!'

'Yeah.'

I could not believe it. My previously super buoyant mood sank like the Titanic on speed. What were the chances of that? There had never been a tattoo shop in Crawley. I was going to be the first. Now, all of a sudden, you had a top pro who actually sold the fucking stuff, coming down to open one up too. And, it looked like he'd have a hell of a start on me because I had yet to learn how to use the bloody stuff, I'd just forked out two hundred and fifty cunt quid on! I was devastated. I suddenly didn't want to be a tattoo artist any more.

'Okay, thanks anyway,' I said and walked dejectedly back out of the shop. I just wanted to get back home and we had that long drive all the way back.

What a dismal trip that had turned out to be: we'd been stopped by the police, were dead tired and probably a bit hungover, we'd driven through the UK version of Baghdad and then been told that the self-proclaimed *tattoo expert* was coming down to my hometown to start up a tattoo shop.

Just brilliant.

I felt like the bottom had suddenly fallen out of my world. My head was spinning.

And even though I'd worked so hard to save up enough to buy my tattoo equipment, I felt like throwing it all out the window on the trip back home.

Paul was very upbeat and tried to improve my mood and cheer me up, but I was pretty inconsolable.

When I finally got back home, I just put my box of stuff under my bed and didn't even look at it for a couple of days.

I gradually got over my experience and did feel a bit better when a girl I knew who worked for Crawley Council checked all the planning records and couldn't find anything regarding an application for a new tattoo shop in Crawley, but I still felt pretty shell shocked for a while.

As a footnote here: Ronnie never did open up his tattoo shop in Crawley. I don't know if it was bullshit or he was just winding me up, but you can imagine how I felt when he'd said that he was going to. The equipment I bought turned out to be pretty shitty as well, but at least it got me my start; so I suppose I should say, 'Thanks,

Ron – bastard.'

But no, if he hadn't been one of the first people to make tattoo gear available in the UK then God knows how I would have got hold of any and got my foot in the door. So, I am eternally grateful to the guy, even though he gave me the fright of my life at the time!

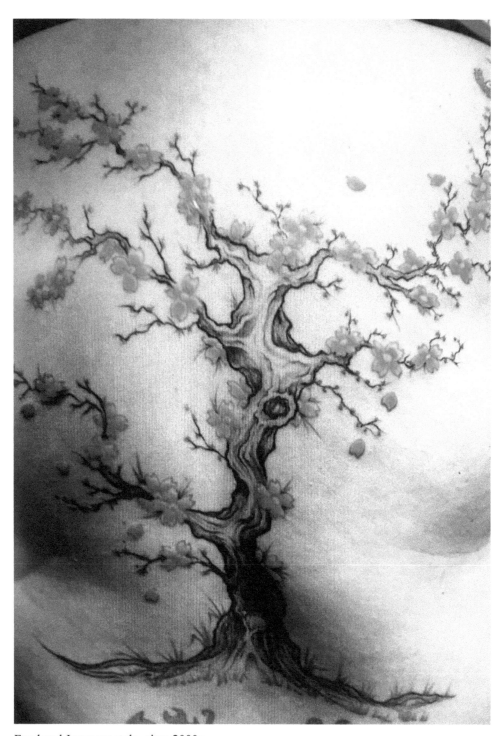

Freehand Japanese style, circa 2000s

Chapter 6: *A shaky start*

The next few weeks back at the factory soon jogged me back into reality and reminded me that I had my mind set on a more rewarding life choice.

I sorted through all my new tattoo gear and got the machine working; it was a simple rotary-type machine. A small electric motor was mounted on a bracket and when you connected it to the power supply the motor had a small cam attached to it that also spun round. The cam had a small hole drilled in it into which you put the bar holding the needles and then as the cam spun on its axis the needles moved up and down. You had to hold the needle bar in place with a rubber band.

This was one of the questions I am most asked: 'What's the rubber band for?'

Well now you know. It is to prevent the needle bar coming out of its socket and making marks where you really don't want them.

I think the little motor was the same as the type used to power Scalextric slot cars. It certainly sounded and smelt the same when it was running. Very tinny and cheap, but it seemed to work okay, so that was fine for now.

There was a packet of 1,000 loose needles, bug pins as they were called. You had to solder the needles into groups yourself, very difficult, but at least I'd been trained in soldering techniques at the factory so I had a relative amount of success.

You soldered three needles tightly together to make up an outline set and nine needles soldered more loosely together to make up a colouring or shading set. Then you soldered them onto a thin bar that fixed to the cam on the motor which turned around and made them go up and down. This was your bog-standard basic set up and was far from ideal, because as the cam went round and round at the top of the bar it would make the needle tips at the bottom move up and down, but they would also move from side to side. This made it very hard to get a nice thin outline and it would end up thick and blurry. It didn't matter so much for the shading as that didn't have to be so precise, but the outline part of the tattoo proved immensely frustrating to me and it was quite a while before I got a fine line like the pros.

I could reduce the side-to-side motion a little by using a tighter rubber band but then I'd have to turn the power up which would make the motor overheat! Aargh!

For any of you who think tattooing is easy and just like drawing, let me assure you once and for all, it ISN'T!

You may think you are quite good with a pen and pencil, but trying to draw something with one of those old, heavy, vibrating contraptions on human skin which is soft, curvy and pliable, sometimes greasy, usually hairy, bleeds and with the ink from

the machine splashing everywhere, covering up the transfer you're trying to follow and going all over your hands and with a customer who is moving his head around and fidgeting or talking to his mate on the other side of him and gesticulating with his other hand. All while being asked endless questions by other waiting customers, with the studio phone ringing, the postman delivering a parcel for next door and trying not to let the little kids that are running around knock anything over or jog you while their mum is outside smoking a fag! Oh, and if you make one little mistake your reputation will be ruined forever.

If you reckon that is easy then go ahead and get yourself a set of tattoo gear.

Joking aside, I had no idea how difficult it was to actually make a tattoo. I thought it would be pretty straightforward. I was dying to use my machine once I had it all set up but I couldn't try it out on paper because obviously the needles would tear it up.

I didn't want to try on my own leg because I wasn't quite brave enough just yet. I wasn't sure how deep to press the needles into the skin, because I didn't want to hurt anyone too much, but I had watched Terry's machine and it looked like they stuck out about three millimetres.

Somebody told me the best thing to use was pig's skin; not still on the pig of course. That sounded like a good idea so I went to the butcher's and bought some pieces of leftover pig skin and took them back to my bedsit. I was getting excited again.

When I got back, I took all the pieces out, washed them, shaved the ones with hair on and threw away the ones with nipples on; yuk! Thinking about it now, I should have kept them because I worked on some dodgy bits of skin over the years.

I got everything ready and made a transfer of a little swallow and put it on the first piece of skin. It looked pretty realistic and off I went.

Well, I must say, it came out pretty well. Being dead skin, the needles did tear it up a bit but after about half an hour, there on my table sat part of a pig with a colourful swallow tattooed on it. He or she would have been very proud if they'd known, I'm sure!

It wasn't the greatest tattoo by any means, but I'd finally had a go with my new gear; I was over the moon that it had even come out at all. That weekend I must have written my name twenty times and done ten or more different tatts. If my landlady, Mrs King, a lady made from the same mould as my own parents – more of her in a while – had any idea of what I was up to in my room – Frankenstein's laboratory – she'd have been horrified.

When I told my friends that I was thinking of becoming a tattoo artist I got a

mixed reaction. Some thought I was mad. You have to remember that tattoos weren't common in those days. You see them everywhere nowadays: on the TV, in magazines, most footballers have at least one sleeve and even some cricketers! But back in the 80s it was almost an underground activity. Fortunately, I did know a few people with a similar outlook on life as me, who were keen to let me practice on them. They knew I could draw a bit because they had seen my design sheets, so they knew there was a fair chance of me getting it right.

My very first proper tattoo was on my brother Steve's, girlfriend's brother. What a brave man. He wanted a rose at the top of his arm.

I took my stuff round to his house one evening; I was so excited but very nervous. I was really going to do a live tattoo. It's very difficult to remember exactly how I felt, I wasn't that nervous about making a mistake, the main thing I was worried about was hurting him.

I have always been of the mindset that there is no such thing as a difficult tattoo. You can either do it or you can't. Some are very complicated and tricky of course and you have to be very careful and organised and take your time, but if you can draw it on paper then you should be able to draw it on the skin.

If you can't, then don't do it. Simple.

When I used to teach students at my academy, many years on, I always used this example and it always made a clear point: never attempt something that you might not be able to accomplish. Otherwise, where tattoos are concerned, you will be in a world of shit.

I managed to do the rose without hurting him too much and without making a mistake but I think I was too worried about hurting him and hadn't pressed hard enough, because when it healed up it was extremely faint, it looked like a watercolour painting. The outline was grey and the colours were hardly there. So a few weeks later when it was all healed and the skin was back to normal, I went back over it with a little more pressure and it came out a lot better. I did the same rose on my own arm sometime after that and, although it was awkward tattooing myself, it looked fine and also it filled up a big part of my arm towards completing my sleeve.

I was getting into it.

As I said, the hardest part was getting a nice thin outline because it was very hard to solder the needles together properly. The machine I had was very basic and the needles would vibrate from side to side making blurry lines.

I was very fortunate to have started in the 80s, because the standard of tattooing represented the equipment available at the time – basic. As long as the tattoo came out bold and reasonably accurate, people weren't too critical of the actual piece. I'm

not saying they were all crap compared to what they do now, it was just that nobody thought of tattoos as art. They were more of a brand, a primitive mark that set you apart from your average person. A mark that meant you knew something they didn't and weren't prepared to toe the line of conformity completely.

The good ones were very good but some of the work was very bad. I think it all depended on how interested you were in bettering yourself and making life easier. I really wanted to see how far I could go with it. I wanted to get myself the best machines I could, the brightest colours and the finest needles. That way I figured: it would make my life easier, but also meant I could make my tattoos look better and then more people would want to come to me rather than the guy down the road who still did the same thing he'd been doing for years.

That was my outlook for the whole of my career. I always thought I could do better or find a better way of going about it. That way everyone would be happy and I'd always have customers knocking on my door.

Once I'd done my first tattoo and was happy with the result, I felt more confident to start doing some of my friends. There were plenty of volunteers; even though they knew I hadn't done many tatts the word *free* was a deal breaker.

My next customer was my friend Paul Miller's brother Julian, we used to knock around together a lot at the time and he had a lot of homemade Indian ink tatts he'd done on himself a long time ago.

One night we were in the local pub and of course we were talking about tattoos and he said he wanted me to do a swallow on his chest, so we had a couple more pints then went back to my bedsit.

5. Part time tattooing at home

This is the only time I've ever done a tatt under the influence of any drug; I wasn't really too keen but he persuaded me. I made the transfer, shaved his chest and did the tattoo. It took ages as we were both a bit worse for wear. We also had to be really quiet in case the landlady heard there was someone else in my room at that time of night.

Afterwards, we both crashed out and when we woke up in the morning, he had slept on the floor and at some point, he must have

been face down, because when we looked at his swallow it was covered in carpet fluff and God knows what else. Oops! It didn't look too hot but he didn't care because it was a new tattoo and he loved it.

I didn't go on about it but that was a big lesson learnt for me: tattooing is something to be taken extremely seriously. It's not something you do for a laugh when you come back from the pub. His swallow didn't heal up too well either, probably due to the carpet fluff that was stuck to it. When it was finally healed it had lost its beak somewhere along the way! I offered to fix it but he said he liked it as it was and made a good memory. I said okay but wasn't too happy with him showing it off. It's weird, but in later years taking his shirt off and showing off his masterpiece would have everyone in fits of laughter every time and I was very proud to say that I was the man responsible. Probably because they'd all seen my proper work.

I probably did six or seven more tattoos on friends at my little bedsit, until one day when it all came crashing down.

One afternoon there was a knock on my door and when I opened it, there stood the landlord and landlady with a look of thunder on their faces, 'Danny, we've just had someone knock on our front door and ask if the tattooist was in!'

Oh my God. What the fuck?

'We take it that's you?'

I didn't know what to say, I had been caught hands down, they knew I had tattoos so who else would it be?

'Oh right.' was all I could think to say.

'We want you to pack all your belongings and be out of here by the weekend. We don't want you here any more.'

They turned around and went back down the stairs.

I was shocked, it was all so sudden. How the hell had word got around so quickly? I was totally gobsmacked; I'd only done a few tattoos on my friends. The weekend was only a couple of days away and now I was homeless.

Looking back on this moment – apart from being made homeless – although I didn't realise it at the time, it couldn't have been better. Someone I'd tattooed had obviously shown their tatt to someone else and word had spread: there was someone in Crawley doing tattoos. Then they'd found out where I was and of course knocked on the front door, which was the landlord and landlady's entrance, instead of going round the back to the bedsits.

If word had spread that quickly after only a few tattoos done at a tiny bedsit in nowhere-special-land, then what the hell was it going to be like when I eventually got my own studio? I didn't realise it at the time but I should have seen the writing on

the wall. I did start to think I was onto something here though and that helped ease the pain of being kicked out of my home. But I still felt pretty down.

I hadn't had a very good relationship with the owners of the bedsits where I was living. I was always in trouble for having people back or doing something they didn't like; some people just take a dislike to you. The final straw – apart from tattooing on their property – came one Saturday night. I had gone out for the evening with some friends. We went to the pub then went to the disco, Cinderella's on the A23 towards Brighton. When I got there, a girl I knew who also lived in one of the other bedsits came up to me and said, 'Everyone's been looking for you; there was a fire in your room and the fire service was called.'

Of course, I thought she was winding me up.

'Yeah, ha ha very funny.' I said.

'No, it's true. Your room caught fire; you left the cooker on and your bread board was on it!'

It took her a couple more goes to convince me that she wasn't joking.

Well, that was just great. My bedsit had caught fire. I ran to my car and raced back home, dreading what I would find but still not fully convinced.

When I turned into the car park, I could see she had been telling the truth.

In the middle of the car park was my little Belling cooker laying on its side where it had been thrown and there were some charred pieces of wood next to it that had once been my bread board! I rushed up the stairs and along the corridor to my room; the landlord was inside.

Luckily, where I had left the hotplate with my wooden bread board on top it hadn't actually caught fire but had smouldered for a few hours. The smoke damage was unbelievable, everything stank of bonfires and the room was completely grey.

I can laugh now, but it sure wasn't funny at the time. All my clothes stank of smoke, the bedding, everything and the landlord was not amused at all. Especially because he had to fork out a shitload of money later on to update the whole building to the proper fire regulations. There were no smoke alarms. Nothing. And my room was at the entrance to the corridor, so if there had been a real fire the people in the rooms further down the corridor could have been trapped. We all dodged a bullet there for sure, but after

FIREMEN CALLED

THE Fire Brigade was called to a flatlet in The Copse Gales Drive, Three Bridges to deal with a fire in a first floor room on Thursday night.

Firemen wearing breathing apparatus went in and tackled the small fire and the room was only damaged by smoke.

6. Fire in my bedsit – oops!

this I wasn't the most popular tenant!

I've still got the cutting from the local newspaper: 'Firemen called to Crawley Bedsit'.

Also, a few weeks after my fire and the fire regs had been updated, one of the girls in another bedsit also started a small fire. She was getting ready to go out one evening and smoking a cigarette. With the cigarette in her mouth, she sprayed some hairspray on her hair and the whole thing caught fire and also set light to some dried pampas grass next to her that she had as an ornament. All the alarms went off. We managed to put her fire out okay, but the smoke alarms kept going off and the landlord – dressed in his pyjamas – was trying to fan the smoke alarm to clear it. While doing so his pyjama bottoms fell round his ankles, showing all present his family jewels!

Not a pretty sight, the guy must have been seventy plus. All of us tenants just creased up laughing but again he was really, really not amused.

I also got the blame for that for some reason.

I think he just hated me plain and simple, ha ha.

After spreading the word round that I needed somewhere to stay pretty sharpish, one of the draughtsmen in my office, Tony, told me he had a spare room at his house and I was welcome to lodge with him for as long as I needed. So that was good. Until I actually moved into the place.

He was divorced and lived on his own and, unknown to me, he was also an alcoholic. The place was a complete shithole but it would do for now. When you're young I don't think you care so much. After a few days there I started to get very itchy; I didn't know why until one afternoon when I was sitting at the dining room table, drawing up some new tattoo designs. I had lots of sheets of paper spread all over the floor next to me and I looked down to see all these tiny little black dots moving around on the paper. They seemed to be making a beeline for me. When one jumped onto my leg I realised they were fleas. Aargh! I'd never encountered fleas before but my new landlord had two cats and that was where they had come from. No wonder I was itching. They'd bitten me to death. I jumped up totally freaked out, suddenly they were everywhere.

I ran up to my room and pulled the bed covers back. It was full of them as well; I went from freaked out to completely paranoid. I really didn't like it.

With all my shouting, Tony came rushing out of his room wondering what all the fuss was.

I told him about the fleas and he said it must be the cats. Really? You don't say.

That was it for me, I didn't want to stay there one more night. Not with bastard tiny things trying to suck my blood.

I left the house and went down to the callbox, phoned my mum and dad and told them the situation, asking if it was okay to come back for a little while until I found somewhere else.

With no fleas!

I really didn't want to move back home to theirs but we were getting on a lot better since I'd moved out. They had left the guest house and retired to a nice bungalow near Horsham. This had chilled them both out a lot and they had started to treat me like a grown up at last. They also knew about my tattoo fascination and the fact that I had, by now, quite a few tattoos.

I must tell you how this came about; it was very funny.

One Sunday during a hot summer, I went over to visit them to have our usual Sunday roast. After eating, we walked a short way down to the village green to sit and watch a cricket match. It was boiling hot and as I usually did when I was around them, I had a jumper on to cover my tattoos, because I still hadn't found the right time for them to see them. Dad was in the beer tent buying a round which left me and mum on our own. Never one to hold back, my mum saw I was sweating my bollocks off in the heat and said, 'Take your jumper off Dan, you look boiling.'

'No, I'm okay thanks.' I replied.

A grin crossed her face and she said, 'We know you've got a tattoo.'

Caught out again. How do parents know these things?

I laughed and said, 'Yes, but you don't know how big it is!' It was half a sleeve by now.

It really was hot, so I thought, what the hell and as I pulled my jumper over my head to reveal my tattoo there was a synchronised gasp of horror as they both caught sight of my half sleeve. Mum just sat there with her jaw literally touching the floor and when he saw my arm – as he came out of the beer tent – dad had walked straight into the back of the guy in front of him, spilling the pints of beer over them both.

Once all the chaos had died down and dad had apologised to the guy; yes, he really had calmed down. He went back into the beer tent and came out with just one pint this time. For him, not me! There followed a few minutes of tense silence and then we all burst out laughing. But I had to go and buy my own pint of beer.

We often joked about that day in the years to come.

So I went back to Crawley, got all my stuff together, loaded it into my car, left the house of fleas and moved back to my parents' bungalow in Barns Green.

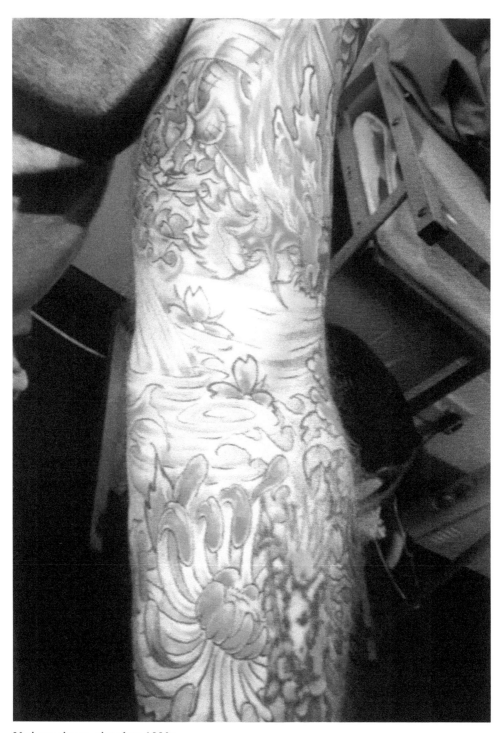

Various pieces, circa late 1990s

Chapter 7: *Crawley*

I didn't stay very long with my parents; we got on a lot better but I didn't like being so far out in the country. So, I moved back to Horsham and lodged in a house share with a couple of girls that I knew – purely platonic of course – as I was engaged to be married by this time. This was around 1981.

I couldn't bear working at the factory any more, it was just too oppressive, boring and downright dull. I decided I was going to go for it and try to open my own tattoo studio. This is one of the advantages of being young, I wasn't really concerned about whether I would actually be able to make a living at it. I had all the usual bills to pay of course but I really, really wanted to be a tattooist and tattoo people and have a studio of my own like the ones I had been visiting to get my own tattoos.

When I handed in my notice at work all of the older draughtsmen were shocked when I told them what I was going to do, 'A tattoo studio? Do people have tattoos?'

I said, 'Well I do and I've already done quite a few on my friends, so yes.'

I couldn't see a problem. Looking back, I remember seeing all the puzzled looks on their straight-laced, run of the mill faces, clearly they were feeling rather amused that I was leaving them to do something so unusual and so different. The kind of thing these people would never dare to even think about doing. I could tell that some of them thought I was mad and would be applying to get my job back within a few weeks. The thought never entered my mind. Even if I couldn't make a go of it I would never, ever work in a factory again.

Crawley turned out to be a good choice for my first studio. There had never been a tattoo studio there so mine was going to be the first one ever. Quite a landmark achievement, you would be hard pressed nowadays to find a city, town or even a small village that doesn't have a tattoo studio. The nearest studios were to the North of me in Croydon or South of me in Brighton, so I wouldn't be stepping on anyone's toes.

After my fairly unpleasant run in with the guy in Fulham, I was a little nervous about

7. Full time tattooing at the Crawley studio

possible negative reactions from other established tattoo artists. So, I didn't want to set up too near to anyone in case there might be any threats or reprisals.

You know how people love rumours? I'd heard all sorts of stories of studios being burnt down, attacks on people starting up too close to others and just general bullshit really. But I wasn't too concerned. The desire to get going in the business was just too strong, and I was young and wasn't a pushover when it came to looking after myself, so I wasn't too worried.

There was some mention of possible trouble from biker gangs. Honestly the things people say, but I didn't know of any in the Crawley area. Or anywhere else for that matter.

As it turned out, I never had any trouble starting up any of my tattoo studios and once I'd been tattooing for a few years I would be one of the experienced ones, so that was all a load of rubbish. Just rumour mongering on the part of jealous, sad bastards. As we all know, the world is full of them.

I started my search for a premises in the spring of 1981. I didn't know anything at all about how to go about getting a studio. You couldn't tattoo in your home, as I had found out! So, I had to find what was called a commercial property. I would have loved to have had a premises with a shopfront like some of the studios in London I had visited. I could sign write it and make it look really posh with designs painted on the front of it, but places like these were well out of my budget for the rent you had to pay. Also, back at this time – due to the usual prejudice of course – some landlords weren't all that keen on renting out their premises as a tattoo studio. You see, it went with the reputation of people who had tattoos.

Prejudice, plain and simple. People don't realise what it was like in those days if you wanted to be different and stand out in the crowd. Most people were of the impression that if you were tattooed you were untrustworthy, had low morals or were just plain dodgy. I never really encountered any negativity personally, apart from my parents! But in time I realised that with the amount of tattoos I had, I would stand no chance if I wanted to gain employment in *upstanding* professions like banking, office work or anything involving working with the general public. I could never have got a job at McDonalds; they would just think you would be bad for business. Wahey! So, it wasn't all bad then.

People simply don't realise the amount of prejudice that was part of life in the *good old days*.

I was tattooed quite heavily by then and there wasn't much I could do about it. I didn't want to do anything about it. I had found my goal in life and knew what I really wanted to be.

CRAWLEY
BOROUGH COUNCIL

No. A 1116

Tel: 28744 PLANNING/BUILDING CONTROL

RECEIVED the total sum of: _Forty_ _Pounds_

----------- Cheq/Cash/P.O. £ 40 : 00

From: _Mr D.P. Fuller_ Analysis:

In respect of: _24 Springfield_ (Planning) £ 40 : 00
Road Southgate Building Control: £ :

----------- Difference: £ :

NB. This is a receipt for money paid.
It does not acknowledge that the correct fee has been received.

Date _26/5/81_ Signed _____
for and on behalf of BOROUGH TREASURER

8. Crawley Borough Council Planning application,
26th May 1981, 24 Springfield Road, Crawley

Tattooman is backed

FAMILIES in Southgate say they don't mind a tattoo parlour opening in their midst.

Crawley Council granted Danny Fuller, of Gales Drive, Three Bridges, planning permission for the studio in Springfield Road. Two neighbours objected.

Mrs Doris Funnell, of Springfield Court, said the tattoo business would present no problems, as it should be a quiet industry.

Another neighbour, Mrs Christine Rich, said she hoped the tattooing would stick to business hours.

9. Article in the Crawley Courier

A tattoo artist.

I often thought about the teachers at the two public schools I had attended; they would have been absolutely horrified, and I loved that. Maybe it was my way of getting a little bit of revenge on those stuck up, bullying, tyrants. Who, with all their bluster and egotistical bravado, would never have had the guts to do what I was doing with my life and marking themselves to make the commitment forever to their trade like I was. They had their canes, corduroy trousers and leather elbow patches. I had my tattoos.

I found a couple of likely premises but was turned down when I told them what I wanted to do.

CRAWLEY may soon have its first working tattoo artist. The council has said yes to an application by Mr D. P. Fuller, of Gales Drive, Three Bridges, for permission to turn an office at 24 Springfield Road, Southgate, into a professional tattoo studio.

10. Article in the Crawley Observer

Finally, I found a small – and I mean very small – room in an office building on Springfield Road, near the town centre in Crawley. It was about the size of your average bathroom, but the owner was keen to rent it out and didn't mind having a tattoo studio in his building. I had to apply to Crawley Council to get permission to change the use of the room from office to tattoo studio. My application had to go before a planning committee meeting that was held every six weeks or so and I had to pay a fee whether permission was granted or not.

It was a nail biting few weeks waiting for notice on whether they would let me have my studio there. To be honest I wasn't very confident, what with all the negativity

An armful of art

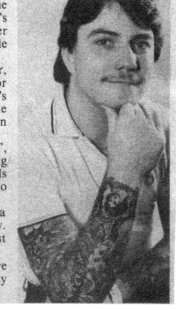

"TATTOO You" said the Rolling Stones — and that's exactly what Danny Fuller (22) will be doing to people from Saturday.

For tomorrow Mr Fuller, an MEL draughtsman for four years, opens Crawley's first tattoo shop next to the Rocket pub on Brighton Road.

"Skindeep Enterprises", he says, will be charging anything from a few pounds for the smallest of tattoos to £300 for a complete arm.

"I think there will be a great demand," said Danny. "At the moment, the nearest shop is in Croydon."

● Crawley Council have given permission for Danny to operate his business.

11. Article in the Weekend Herald, 26th February 1982

I had received so far. But at last, the brown envelope arrived on my doormat. I knew it was from the Council. I was so nervous as I undid the envelope and opened out the letter, and there it was: permission granted! Yesss!

I couldn't believe it; I had permission to start.

My emotions just rocketed off the scale. I called everyone from the nearest payphone and told them the good news.

That was it then. I was going to get my chance to be a tattooist. All I had to do was set my studio up.

It didn't take too long. I had made up about twenty sheets of designs – flash as they're called – and stuck them on the walls. I found a desk and a couple of chairs; brought all my equipment down and set it all up.

It was a very basic setup. I laugh at it now, but once I had it all in the room and everything was in its place, I have to admit it looked quite professional. I even had a small TV and an ashtray on the desk!

I didn't realise at the time, but when I applied for the change of use from office to tattoo studio, the local press – who used to look for any interesting information at the Council Planning Department – had noticed my request. As I was going to be the first tattooist to open up in the town this was a big story. They found my contact details and phoned me to ask if they could come down and see the place, take some pictures and do a story.

This was great; free advertising. So, I arranged to meet them and they duly turned up and stayed for quite a while, asking me all sorts of questions and taking pictures of me holding my machine. They were very interested to know how I had got the idea to open a studio. Tattoo studios were only really in seaside towns and major cities up until then, so it was unusual to find one opening up in a smaller town like Crawley.

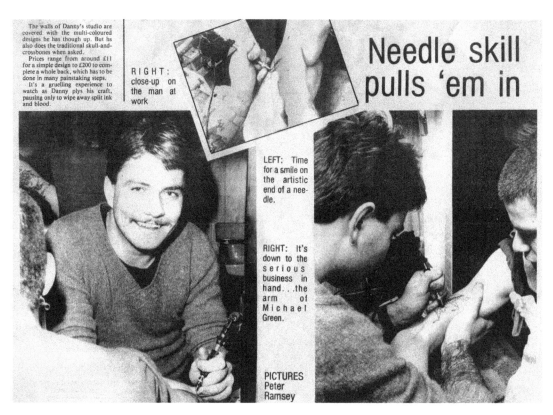

The walls of Danny's studio are covered with the multi-coloured designs he has though up. But he also does the traditional skull-and-crossbones when asked.

Prices range from around £11 for a simple design to £200 to complete a whole back, which has to be done in many painstaking steps.

It's a gruelling experience to watch as Danny plys his craft, pausing only to wipe away spilt ink and blood.

RIGHT: close-up on the man at work

Needle skill pulls 'em in

LEFT: Time for a smile on the artistic end of a needle.

RIGHT: It's down to the serious business in hand. . .the arm of Michael Green.

PICTURES
Peter
Ramsey

12. Getting the Needle with Danny, the Crawley News, 18th March 1982

I must admit I enjoyed all the unexpected attention and when The Crawley News ran the story a week later I was very proud to see I had made the front page! They put my opening day in as well, which really was a bonus, as I hadn't done much in the way of advertising.

The headline ran: Getting the Needle with Danny!

Groan. But that's the media for you!

I planned to open up for business on Saturday, 20th March 1982. The night before, I did a tattoo on a friend of mine to make sure I felt comfortable and had everything set out as I wanted. We were there until fairly late that Friday evening. I made sure I didn't have too many pints in the pub afterwards because I needed to be on the ball for the next day. Everyone was coming up to me in the pub and talking about my studio opening. I was pretty much the in thing that night.

By now I couldn't believe all the attention I was getting, people were so interested in the whole idea. I was beginning to feel I really was onto something here and couldn't wait to see what would happen the next morning. Of course, I didn't sleep a wink that night.

Saturday morning arrived and I made my way down to the studio around 10 o'clock. I had no idea if anyone would be there or if I would even get to do a tattoo. You didn't take bookings in those days; it was first come first served and I hadn't arranged for anyone to actually get a tattoo but a few of my friends said they would pop down and see how things were going at some point in the day.

As I drove into the little car park, I saw someone standing by my window. Oh my God was he waiting for me? Of course, he was; it was a Saturday and the offices were closed.

I got out of my car and walked towards the back entrance to the building which was my front door.

'Hello mate.' I said, 'Are you here for me?'

'Yes, are you the tattooist?'

I could have kissed him. My first paying customer. I was on cloud nine; my stomach was doing somersaults and the smile on my face stretched from ear to ear.

'Come on in.' I said. Inside I think I was just laughing maniacally.

I can't actually remember what design the guy chose. I wish I could, but I'm not going to make it up. It must have been a nice one though because all of my designs were things I would have liked to have on myself. I found this was the best way to decide what to have on my walls. Then at least there wouldn't be any I didn't fancy doing.

It was probably a flower of some sort or an eagle. Halfway through working on my first customer I heard someone else walk in through the back and they poked their head around my door. Customer number two!

It went on like this all day; as I was working on one person another one would come in and get in line. I couldn't fit too many people inside, there was only enough room for me and two others. So by the afternoon there were three or four guys sitting outside in the car park happily chatting and smoking waiting their turn to get inked! I can't remember having too much trouble with the designs but my machine did get a bit hot after a while.

I was still technically a beginner but I put on a good show and didn't let on. Everyone seemed very happy with the work I had done. A few of my friends turned up to have a look and were amazed that I had people waiting in the car park to go under the needle.

I finished my last customer around six o'clock. I had done about six or seven tattoos on my first day. That was six or seven more than I had expected to do so I was absolutely stoked. Who'd have guessed it? I felt so proud. All the people who had

doubted that there would be any business in tattooing had just been proved wrong. But no one was more surprised than I was.

I counted up the money in my back pocket and could not believe it, I had earnt more in one day than I used to earn in a week at the factory! Was this for real? I had enjoyed myself so much and had actually got paid for doing it.

I must stress though; it certainly wasn't easy. I probably lost a few pounds sweating that day. My machine gave me a few problems, running erratically throughout the day. It was hard to get the transfers on properly, the ink splashed all over the skin making it very hard to see where I was going and I wasn't that comfortable knowing I was hurting people. But they were all very brave and no one passed out!

I had that pleasure to come!

But all in all, what a debut. I went out and celebrated that night. Big time. I had successfully completed my first day in my new job. At last, I could call myself a tattooist.

Now that felt really strange.

I was so pleased with my start on the Saturday that I gave myself the next Monday and Tuesday off just chilling and sorting some things out. When I went along on Wednesday morning to have another go there was already a guy waiting outside my door.

'I thought you weren't coming. I came yesterday and the day before to see you.' He told me.

Wow, I hadn't really thought that now I was up and running I might be in demand. I decided I'd better start taking this a bit more seriously.

Another local newspaper came down to see me that week and did another story on my launch and took a photo of me actually tattooing somebody which looked great. I was ticking over quite nicely and thoroughly enjoying myself. There's nothing quite like the freedom of working for yourself; especially after the crap job at the factory I had for the past four years. It was very demanding but I was on top of it and everyone seemed very happy with the work I was doing on them.

But every day is a lesson.

One day I was working on a nice piece on a guy's back with another guy waiting to go next. All of a sudden, my machine just stopped working. I tried everything I knew to get it going, which in reality involved shaking it, banging it on the table and offering up prayers to the good Lord to help me! No deal. It was fucked.

The guy must have realised something was wrong by my demeanour and sudden silence.

'Everything okay?' He asked.

'My machine seems to have packed up!' I said.

He took it really well considering he had a half-finished tattoo on his back and there was nothing I could do about it for now. The other guy waiting took it much worse. He had been really looking forward to getting his tatt and stormed off in a huff.

I told my guy I would have to get a replacement machine and he could come back in a fortnight when his semi-tattoo had healed and I would finish it off for him and he was happy with that.

How embarrassing? I was gutted. I'd managed to talk my way through it but I felt like a complete idiot. My budget for equipment hadn't stretched to buying two machines and to be honest I hadn't even considered the possibility of a tattoo machine breaking down. Oh, they break down alright, take it from me! Fortunately, that was a lesson learnt very early on. Make sure you've always got spares and enough equipment to last you. You can't run out of tissues for instance and just get up and go off down to the supermarket to buy some more leaving your customer sitting in the chair.

13. Springfield Road, Crawley, my first tattoo studio

As luck would have it, I was due to go up to get tattooed by Rob Robinson in New Malden that week. By now I had been to a few tattoo studios to get work done, my main aim being industrial espionage. I would check out how they were doing things and copy anything I liked back at my own studio. Rob at New Malden knew I was a tattooist and was fine with that.

Rob was a very good artist at this time. One of the best. I had seen a piece he did on a friend of mine and was very impressed; the lines and colour work were amazing. So, I made sure to go to him for a few pieces and take a look at how he did things.

When I first visited his studio, there was a Rolls Royce Silver Shadow parked on the drive with the bonnet up and a guy fiddling with the engine. Rolls Royce Silver Shadow!? Yes, he wasn't cheap. But hey, you get what you pay for right?

I'd been up to see him a couple of times and loved what he'd done on my arms and we got on very well. Early on I had told him I was tattooing in Crawley but hadn't been doing it very long and I think he looked at me as his little tattoo buddy.

I phoned him and asked him if he could give me an address to get some more

machines – but not Ultra Tattoo Supplies – as I wanted something a bit more upmarket. He said he'd see what he could do and would let me know when I got up to his shop.

When I got there that day, he showed me a catalogue of tattoo equipment by a firm up north called Panther Products. They had some posh looking stuff in there so I got him to order me two machines, gave him the money and Panther said they would arrive early the next week. Brilliant, I was back in the game and these new machines looked very nice indeed.

I went back up the next week to collect my machines and Rob also gave me some old bottles of colour, the type he was using, for me to try out. I'd used all my money up buying the new machines and getting tattooed but when I started back at my studio the next day I felt much more confident with all my new stuff.

I was climbing the ladder.

The machines worked very well and the colours were better than what I'd had before, so things were looking up.

So, my first studio in Crawley went rather well and I was extremely happy, no real dramas after the machine failure and enough customers to earn a decent living.

There was one funny incident I remember though. I say funny but usually when I say that they aren't funny at the time. It has been known for the odd person to pass out whilst having a tattoo. Not very often, but it happens. I had my first *flaker* not long after I started.

A guy came in one day and wanted a piece on his leg. He'd had quite a few tattoos already. All was going well and we were laughing and joking around and he told me that one time when he went to get a tattoo, the guy before him had passed out halfway through having his tatt done.

I hadn't known this was possible. I don't think I'd even seen anybody pass out before. All of a sudden, he started shaking and going a bit weird, as if he was going to pass out. I thought he was just joking and larking around.

'Yeah, very funny mate. Good one.' I said.

No reply.

'Mate!?'

He dropped to the floor and lay there in a heap. He'd actually passed out! I couldn't believe it. What do I do now?

Luckily, he wasn't out for very long and he came round a bit confused but none the worse for wear.

'Are you okay? I thought you were joking around.' I said.

I managed to finish his design and he went off happy but it just goes to show, you never know what's around the corner.

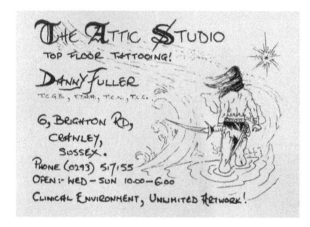

14. Crawley Borough Council, planning application, 7th January 1982 (2nd attempt), 6 Brighton Road, Crawley

15. Business card, Danny Fuller, the Attic Studio

16. Christmas party invitation for the Attic Studio

I was only at my studio in Springfield Road for about a year because the council decided that the owner of the building had sublet too many of the rooms, so I had to leave there. Last in first out. I found another place on Brighton Road near The Rocket pub. This was a much larger room on the second floor above a motor parts shop and estate agents. It was great having the extra space because I partitioned off a waiting area with a sofa and some comfy chairs where customers could wait until it was their turn. I even installed a phone line and made a load of business cards. As it was on the top floor I called it, The Attic Studio.

The estate agents below me weren't very keen to have a tattoo studio above them, or at least the secretary wasn't. She was probably about thirty years old and a complete square. I can't stand people like that. If ever there was a message for me or any post or parcels arrived, she'd knock on my door but wouldn't come in the room because she thought we'd all be covered in blood. Instead, she would stand outside until I stopped what I was doing and went out to her to collect anything. As the months went by though she gradually warmed up to me, as I hadn't slaughtered any virgins or eaten any babies upstairs.

I kept trying to get her to come in and have a look so she could see for herself it was all quite civilised.

One day while I was upstairs doing a red devil on a guy – which was a popular design in those days – they were small and good beginner pieces. She came up with a letter for me, knocked on the door and came straight in. She took one look at what I was doing, saw the red ink, thought it was blood and fainted flat out on the floor! I nearly jumped out of my chair in shock, checked she was okay, rushed downstairs and fetched her boss who ran up, panicked and called an ambulance.

The ambulance turned up outside the building. Great, that's every tattooist's nightmare! She had woken up but was in a pretty bad way. They didn't end up taking her off to hospital but sent her home for the rest of the day to recover.

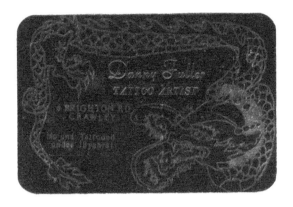

17. Business card, Danny Fuller, 6 Brighton Rd, Crawley

Don't have a baby will you love?! I thought.

Things were a little shaky between us for a while after that, but there you go. She never did believe that it wasn't blood!

I did enjoy it at The Attic Studio, I started getting quite busy and was beginning to make a bit of a name for myself.

You certainly do meet some characters being a tattooist that's for sure and Crawley was a baptism of fire. I was only twenty, young, still quite shy and a bit wet behind the ears but being a tattooist does come with a certain image. So, I'm not saying I got taken for a mug but obviously it's a tough world out there.

One guy I'll never forget was a guy known as, Spider. He was a great big monster of a man, a black belt Karate expert, – apparently – he had hands like shovels which looked like they'd been taken apart and glued back together willy-nilly. He was always going on about people he'd smashed up and trouble he was in. When he came in he'd pretty much take over the place and scare the shit out of everybody.

I would usually do a small tattoo on him for free and this would keep him happy and off he'd go. He never actually scared me as such, but I was always very wary of him because he obviously had issues. He reminded me of a Charles Bronson type. He took a shine to me after a while though and was always saying things like, 'Anyone fucks with you Dan; they're fucking with me!'

Which was nice to know but I wasn't really looking to get on the wrong side of anybody anyway.

He used to come in at least once a week, cause complete chaos and then disappear. I did get quite used to it in the end.

At one point I realised I hadn't had a Spider visit for about a month or so.

Believe me, I'm not complaining here.

Seeing as he was such a well-known character in Crawley I asked around and it turned out he was in prison. Apparently, he and a couple of other lads had attempted to carry out an armed robbery on a small Post Office somewhere out in the country. They hadn't cased the joint at all, just turned up and decided to rob the place.

The newspaper said, Spider was first to the door, wearing a balaclava and brandishing a shotgun, he gave it some mighty kicks to try and force his way in. The door was badly damaged but wouldn't budge. The staff were immediately alerted and set off the alarm.

Spider and his two cronies hightailed it back to the car and sped off. After some time had passed, Spider apparently thought it would be a good idea to go back, drive past the Post Office and check out the damage he'd done to the door with his mighty karate kicks.

Can you guess what's coming?

Yep, as they drove past the scene of the crime, the postmaster was standing outside talking to some police officers about what had happened. He looked up, saw Spider in the car – still wearing his balaclava! – pointed and shouted, 'That's them!'

Spider and his cronies raced off. The police jumped in their car in hot pursuit and caught up with them a mile or so down the road where they had run out of petrol!

Not exactly the Italian Job.

It turned out that to open the Post Office door, you pulled it as opposed to pushing it.

I drove up to this Post Office a while later because I wanted to check out the story, and to confirm I wouldn't be getting any more Spider visits in the near future. I saw the recent signs of damage to the door, PULLED it open and went in!

I found out later that Spider was actually quite a sad character in reality. He was a heroin addict – not a black belt, although he certainly acted like one – and had been in and out of mental institutions for most of his life. I met many Spiders during my career and I'm sure we'll be meeting a few more of them as we go along.

A few months later I was offered a bigger room across the corridor, which had a lot more space. This was great as I was able to divide my studio up into a waiting room and tattooing area. The waiting area walls were plastered with sheets of flash

and by now I had built up quite a collection of designs in scrapbooks and folders. Funnily enough my old room was taken over by a taxi firm, owned by Alan Minter, the former Undisputed World Middleweight Boxing Champion, a Crawley lad.

Tattoo Studios in the 1980s were the only source of tattoo designs. You very rarely had a customer come in with an idea of their own, unless it was a memorial or perhaps a tattoo with a sentimental meaning. So, everything they chose would be one of the designs I had bought and approved or drawn myself.

Tattoo conventions were just starting to appear around this time and you could usually find sets of A3 sheets for sale on some of the artists booths. These were outlines only that you had to colour in yourself, so this helped boost my collection.

I remember the first tattoo convention I ever went to, it was in Deal in Kent, run by a character called, 'Painless' Geoff, that name shows you the kind of character he was! I went with my wife at the time and my mother-in-law.

It was a pretty small affair but I loved it. There were about six artists working in the hall, there was a band on the stage and they had competitions for best tattoos in a couple of different classes. I'd never seen so many heavily tattooed people in one place before. I thought it was fantastic.

Being quite heavily tattooed myself now, I felt like I fitted in. I was chatting to lots of people as if I was one of the gang. I remember seeing one older guy in particular, grey haired with a ponytail, he must have been in his late sixties and he had sleeves. To me – being that age and having sleeves – he looked the coolest person I'd ever seen. Imagine having a grandad who looked like that?

The atmosphere was amazing and you could walk around at your leisure, watching all these tattooists working away on customers and no one cared. People were walking around only half clothed, showing off all sorts of tattoo work. It was like another world to me and especially to my mother-in-law who, bless her, was a little on the posh side and had never seen such sights. But she told me after, she had very much enjoyed her day out and it was nice to see how *the other half lived.*

I bought myself a couple of sets of tattoo designs. Stuff I couldn't wait to colour in and put up in my studio. Other than flash – there was no actual tattoo equipment for sale – as there would be in later conventions; they were still a bit protective over newcomers joining the trade.

I had an amazing day and really felt as if I was beginning to be a part of it all. I still had a long way to go but after being around some of the older guys who had obviously been involved with the tattoo trade for a long time, I knew there was nothing else in this world I wanted to do with my life. I wanted to become really good at this tattooing business and I wanted one day to work at a tattoo convention myself.

After going to my first convention and having worked in my studio for a couple of years, I started to feel I was on a par with some of the established tattooists around. I was very keen to hone my skills and was constantly seeking to improve. Every chance I got, I would still go and visit other studios to see how they operated to see if there was anything they did that I could use myself to make life easier.

I went to Croydon to see Ian 'Frostie' Frost, he was a great guy who had been working for a very long time. When I first started in Crawley, anyone who came in and already had a tatt would have got it done at Frostie's. His work was all over the place. I loved his simple style and good solid work.

My elder brother Steve had always had an interest in tattoos, he had a Munsters' head on his forearm and had let me do a couple on him as practice when I first started out. One day we decided to go up and see Frostie as I really liked the roses he did and wanted to get something off him and see how this legend went about things.

We were told you had to get to his studio pretty early as he always got very busy, so if you didn't want to wait all day for your turn it was best to get there at least a couple of hours before he opened.

We got to his studio about 9 am and there were only a couple of people waiting so it looked good for an early start. We waited and we waited, finally about 1 pm he turned up! A great big smile on his face from ear to ear, there were about ten people waiting by now.

'Morning lads.' he said. There was another guy with him who turned out to be his son, he did the colouring in after Frostie had done the outline.

A tattoo production line, I was impressed!

He unlocked the door and we all trooped in behind him. The place was fairly small, so it soon got wall to wall in there. It was a nice place but looked like it had seen quite a bit of action over the years. The design sheets on the walls were quite faded and nicotine stained but there were lots I liked the look of.

When my turn came, instead of the roses I decided to get myself a *Tattoo Artist* tattoo – I had seen this on a guy in Cheam, Paul Thorpe – he had a tattoo machine with a scroll above it with his name inside: Paul Thorpe and then another scroll below it with: Tattoo Artist inside. Frostie said he didn't have any designs with a tattoo machine so I decided to have a bulldog which was very popular at this time and being a bit of a patriot and ex-public schoolboy, I thought was a good choice.

Frostie put the bulldog transfer where I wanted it at the bottom of my right inside forearm and then drew the scrolls above and below in biro. He asked me how to spell my name, which was fine and then as he went to write *Tattoo Artist* in the bottom scroll, he paused and said, 'How many t's in tattoo?'

We all burst out laughing but he was serious. Good old Frostie, shit-hot artist but not so good at spelling!

This was my first tattoo with him, so I was looking forward to seeing how he went about it. He fired up the machine, dipped it in the ink and off we went.

Jesus! He dug in hard. I'd had a few artists work on me by now, but fuck me it hurt! Of course, I couldn't show it – that wouldn't be so good – a tattoo artist crying over the pain, but I did go pretty quiet for a while.

He finished the outline very quickly and then I went over to where his son was sitting to get it all coloured in. Because the outline had hurt so much the colouring in was completely numb so, panic over, it was all good.

Once it was all finished, I absolutely loved the result. I had, *Danny Fuller Tattoo Artist* tattooed on me for life, no going back now. I would have to do this for the rest of my working life. There was no way I was going to walk around with that tattooed on my skin and then be doing something else. It just wasn't going to happen.

I thanked Frostie profusely and as we walked back to the car, Steve with a great big smile on his face, said, 'That hurt, didn't it?'

'Yeah, how did you know?' I asked.

'Because your knees were doing a figure of eight!' He said.

We pissed ourselves laughing all the way back to Crawley.

Now that I'd got my *Tattoo Artist* tattoo I really started to feel the part. I couldn't stop looking at it for quite a while. I spent more and more time honing my craft. I would tattoo all day and then when I got home, after a bite to eat I would sit down on the sofa in front of the TV with a board on my knees drawing more tattoos. To me they were such enjoyable things to draw, you sketched something out in pencil then sharpened it up with an outline in black ink and then coloured it in with felt tip pens, and there you had it: a new tattoo design you hoped someone would choose and which you couldn't wait to do. This really was, for me, *the Golden Age of tattooing*, I was the one who dictated what people wore on their skin. Once a customer had visited my studio, he or she walked around for the rest of their life with a Danny Fuller exclusive on them. Something I had thought up and designed and then offered up for sale in my own tattoo studio.

It's only now after all these years and the way things have completely turned around to the point where most customers bring their own ideas in on their mobile phone screens that I realise the tattoo artist has lost a lot of the control they once had over how things looked. The internet and social media have totally changed the business of tattooing, which is a shame because a lot of the stuff you are asked to do now is stuff that is already tattooed on someone else. So a tattoo artist's day can

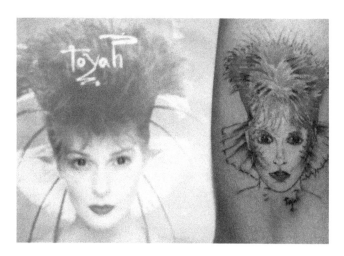

18. A very early portrait – Toyah Wilcox – done at Crawley, 1985

become repetitive when it never used to be. It's quite possible to do three or four fucking pocket watches in one day! But I digress.

Felt tip pens were great for colouring in because they were very bright and bold, but you couldn't get the subtle shading and blending of colours that you could when actually tattooing with a machine. So, after looking closely at some of the fantastic stuff that other – more talented artists were doing – I realised they were using watercolour pencils to colour their flash in, so I switched to these and was more pleased with the results.

Unfortunately, I was only to be in the Attic Studio for a couple of years because the landlord decided he wanted to sell the building and retire to Brighton. This was fairly annoying because when you start up as a tattooist, you don't want to move around too often because people get to know where you are and word gets round. Also, after having gone through all the rigmarole of applying for change of use on a premises and decking it out with plumbing, clean surfaces etc. The premises you were in could easily be used as a studio by someone else. Someone who could come along, move in and then benefit from all my hard work. This is an important point to remember in any business. In this case and fortunately for me it didn't apply because the building was being sold and redeveloped.

I had a couple of months' notice before I had to move on, so at least I could make the most of it. Then one morning –when I turned up for work – as I climbed the stairs, I noticed that a window had been broken on the first-floor landing and there were muddy boot prints on the stairs leading up to my studio.

Strange.

I had a weird feeling this wasn't a good sign. When I got to the top of the stairs, I saw that my studio door was open; I rushed in and saw that the whole place had been turned upside down.

I had been burgled! They had taken everything they could get their hands on: my machines and power pack, all my colours and a lot of the flash off the walls. They'd even taken my envelopes full of transfers. Motherfuckers! I was livid, absolutely

Tattoo thief

TATTOOIST Danny Fuller has had to stop work after being in business just six months following a break-in at his Crawley shop.

A determined thief removed the putty from a window at his shop in Brighton Road at the weekend and stole all his tattooing equipment.

The loss of the guns, worth £250, has temporarily put Danny out of business, but he hopes to be back early next week.

19. Crawley Studio – the window the burglars came through!

20. Article about the theft

inconsolable. They had been able to get in by coming across a roof and through the first-floor window.

I couldn't believe it; all my hard work and I was almost back to square one. I didn't have any copies of my design sheets. They were all originals and the transfers had taken years to build up and were for every design I had. Both of the machines I had bought from Rob Robinson were gone. They had worked reliably all this time and I had become properly used to them. I went downstairs and told the estate agents and we called the police.

The police came but weren't very interested, it wasn't really a major crime, no one had been hurt and it was only tattoo gear that had been taken after all!

I learnt another lesson that day and put bars on every window in every premises I rented after that. Burglary is a horrible crime; some cowardly bastards break into your castle while you're not there and help themselves to what they like. You feel like you've been raped. I can only imagine what it must feel like if someone burgles your home, it must be even worse.

So that upset the apple cart for a while. I was able to get some more equipment fairly quickly but I had to buy a load more flash and colour it all in again. Then I had to get used to the new machines which I didn't like as much as my old ones. I swore that if I ever found out who'd nicked my stuff, I would do them all free tattoos: cunt, in great big black lettering right across their foreheads, and I meant it too.

Understandably, I was pretty downhearted for a while after this, and I must say thank you to Dave 'Dodgy' How, who had enrolled himself as my unofficial helper, assistant and ink test dummy, while I was at the Attic Studio. He retraced pretty much

all of my transfers for me, it took him weeks and saved me a lot of time and bother. It must have benefited him greatly though because he went on to become a pretty mean tattoo artist himself.

I put the word out after this to see if anyone had heard who'd robbed me or was suddenly tattooing from home but I didn't get anything certain. I heard a rumour of one twat I'd tattooed a couple of times who it might have been but funnily enough I never saw him again after that.

Bizarrely, about fifteen years later – one day while I wasn't there – someone walked into my Blue Dragon studio in Brighton and gave one of the guys there a carrier bag and said he'd got hold of this some time ago. He had thought I might find it interesting and I should have it back.

The bag contained a load of my old flash, the stuff that had been nicked all those years back and also lots of very old transfers! Fifteen years that stuff had been knocking around and somebody had it all that time. I never found out who the guy was and I'm sure he wasn't the one who stole it because no one would be stupid enough to give my stuff back to me face to face. But I was very grateful that he had taken the trouble to bring it back to me, especially after so much time had passed.

With the help of the estate agents below me, I managed to find another premises that was available to rent. My third by now! I went through the change of use procedure again and paid my fee. I think I must have financed a couple of Council houses by now. After the sorry episode of the burglary, I was quite glad to be moving on.

The new place was one great big room, sort of a former stable, behind the George Hotel in Crawley High Street. 'Dodgy' Dave moved with me and I started to let him do a bit of colouring in *a la* Frostie and Son. It worked quite well, so I had my own tiny tattoo production line running.

One day an attractive looking woman came in and saw how much room there was and asked if she could rent some of the space for an office and get an extra phone line installed. It was for her recruitment agency, she said. She would also pay me a small amount of rent each week. That sounded good to me, so I said, yes. Her and her bloke built a little partitioned office with a door on it and they were soon up and running.

Well that phone never stopped ringing, there were a lot of different girls – all young and attractive – coming in, answering the phone and going out. Then another one would come in, answer the phone and go out, this would go on all day. We were fascinated, after a few days they had more business than we did!

I was puzzled with what was going on and one day I just had to ask one of the

girls what all the activity was.

'It's an Escort Agency.'

'Whaaat?!'

`We're Escorts.' she told me.

Being a bit naive I had no idea what an escort was but I later found out it was a posh term for prostitute. Oh, my Lord, I had a brothel in my studio! Well not quite a brothel but the closest thing. Was this legal? I found out it was nothing to worry about as there was nothing actually going on in my studio but it sure got a laugh down the pub and a few people started calling me 'The Pimp'.

Very funny, I'm sure.

As it turned out I wasn't to be at this studio very long either because my brother Steve had expressed an interest in becoming a tattooist after he'd seen what I was doing and realised there was a living to be made drawing on people and hurting them.

His words not mine!

He had gone down to Brighton and found somewhere to set up a studio. At that time – around 1987 – there was only one other tattoo studio in Brighton and that was Bob 'Peg-Leg' Bonwick on the Palace Pier. So, it was ideal really and I was immediately jealous. Crawley was okay but Brighton? A tattoo studio there? Come on now. Who wouldn't want to work in Brighton?

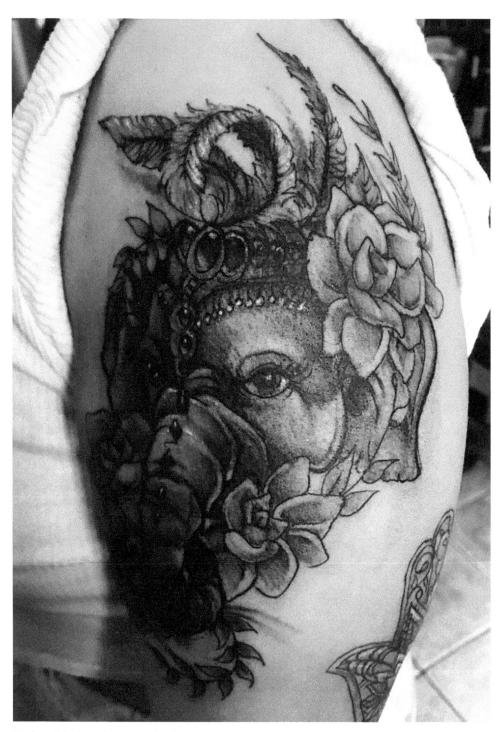

Various black and grey work, circa 1990s

Chapter 8: *Brighton*

The summer of 1983 was not the happiest time for me. For a few months I had been feeling really, really rough. I put on a lot of weight and developed a constant, raging thirst like I'd eaten a couple of bacon sandwiches with extra salt on and I had no energy to do anything whatsoever. Every day was a struggle. I once played golf with my father-in-law who suffered from Angina and he tore around the course leaving me for dead. I had to take two large bottles of coke, four litres in all, just to get around the course; I was that thirsty. If I went to the cinema, I would take the biggest drink they had in with me and then halfway through the film I would have to come out and buy another one. Of course, all this liquid had to come out, so I would be in and out of the toilet all day. It was awful. I was only twenty-three. I should have been in my prime.

The final straw came one morning when I woke up feeling like shit as usual, I struggled to get dressed and then just collapsed back on the bed breathless. My mother-in-law came round, took one look at me and said she was taking me to the doctor. She had to help me finish dressing.

They got me to the surgery and I went in and saw the doctor and once I'd told him my symptoms, he looked at me and said, 'It looks like you may be diabetic.'

He pricked my finger and put a sample of my blood on a test strip to check my blood sugar and it was off the scale! I was diagnosed with Type One Diabetes.

Just brilliant! What the fuck did that mean? I knew it wasn't very good.

I'm not going to go into too much detail about the illness because I think that by now – in this day and age – we all know someone who is diabetic. It's known as a chronic illness, where the pancreas which makes insulin fails. Insulin turns sugars, or carbohydrates that you eat into energy. My pancreas was on its last legs, which is why I was so knackered all the time. Once your pancreas fails and no longer manufactures insulin you have to manually inject insulin every time you eat something, otherwise you'll die.

They got me into the hospital at Guilford and sorted out my blood sugars and told me – kind of – what I had to do from now on i.e. inject myself with a syringe full of insulin whenever I ate something and how I must be careful with what I ate blah, blah, blah.

Inject myself with a syringe every time I ate something? That was it, my life was over. I couldn't have felt worse.

Treatment for diabetes nowadays has come on a hell of a lot since I was diagnosed. There are now meters that measure your blood sugars very accurately and

the insulin comes in pen form with tiny needles that you change after each injection and can hardly feel going into your skin. Unlike the Frankenstein type syringes they first gave me. At first, it was very depressing to have such upheaval in my routine, but I had my tattooing to concentrate on. That helped me a lot, as it did through other traumas I had coming in my personal life. And I'm still alive and kicking so I suppose it could have been worse. There are some side effects and complications with being diabetic that aren't so good, but I can't really complain.

One of the worst episodes you get is when your blood sugar goes too low, i.e., you have too much insulin in your blood system. This is called: having a hypo, which makes you feel very strange. You get very confused which has led to quite a few *interesting* moments for me, sometimes hilarious and sometimes not so. I may relate some of these hypos if they're relevant later on but if I do mention the word hypo in a sentence you'll know that things got a bit crazy for a while.

After just getting used to my special condition and learning to live with it, another bombshell was about to hit me.

I had been married for four years but things had slowly started to deteriorate and eventually my wife and I decided to separate. I was extremely upset because I had thought that once you were married you were together for the rest of your life. In sickness and in health, for richer or poorer and all that. My mum and dad had been together nearly fifty years and I hoped we would do the same, but it was not to be.

It wasn't the worst break up I had in my life but to suddenly be on your own was pretty devastating all the same.

My brother Steve had found a place to set up in a flea market type affair in Duke Street, Brighton; this was an arcade of stalls and rooms available to rent. There was a fruit and veg stall out the

21. Steve's Tattoo Studio, Duke Street Brighton, flyer

22. Business card, Steve Fuller, Dukes Market studio

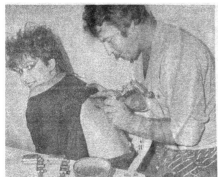

Now it's the tattooed lady!

By ALISON CRIDLAND

BRIGHTON tattooist Steve Fuller didn't turn a hair when I asked him for a tattoo.

It seems that tattoos are a growing trend among women.

But it is not "I love mum" on the forearm. They prefer small, discreet, pretty designs like roses or bluebirds that hopefully won't be a life-long regret.

I had a small, swallow-shaped bird tattooed on my back coloured in red, yellow and blue.

The 15-minute session was unique, painful and intriguing as Mr Fuller stuck the needles in and out.

And admittedly all the way through I was wondering what on earth I'd tell my mother.

But it was all in a day's work for Mr Fuller, 34, who has just opened up a studio at Dukes Market in Duke Street.

Tattoos are making a come-back, according to Mr Fuller. He was trained by his brother in Crawley and gave up his job as a security guard at Gatwick Airport to open his own studio.

Mr Fuller specialises in Oriental designs, like Japanese samurai fighting warriors, kimono - clad women and detailed dragons.

He is also very patriotic and has Britannia and the Union Jack on his own arm.

And he has designed a Falklands victory tattoo incorporating the Islands and the Union Jack.

Mr Fuller believes the improvement in tattooists' skills and designs are the reason more women are becoming marked for life.

"Tattoots have progressed from back - door scratchers to artistic designers," he said.

Another new craze is tattooing the inside bottom lip with obscenities.

Mr Fuller, who charges £2 for this service, said: "It is very difficult to do — and defeats the object of tattoos which are meant to be pictures on the body for everyone to see."

He refuses to tattoo hands or faces but does stars on earlobes for £3 and entire shoulders for £100.

Alison Cridland gets her bird tattoo from Steve Fuller.

23. Article, Steve Fuller, Brighton and Hove Gazette, 27th August 1982, Duke's Market

front, a cafe as you walked in, a jewellery stall, a psychic medium and a few other stalls selling junk and bric-a-brac and Steve had a separate little room down some steps that used to sell shoes. It was a great place full of characters and buzzing all day.

He hadn't been open very long but he was already turning over quite a bit of business and not doing too badly for himself. I used to visit as often as I could, whenever I had a day off and I really liked the atmosphere.

Brighton versus Crawley for atmosphere and action was no contest.

Because of my personal situation I had lost any desire I had to stay where I was. I still had plenty of friends in Crawley and nearby Horsham but I didn't like going out any more in case I bumped into my soon to be ex-wife as things were often a bit raw after the breakup. I was still hanging around with the Burgess Hill Barkers and we often went to Brighton on the weekend.

I loved going to Brighton. Everyone loves Brighton. Especially if you're young and single. There was so much to do there and so many places that you didn't find anywhere else. You had: the seafront, the Pier, the Amusement Arcades, the ice rink, fortune tellers, the Marina, there were loads of clubs that were open till late, there were illegal drinking dens and countless pubs catering for every taste. There were discos, rock clubs, casinos and even a dolphinarium. You could get your photo taken on the Pier with a parrot or even a squirrel monkey. I had owned one of these cute little things when I was living at the house with the two girls! It was like London by the sea but better, because everything was pretty much within walking distance.

I loved Brighton and in 1987 after we'd sold our house – divided up the money and got divorced – I decided I was going to move down to Brighton and buy a house there. Brighton was cheaper than where I was living anyway, so that was a bonus.

Steve said I could go and work with him at his studio so I didn't even have to look for a place of my own. Brilliant. Things were starting to look up and I felt a lot

better and was very excited. Steve was living in a flat – smack bang in the middle of town – but he'd also bought himself a small sailing yacht by this time and wanted to sell the flat and go and live on his boat at Brighton Marina, so he let me stay in his flat until my house purchase went through.

Oh, my God, what a treat! Living in the centre of Brighton with all its attractions and temptations and being a young single man. I could walk to work, walk home, have some dinner and watch a bit of TV, then before the next show on the TV I could go out the front door, walk a few yards, have a drink in a pub and go to the arcades and play Street Fighter or any other games for a while. Then walk back to the flat to watch a bit more TV and then – as they now say – rinse and repeat. It was just great and those couple of months I spent living at Steve's flat in Cannon Place were some of the best times I had while living in Brighton, it was the perfect tonic after all the recent crap I'd been through.

I found myself a house at the very top of Hove (actually!) in Elm Drive. A three-bedroom end of terrace, £54,000! It's gone up a bit since then. I moved in with two of my friends as lodgers – Karl and Dean – they were both very good friends and were also covered in tatts so we had a lot in common.

At the top of Elm Drive, within easy walking distance, was The Grenadier Pub which seemed an excellent bit of luck, but after asking around it turned out that apparently it was one of the roughest pubs in Brighton at the time!

Well, that wasn't so good. It looked like we'd be avoiding that. There were plenty of other pubs not too far away though so it wasn't a complete bust.

After living there a few months and walking past The Grenadier most days, I didn't see any smashed windows or pools of blood outside, so one night we thought why not? and decided to give it a try. It was summertime so it was t-shirt weather. Dean was six foot four and Karl and I weren't exactly small and we all had tattooed sleeves. We were a bit anxious going in because of The Grenadier's reputation but thought that if anything kicked off, we could either deal with it or run away.

It was a Friday night and the place was packed. As we walked in, a little bit of a hush descended, as you'd expect when three strangers walk into a locals' pub. There were a few inquisitive looks, but otherwise everything was fine and we ended up having a great night. We didn't know what all the fuss was about.

The Grenadier turned out to be a fantastic pub with a great crowd of regulars, I got to know them all. We had some brilliant nights out and after all these years I can still go down there for a drink and know there will be someone in there who I can talk to.

One night – sitting in the public bar as usual – I told the story of how we'd heard it was such a rough pub and were very wary of going in for a drink because the locals might not like three strangers walking in. It turned out that when the three of us walked in that night – looking as we did – especially sleeved up, everyone had shit themselves and thought it best not to upset us in case we turned the place over!

The moral of the story is: if you're going to walk into the meanest pub in town, make sure you have sleeves. You're bound to fit right in!

That's one of my favourite tattoo stories.

My big brother Steve was one of the funniest blokes I've ever met. He was a big guy with a big sense of humour. He had lived quite a life before we worked together. He'd been in prison for a short while and was definitely a rebel without a cause, but he had a good heart. He also liked a drink. In fact I never met anyone who could match him on a night out drinking. He had a very relaxed outlook on life and wasn't one to follow rules or do what people told him. A perfect candidate for a tattoo artist, but he wasn't one for taking other people's advice either.

He was fifteen years older than me and I hadn't seen a lot of him when I was growing up because he was living in London and I was away at school a lot of the time. It was only after I started tattooing that we saw more of each other and got closer, as he had left London and moved down to Horsham to live with his long-time girlfriend, Sylvia.

That relationship had ended abruptly one afternoon when he came home unexpectedly and found her in bed with another man. He didn't make too much of a fuss, he just grabbed some of his things and walked out of the house leaving a shocked Sylvia to call the ambulance for her – now unconscious – lover lying on the bedroom floor.

I thought that was rather cool.

He moved into the Pine Lodge guest house briefly before buying his flat in Cannon Place in Brighton. He had let me do a couple of tattoos on him when I was practising which I thought was very good of him. As he was working as a Security Guard at Gatwick Airport, he would often pop into my studio on his way back to Brighton after a shift. He certainly would brighten the place up.

When I told him that I was thinking of taking on 'Dodgy' Dave as an apprentice he said, 'Don't forget about your big brother.'

I was quite surprised that he wanted to have a go at tattooing, but he would often do paintings and draw stuff so I suppose it was natural that he'd want to follow in my footsteps. In my family, tattooing was obviously starting to be in the blood.

I thought he'd be helping me for at least six months while apprenticing and I

showed him the ropes and explained all the intricacies of the art of the tattoo before he set up on his own. But no, that wasn't Steve's way. After one afternoon of showing him how everything worked and what to get in the way of equipment and colours etc, he decided he knew enough!

He bought a set of equipment and cobbled together a load of flash sheets and set out to find a suitable studio in Brighton. The place he found was in the basement of Dukes Lane arcades, and there you have it. As quick as that Brighton had its second tattoo studio.

The only other studio down there at the time was run by a guy called Bob Bonwick, he had a small studio on the Palace Pier which he had worked for a number of years, mainly during the summer months. The Pier was perfect for summer trade and most seaside towns had a tattooist on the pier. It would get very busy during the summer and he must have done a roaring trade. Every time I visited Brighton I would always have a walk to the end of the Pier and there were always plenty of people hanging around outside Bob's little booth waiting to be inked.

I popped my head in there once, before I was old enough to get a tattoo and while it was fascinating, it looked a bit seedy to me. The room was dark, it was nicotine stained and smelt a bit *off* and the people in there looked a bit unsavoury.

Bob had lost a leg in a car accident. Apparently, he was not the most hygienic of artists. He had a reputation for drinking and smoking and he also liked to fish while he tattooed!

He would tie a line to his leg and drop it through a hole in the floor to the sea below. If he felt a tug on the line, he would quickly drop his tattoo machine and pull the line back up. If there was a big enough fish on the end, he would take it off the hook and drop it in a bucket of sea water. If it was only a small one, he would drop it back through the hole in the floor. Then he would bait the hook up again and drop it back down through the hole, pick his machine up and carry on with the tattoo! That might have accounted for the ever present *off* smell.

He would also drop his dirty tissues used for cleaning the ink – and God knows what else – off of people's arms down through the hole and into the sea below. He eventually got told by Brighton Council to refrain from doing this as people were complaining about them washing up on the beach and they thought the red ink looked like blood. Shades of the Attic Studio there!

He certainly was a character though and was well known around a lot of the pubs because he liked a drink. Even though he only had one leg he wasn't shy of getting into a few scrapes once he'd had a few. I heard one story of him getting into an argument with a guy in the Bear Inn, it turned physical and Bob ended up hitting

the guy over the head with his false leg! I could only assume it had come loose in the struggle.

I don't mean to put the guy down but he wasn't the greatest artist Brighton has ever known. I think this had more to do with drinking while he worked. Unlike some, I have never, ever thought the two go together. Once I took it up professionally, I never tattooed anyone after taking a drink. Can you imagine going to your dentist to have some work done and finding that his breath stunk of alcohol? There's plenty of time for a drink or whatever your poison is when you're finished for the day.

It's far too easy to get a bad reputation and reputation is what tattooing is all about.

I soon settled into my new workspace, the studio was down some steps and was just big enough for the two of us. Being the most experienced, I was out the front behind a small counter and Steve was tucked back into an alcove in one corner. The walls were covered with flash sheets and there was a large round table in the middle of the room with more flash sheets in folders.

The only downside was there was no running water or drainage, so we had to have a water dispenser with a tiny sink – and a bucket below it –in a small cupboard to catch the waste. Then one of us had to take this bucket upstairs to the toilets and pour the water away. I hated this arrangement because when we were busy it was quite easy to forget to check the waste bucket and we'd often get a puddle of disgusting grey water leaking out under the cabinet door and across the lino where we worked.

We got very busy in the summer and the place was always buzzing. Being a lot older than me and therefore a lot more confident, Steve was the consummate entertainer and would have everyone in stitches most of the time. I don't know how he got away with some of the things he said to people but it was the 1980s so things weren't quite as PC as they are now.

It was all taken in good spirits though, apart from one time when he said something out of order to a mean looking lesbian; I forget what it was now but she took offence and punched him straight in the mouth! The look of shock on his face was priceless and that was one of the only times I ever saw him speechless. Good girl. He did deserve it sometimes.

I remember one good example that I wouldn't have dared to try at the time. These two great big guys came in one day, they were enormous and both were bouncers at one of the clubs. We used to have a boogie box playing cassettes in place of a sound system on a shelf. We were all chatting away quite happily when the cassette stopped. Steve looked up and said to one of the meatheads, 'Are you technically minded mate?'

The guy looked at him puzzled and said, 'Er well yeah, I suppose so. Why?'

Steve pointed and said, 'Can you turn the cassette over?'

There was an awkward silence for a couple of seconds while the guy thought about what Steve had just said to him and then he burst out laughing, a great big Frank Bruno type of laugh. I breathed a sigh of relief and got back out from under my counter where I was hiding!

It wasn't all laughs though, as some of you might know if you've worked with family members!

We used to split everything we earnt down the middle at the end of each day, which is a silly idea really because our takings would never be the same, but the idea was if one of us earnt more than the other on any day it would even out by the end of the week. I would have Mondays off and Steve would have Tuesdays off and whoever worked while the other one was off would leave half of the money they earnt in a box so we could get a paid day's holiday each week.

I was taking my work really seriously and was putting all of my energy into becoming a better artist. I really did want to make a name for myself and try to make myself one of the best around, so I was trying out all sorts of different needle combinations, buying machines and drawing new flash when I had a spare moment. Even when I got home in the evenings. Steve didn't quite have the same work ethic as me. He just saw the whole thing as a good crack and would be more inclined to arse about whenever he could and be upstairs talking to the other traders whenever it was quiet.

Consequently, there was a big difference in the quality of our work. I lived to tattoo; Steve tattooed to live.

Most days I would be doing more than he was and on our days off I would be doing a hell of a lot more than he was but we were still splitting it fifty-fifty. I would imagine he loved that, but I didn't. I was also dying to get a proper studio with a lease and a shopfront of our own. A place where we could open and close whenever we liked and open Sundays if we wanted. Being in the arcade meant we had to stick to their opening hours and they closed at five o'clock so we would lose a lot of business in the summer when people would still be out and about.

Sometimes I used to go onto the Pier on a spying mission and Bob Bonwick would still be tattooing at eight or nine o'clock on a summer's evening and that made me proper jealous. But Steve wasn't interested in putting any money back into the business and paying more rent because where we were was pretty cheap.

He did make one compromise though. A bigger, separate room became vacant which had its own entrance around the back of our arcade. It was a little more rent but it had plumbing and a drain so we didn't have to keep emptying that goddamn waste

bucket every day.

Progress! This made me a bit happier but it still wasn't what I was looking for but blood is thicker than water so I went along with it.

As we worked through that summer – it must have been 1989 by now – we were getting busier and more established. Well, I was. I would be working my nuts off most days, doing twice as many tattoos as Steve on average who would sit there reading the newspaper and arsing about as usual. I mentioned it a couple of times but he said it was his place and fifty-fifty was our agreement.

Fucking older brothers!

Inevitably things gradually started to deteriorate between us. I'm a bit ashamed to admit it but when he was off and I was on my own I used to just match the money he'd left for me when I was off with maybe ten or twenty quid more in it so as not to be too obvious and keep the rest for myself. Why not? I was doing most of the work.

Then there were a couple of things that happened – well three actually – that finally broke up the partnership.

One Saturday morning I was busy on a piece while Steve was sitting having his morning coffee and reading his newspaper. Surprise, surprise! I think it was the Daily Mirror, but that wasn't why I got annoyed.

A young Black kid – only about ten years old – stuck his head through the door to have a look. He saw all of us scary tattooed guys in there and quickly ducked his head back out again. Understandable of course, who wouldn't?

Steve looked up from his paper, laughed and said, 'Probably wanted to ask about a respray.'

This was unforgivably offensive and what happened next was truly one of my life's most terrifying moments.

The door, which was a great big heavy double door, got kicked open from the outside and I swear it almost came off its hinges.

This was followed by, 'Who the fuck said that?!' in the loudest, angriest voice I'd ever heard. In burst one of the biggest, meanest Black guys I had ever seen.

'I said, who the fuck said that?!' He was obviously the kid's father and he was fucking pissed. He was looking around at everyone like he wanted to rip us limb from limb and he was blocking the only exit from the room.

Put yourself in my position here for a moment, I had just got into work, a little hung over with its being a Saturday morning and feeling a little delicate. I just wanted to quietly get on with what I had to do, enjoy my day with everybody and get back home.

Instead – all of a sudden – I was staring wide-eyed in disbelief at the instrument of my imminent death. Or at least serious bodily injury, standing there growling and flexing like Mike Tyson who had just found out Don King had ripped him off for one hundred million dollars.

And I hadn't said a fucking word. I hadn't even seen the kid open the door. I was only enlightened of that fact later on.

Steve hastily offered up apology after apology while the irate father, thankfully, turned all his attention on him.

Luckily for us – well Steve mainly – grandmother was standing outside with the rest of the party and was furiously trying to calm her son down, telling him to leave it and walk away. Maybe she'd seen him in action before and seen the devastation he could dish out?

The guy gradually calmed down and finally walked back out of the studio swearing about what he'd do if he ever saw Steve again.

I stopped trying to burrow out through the brick wall next to me. Everyone was speechless, except Steve of course, who just laughed and said, 'Phew, that was close.'

'Close?! We nearly all got fucked up there and you think it's funny?'

I never usually smoked during the day but I was pretty shaken up and my customer and I went outside for a quick fag to calm our nerves before finishing off his tattoo. I could accept getting into trouble if it was my fault, but not first thing on a Saturday morning when I wasn't even aware of what was going on around me.

The second thing that did my head in was when a guy Steve had tattooed a day or two before with one of our fantasy wizard designs, came back in with a bit of a complaint. The tattoo was of the head of a Wizard holding a crystal ball in one hand whilst pointing and casting a spell with his other hand, it was a great design to do and one of my favourites. You could see the fingers of the hand holding the crystal ball around the outside and obviously you could see the fingers of the other hand pointing.

'There's a bit of a problem with the tattoo you did for me,' the guy explained.

I looked over; my interest suddenly piqued.

'What's up mate?' Steve asked.

'It's my wizard, he's got eleven fingers!'

I rushed over to have a look. Sure enough, five fingers on the pointing hand and six fingers holding onto the crystal ball!

Steve took a long hard look at it; I could see the cogs whirring round in his head. He looked up at the guy, shrugged his shoulders and said, 'Well, it's fantasy, isn't it?'

And off the guy went without another word.

Looking back on it I must admit it was pretty funny, but not at the time, he hadn't even said he'd try to fix it.

That's another customer lost, I thought.

The final straw came one day not long after, when we'd arranged to repaint the studio to brighten it up. We were going to do it on a Sunday when we'd be closed.

I got there nice and early, ready to go but Steve never turned up. I was excited to get on with it and make a start. So, I went to the cupboard near where he sat where we kept our decorating gear, brushes and the like. I opened the door and started pulling stuff out and there came the sound of clinking glass bottles. As I pulled more stuff out, I saw the reason: there was a load of empty whisky bottles – Steve's favourite drink – tucked away at the back.

When I had pulled them all out there were twelve empty bottles. Twelve!

I knew he had a bit of a drink problem but drinking at work? I had no idea.

That explained some of the episodes we'd had.

I was shocked and upset, why leave them in the cupboard? And why at work? They were bound to be found. It's a common alcoholic trait apparently, something to do with trophies.

Well, the studio didn't get painted that day. I left the empties on his station so that when he came in, he'd know I'd seen them and I went straight home. That was the day I decided I couldn't take any more. I felt betrayed. We obviously didn't have the same goals in mind. It was a very sad day once I realised, I wasn't going to be working with my brother any more. But I was going places and he'd just lost any enthusiasm he'd once had and the demon drink had taken over his life.

I'd seen it coming and had tried but you can't talk people off that road once they get on it.

The next day was Monday, my day off, so I went in to see him and tell him I was going to go my own way. I was dreading it because I didn't think he'd take it very well and there were the empty bottles I'd purposely left out.

When I told him I wanted to go off on my own, I didn't know where yet, he took it rather well. Too well I thought. I said I'd still work there until I found somewhere and then I'd be off. He said that would be fine and not to worry about it. I thought that was good and was relieved there hadn't been a scene.

When I got in to work the next day – Steve's day off – the studio door was already open. I walked in and Steve was sitting at his station with his newspaper. I looked over to my station and all my stuff was on the counter in a cardboard box!

'What the fuck?' I burst out, shocked.

'Well, you're leaving.' he said, not looking up from his paper.

'But you said it was okay to stay til I found somewhere?!'

'Did I?' he said, still not looking up from his fucking paper.

I was shocked, saw the old red mist and just went ballistic. I snatched the paper out of his hands and ripped it into about a thousand pieces. All the pent-up frustration I had felt over the last few months came out. It was a once in a lifetime tirade that I don't think I've matched since. I told him exactly what I thought of him and what he could do with his shitty arcade studio. I didn't actually attack him but I came very, very close. I kicked and smashed a few things, then picked up my cardboard box full of stuff – no designs again! – and walked out.

When I got home, I phoned my dad seeking a friendly ear, and had a bit of a rant at what Steve had done, kicking me out with no notice, but he just put the phone down on me. Aaargh! Families!

And so ended the Fuller family tattooing empire. Well, that go at it at least.

Poor old Steve. Things just went a bit pear-shaped for him after that, it was very sad. We never really made up; he couldn't give up the drink. Of all the alcohol choices I think that whisky is the worst, it can turn normally mild-mannered people a bit psychotic. I saw it happen a few times. It didn't make my brother go psycho as such but it turned him into a different person, argumentative, moody and just not really caring what he said to you. Hence the wizard episode, maybe?

He carried on tattooing for a few more months at Dukes' Arcade and then he closed up and moved onto the Palace Pier when a booth became available. That only lasted for one season and then he decided to try to sail his boat down to Spain, moor up and tattoo off the beach in his floating tattoo studio. It was a great idea, only he wasn't the best sailor. He hadn't bothered to take his captain's licence, which would have taught him how to navigate properly. He set off from Brighton Marina one afternoon and only got as far as Chichester when – apparently the worse for drink – he got caught in a sudden squall and couldn't control his boat so he had to send out a Mayday call to the coastguard.

The coastguard's helicopter managed to find him and winched him off his boat but Steve didn't drop his anchor. A fishing boat came by at some point and saw his unmanned boat floating freely and took it under salvage.

Apparently, according to maritime law, if you have to leave a boat unattended at sea for any reason, you are supposed to drop the anchor so you know the rough position of it and so passing boats will know you are coming back to retrieve it. If the anchor isn't dropped then any passing boat can come along and claim it for themselves! I suppose it's a bit like leaving your car somewhere unlocked and with

the keys in the ignition.

So that lucky fisherman caught the catch of his life that day. They towed Steve's yacht back to harbour, did all the correct paperwork and claimed his boat. It went to court but due to maritime law, Steve lost his boat and therefore his home. There was nothing that could be done. If he'd taken his captain's certificate, he'd have hopefully known that.

He had to go back and stay at Mum and Dad's for a while and they had now retired to Saltdean in Brighton.

Unperturbed, he decided to stick with the Spanish plan and got himself a cheap Ford transit van and decked it out as a campervan/ mobile tattoo studio instead.

After a solid day or so preparing the van, he drove it down to Portsmouth to catch the twenty-four-hour ferry trip to Santander in the south of Spain.

Unfortunately, there was a duty-free bar on the ferry …

Yep, you guessed it – after drinking for most of the trip – when the ferry finally docked at Santander my thoroughly pissed up brother drove his mobile tattoo studio off the ferry and set off on his way to the Costa Del whatever it was, forgetting that they drive on the right-hand side of the road in Spain!

He got about two hundred metres into Spain before hitting an unsuspecting Spanish motorist head on. Both vehicles were written off. The Spanish Garda were called, saw the state of Steve who could hardly walk in a straight line, kicked the shit out of him and took all his money to give to the Spanish driver to help pay for the damage.

Insurance? Who needs that?

They took him to the cells where he got his allotted phone call eventually, which he used to call home and plead with Dad to wire him the money for a plane ticket to fly back home.

That really was the end of things for Steve Fuller as a tattoo artist. Mum and Dad didn't want him at their place, understandably, so he ended up in a halfway house hotel in Brighton. Unable to stop drinking, he was only there a few months before he got into an argument with another resident at a phone box near the hotel. It turned into a fight and the other guy got the better of Steve as he was way past his old best due to years of alcoholism. Badly injured, he managed to drag himself back up to his room. Later that day somebody in the room below heard a loud crash which shook the ceiling. When there was no sign of Steve the next day the manager went up and knocked on his locked door. Not getting an answer he used his key to get in the room and found Steve lying dead on the floor.

The police and ambulance were called and they took him to wherever they

take a dead body. Apparently, he had got to his room, rolled a cigarette and passed out falling flat on his back which explains the crash the people below him had heard. He died of a ruptured spleen caused by the fall. The guy he had fought with by the phone box was arrested and charged with murder. But when the case went to court it was decided that as Steve had managed to get himself up a few floors to his room he wasn't to blame. The jury took a while to make their decision though.

The day it happened, was a Saturday which I won't forget. I was working at my Blue Dragon studio when the police came in and told me Steve was dead and what had happened. It was a total shock of course, I managed to finish the tattoo and then I walked the short distance to the phone box where the fight had occurred. There were blood drips outside the phone box and a blood trail back to his hotel and bloody handprints all over the front door where Steve had tried to get his key in the lock. They hadn't even cleaned up the blood! I was outraged. I went to the manager's office, got hold of him and dragged him outside and made him clean the blood off the door. It broke my heart seeing the blood trail of my once mighty big brother. He was only fifty years old. The worst part about it was having to go and tell Mum and Dad that he was dead. My poor mum, I didn't mention the blood. That was a bad day.

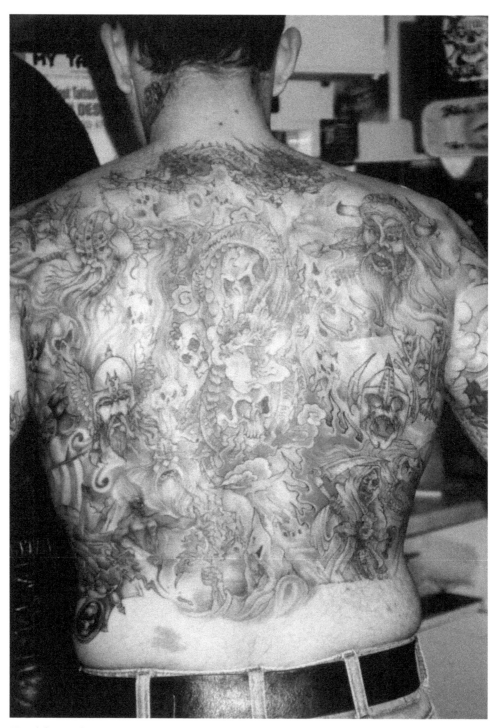

Henri from Dieppe

Chapter 9: *A beautiful dragon is born, and it's blue*

It was now the summer of 1989 and all of a sudden, I was a tattooist without a studio. But at least I was free to find my own place in Brighton.

One morning I was getting my hair cut at my friend Tony Wheeler's barbershop in the middle of town, right by the Clocktower. He asked me how everything was going and I told him I'd just left my brother's place down the road in Duke Street and was looking to start out on my own.

'Well, I've got a couple of rooms downstairs you might want to have a look at,' he told me.

Now that sounded promising.

'Mate, let's have a look,' I replied.

He finished my haircut and then took me to a door at the back of his cutting room. Behind this door was a set of stairs leading down and at the bottom were two good sized rooms and in one of them there was a toilet. At the top of the stairs leading down there was another door, which was a separate entrance to the back of the building leading out onto Air Street

This was a perfect set up: there would be a studio room, a waiting room, running water, a proper drainage system, a toilet for customers and my own entrance in Air Street. The positioning was also perfect, right by the Quadrant pub and the Clocktower, which everybody who had been to Brighton knew. We agreed on a rent and that was it. All I had to do was apply to the Brighton Council Environmental Health Department for my licence and I was back in business. Oh, and of course deck it out as a tattoo studio and give it a name.

I decided to call it the Blue Dragon Tattoo Studio; I really liked the Japanese style of tattoo art and dragons were meant to be ancient creatures bringing their owners luck, wisdom and good Karma. I got everything sorted out pretty sharpish and was able to open up before the end of the summer. What a stroke of luck. That was definitely the best haircut I'd ever had. I was only out of action for a couple of months but I was able to get myself a brand-new load of flash drawn out, again!

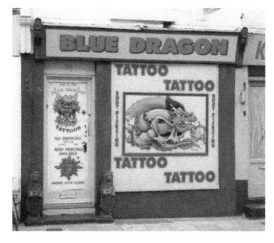

24. The Blue Dragon, 1998

111

When I finished setting it all up it really did look fantastic down there. I even had a TV playing videos in the waiting room. Tony was pleased, the Council were impressed and I was very proud. It was definitely a step up from a backroom in a flea market.

Air Street turned out to be as good a location as I had expected. Tattoos were starting to become a lot more popular, the standard of artwork was getting better, the equipment was getting a lot better, especially the machines. Micky Sharpz – a top tattoo artist from Birmingham – had started to make a range of machines that were a lot more powerful, very reliable and they sold very well.

There are two main types of tattoo machines, or *guns* available. There are the rotary types, which are powered by a small electric motor with a cam arrangement that moves the needles up and down. This type of machine is quiet and reliable but tends to overheat and you have to keep oiling the hole in the cam where the needle bar is connected to the motor to stop friction wearing away the hole and ruining the movement. These are more like beginner's machines because oiling is the only real maintenance you have to do.

The main problem with the older rotary machines was that the bar where you had to solder the needles onto ran through a tiny sleeve at the top of the tube – which you held the machine with – to help keep the needle points steady, but once you had soldered the needles onto the bottom of the needle

THE TATTOO MACHINE

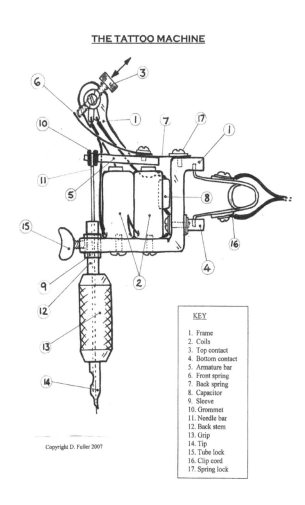

KEY
1. Frame
2. Coils
3. Top contact
4. Bottom contact
5. Armature bar
6. Front spring
7. Back spring
8. Capacitor
9. Sleeve
10. Grommet
11. Needle bar
12. Back stem
13. Grip
14. Tip
15. Tube lock
16. Clip cord
17. Spring lock

Copyright D. Fuller 2007

25. The tattoo machine

bar you couldn't pull the bar holding the needles back out of the tube unless you unsoldered them.

Unlike nowadays, Environmental Health regulations at the time didn't require

you to change the needles for each customer, or the inks, or anything else for that matter. We had only just begun to wear latex gloves! They were quite happy as long as you kept your machines and needles soaking in a rack with test tubes containing methylated spirits or alcohol. The problem was that after prolonged soaking in these liquids the sharp points of the needles could end up dissolving. It killed most germs alright but didn't do much for the skin of your customers! Luckily – for my customers mainly – I found this out fairly early on and I would never leave the machines in the test tube rack overnight or for periods longer than half an hour.

Getting back to the machines. The other type of tattoo machine is called a *coil machine*, these are a lot harder to use as they require constant maintenance because when they run there is a lot of metal-on-metal collision. This is the buzzing sound of the tattoo machine that we all know and love, the one that you can often hear halfway down the street!

The coil machines work in a completely different way to the rotary machines and there are a lot of advantages. I personally think whoever invented this type of machine was an unsung genius. I'll try to explain how they work but if you get lost check out my diagram of a coil type tattoo machine.

There are two electromagnets fixed to a small frame, electromagnets consist of a steel post with insulated copper wire wound around it from top to bottom, usually ten or twelve layers. The more layers the more powerful the magnetic force produced. The two magnets are connected together in series and one end of the copper wire connects to the frame – the earth or negative terminal – and the other connects to an insulated screw fixed to the top of the frame above the magnets, the positive terminal.

When the machine is connected to an electrical power supply – preferably variable – using what is called a clip cord, electricity passes through the entire length of the copper wire turning the steel posts into temporary magnets – very strong magnets indeed. There is a thin, flat, flexible piece of metal that is fixed to the machine frame above and in line with the magnets called the back spring. Attached to the back spring is a much thicker rectangular piece of steel called an armature bar.

Go on, check out my drawing because you must be lost by now!

Have you looked yet?

Good, let's finish this.

The needles are soldered onto the bottom of a thin stainless-steel bar, like a welding rod, called the needle bar and at the top of the needle bar there is a loop so that you can attach the needle bar to the armature bar. Finally, there is another spring attached to the armature bar which is bent upwards at an angle so that it connects to the screw or positive terminal, remember, at the top of the frame when no electricity

is running through the circuit.

Nearly there.

The genius of this set up are the back and front springs because when the machine is at rest the electrical circuit will operate because the front spring is in contact with the screw – positive terminal – but when electricity flows through the circuit thus magnetising the coils, the magnets pull down the armature bar which the needle bar holding the needles is connected to.

Deep breath.

As the armature bar is pulled downwards by the magnetic force, the front spring, which is attached to it, gets pulled down with it thus breaking the electrical circuit and therefore deactivating the magnetised coils. So, the back spring will then pull the armature bar upwards. The front spring comes into contact with the screw again thus completing the circuit and activating the magnets and the armature bar is then pulled downwards, breaking the electrical circuit and so on and so on. The magnets are probably activated and deactivated in this way ten times per second, at a rough guess, so the ends of the needles will move up and down very fast creating a perfect tattooing motion.

Because the needles are moved up and down by the magnetic force this negates the need for a cam, which moves up and down but also side to side as it moves in a circle. This enables you to get a perfectly straight up and down movement of the needle points thus producing a nice fine line, not a blurry line like the basic rotary machines.

I hope you understood all that, but it's only really of interest if you intend to understand how clever some of us tattoo nuts are. Ones that have bothered to arse around with the infernal machines every spare minute of our working day when they go wrong so we don't break down in tears in front of our customers.

Oh, there were tears alright, but that's another story. I must have spent hundreds of hours over the years tuning, adjusting and fiddling around with my coil machines, trying to get the ultimate set up. I managed it in the end and even made some machines of my own, so if your coil machines are driving you mad don't hesitate to get in touch with me, I'll sort the bastards out for you. Oh yes.

Even though I was now a fairly established artist with my own studio I still liked to go to different tattoo studios to get tattooed and see if they were doing anything that I might be able to adapt to help me improve myself. I heard there was a good artist in South London called Barry Louvaine and he owned the *House of Living Art,* cool name or what? So, one day me and a friend took a trip up to his studio to get a piece and check him out. He had done very well and was always busy. Apparently, he even

had his own private Cessna aeroplane!

We found his studio okay, but when we got to the door it was locked so we thought we'd had a wasted journey, but there was a handwritten sign stuck to the glass: For Tattoos go next door to the Pub. There was an arrow pointing down the road. We walked to the Pub and poked our heads in through the door, it was quiet as it had only just opened. There was a Teddy boy looking fellow sitting in a corner with a pint on the table, he looked up at us and said, 'Tattoos boys?'

I nodded.

'I'll be right there,' he said, downing the pint in one gulp, and he led us back up to his studio. Phew, we could get our tatts after all! Never mind the fact that he'd been drinking in the pub before we started. Barry was a great character, he used to like to tattoo with a glass of whisky beside him which he'd sip all the way through, so I suppose the odd pint before work didn't really affect him.

Another time I heard there was a good artist at the Elephant and Castle in London so we took a trip up there to have a look. We found the studio and walked up to have a look through the window before going in. The guy himself was a skinhead and there were about five other skinheads sitting in the studio chatting with their feet up on the tables and generally looking as if they owned the place.

One of them, a big, mean looking bastard, turned around and saw us looking through the window, wondering whether we should go in or not. I was a soul boy at this time with a wedge haircut, peg trousers and all the gear and I thought to myself, hmm, this might not be such a great idea!

He turned back and wrote something on a piece of paper. Then he got up and walked towards the window where we were standing, he looked like he was going to put his fist through it. He stretched his hand out and we braced ourselves, then he stuck the piece of paper on the window with a bit of Blu Tac. He'd written: GO AWAY! on it.

We ran off laughing, what a knob. He could at least have written, Fuck Off.

So, we didn't bother with the Elephant and Castle studio.

The guy at Cheam was really nice, Paul Thorpe. He was a couple of years older than me and helped me quite a bit with advice. Paul had a

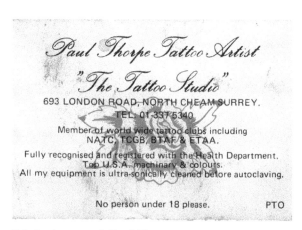

Paul Thorpe Tattoo Artist
"The Tattoo Studio"
693 LONDON ROAD, NORTH CHEAM SURREY.
TEL: 01-337 5340
Member of world wide tattoo clubs including
NATC, TCGB, BTAF & ETAA.
Fully recognised and registered with the Health Department.
Top U.S.A. machinary & colours.
All my equipment is ultra-sonically cleaned before autoclaving.

No person under 18 please. PTO

26. Business card, Paul Thorpe

really nice studio with a shopfront and we got on very well. He was another character and a proper joker.

One time I was at his studio and I was getting my first piece on my chest, a Japanese demon. I was expecting it to really hurt but it wasn't too bad at all. When he got to the black shading, he was doing the usual quick strokes and I was looking down watching him like a hawk as usual. Suddenly on one of the upward strokes he caught the end of my nose with his needles. Fuck! I nearly jumped out of the chair.

'Oh, sorry mate,' he said. 'Got a bit carried away there.' I'm not sure if he meant to do it but I think he must have because my nose wasn't that close! We laughed and when I looked in the mirror there was a thin black line tattooed on the end of my nose. He told me just to pick at it and rub it with a Brillo pad before it healed up and it should come off. It did come off eventually – most of it – but there is still a very faint mark on the end of my nose which I'm actually quite proud of.

Just to let you know if anyone is thinking of having a tatt on the end of their nose – it hurts more than the chest!

The last time I went up to see Paul in Cheam he told me he was having a bit of trouble with some travellers. I can't remember what it was all about but it seemed pretty serious because before he started my tattoo he reached under his counter and pulled out a sawn-off shotgun!

'If they come in again, I'm ready for them though.' he said.

I don't know if many of you have ever seen a sawn-off shotgun, but take it from me, they look as scary as fuck.

I didn't really know what to say. He started my tattoo, and this time rather than watching what he was doing my eyes were fixed on his studio door. Luckily the Travellers had other business elsewhere that day, but I couldn't get out of there quick enough and I decided that was all a bit heavy for me. I'd have to find somewhere else to go.

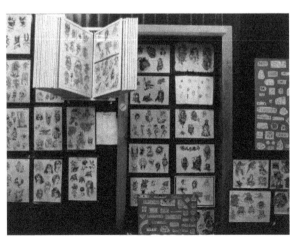

27. Flash inside the Blue Dragon, 1988

That visit to Cheam shook me up a little, so I didn't go visiting anywhere else for a while, I just concentrated on my work and being happy with my nice safe studio down in the middle of Brighton.

Business was pretty good at the Blue Dragon; I was getting more confident in my work and more

relaxed dealing with the customers. Nowhere near my brother Steve's style though. You have to be a people person if you're going to be dealing with Joe Public. You might not be the most talented tattoo artist there is, but if you look after your customers and generally make their visit fun and entertaining – of course you have to do a decent piece on them – they will come back time after time and a genuine relationship can develop.

Everybody wants to be your friend.

Most days were just a scream from start to finish. A bit of banter here, a bit of a wind up there. I didn't see it as work because I was having the time of my life. I was in the heart of Brighton; I had my music on all day. The guys from the barbershop upstairs would come down and joke around and there was no one to tell me what to do. I really was living the dream. I often thought about those poor mugs still working at the factory, who'd thought I'd soon be begging for my old job back. If only they knew how things had turned out.

Tattooing still wasn't a mainstream activity like it is nowadays. It was still fairly underground which was one of the things I loved about it. My customers were mainly men, mainly lower to lower-middle class. Builders, tradesmen and a lot of people on the dole. It wasn't so popular with women yet; it was still looked down upon a little, I think. Also, the designs were much more masculine, skulls, daggers, eagles and the like so they wouldn't appeal to women like the lovely feminine stuff available today. There were only one or two female tattoo artists that I knew of, but that sure would change in the next century.

Wintertime was still slow though; trade would suddenly drop off after the summer holidays when the kids had gone back to school and parents had taken their usual two weeks off in August and would start saving up for Christmas and it always got me down a bit at first. Suddenly the customers weren't queueing up at your door when you arrived.

I used to call it the September blues. You could almost set your watch by it. You would go from being run off your feet, especially on the weekend, to having nobody come through the door for two or three days.

Thank God for the PlayStation!

I always made sure I'd put enough by to pay the rent throughout the slow winter months and there were a few diehard regulars who would come in but very little walk-in trade.

A little description of how the average tattoo studio used to look in those days; tattoo parlours, as they were sometimes affectionately known were set up completely differently to what they have become in the 2000s.

As soon as you walked in through the front door you were hit with a smell of disinfectant – usually neat Listerine with a tiny bit of bubble bath mixed in – that they would constantly spray on your tattoo using a misting bottle to clean the excess ink off. The atmosphere would usually be full of cigarette smoke and sweat.

Every available bit of wall space would be covered with flash sheets of tattoo designs and these were the only choice you had. Most studios had hundreds, if not thousands of designs to choose from, but you rarely brought your own designs in.

This was what people liked most about the old tattoo studios, they really looked and smelt like tattoo studios. Walking into one was a unique experience. Each one would have a theme and atmosphere all of its own, good or bad. Most of them would have a few skulls or fantasy sculptures of different sizes up on a shelf or in cabinets and a lot would have glass cases with tarantulas or scorpions in them. Ugh! No way, not for me, thanks.

They were also a lot more light-hearted with some of the signs they displayed: It might say: Complaints Department underneath a baseball bat hung up on the back wall, or: Tattoo Removal underneath a large carpentry saw or: Jesus gets credit, all others pay cash!

Hilarious, eh?

My brother made a classic which always got a laugh, it read: Does a tattoo hurt? under this was: It's not as nice as this. and there was a cartoon drawing of a couple under the bed covers obviously having sex, and under that it read: but it's not as bad as this! with a cartoon drawing of a shotgun blasting a scrotum with both the testicles flying off in different directions through the smoke! I'm not sure what they'd think of it nowadays but it sure got a ton of laughs at the time and lightened the mood.

I even visited one studio in the States where the guy had a glass box frame hanging up on the wall with a shiny, brownish piece of something mounted in it, it had a very old Indian ink eagle design drawn on it and when I asked the guy what it was, he said, 'Why, that's mah pa's tattoo that he let me do when ah was a kid.'

Only in America!

We didn't take ourselves so seriously in those days.

Most studios would have a phone with the number on a business card. On the back of this you would sometimes see: Aftercare Instructions, which would tell you to put Savlon cream on twice a day, stay out of the sun and not go swimming for a week. If the studio had a double-sided business card you at least knew that the guy had put a little of his profits back into the business, because double-sided business cards were pretty expensive in those days!

There was no such thing as an appointment, it was first come, first served so

you were tattooed in the order you arrived. That was why it was best to get there early unless you wanted to wait all day. Nowadays studios also offer consultations, which I think is a bit rich. The only consultation I ever had in a tattoo studio was when the guy said he didn't have time to do my cover up and told me to have a bird done instead!

I used to love it when I parked my car and then walked down to my studio, as I came round the corner, I would see one or two people standing outside waiting for me; fantastic. Unfortunately, those days are gone now, it's all done by appointment.

So, no appointments and no consultations. How on earth did we manage, you might ask? Well, people tended to sort themselves out – under my watchful eye – and there were very few arguments. It was like *brothers in arms*, you were all there for the same reason. There was a camaraderie that would build throughout the day. You'd have: bikers, skinheads, casuals all sitting in the same room chatting and laughing; offering each other cigarettes and getting on like a house on fire.

Put them all in the same pub on a Saturday night though and you might have a different story.

That was the life I lived, the life I loved and I made the most of it. Life has its troubles and worries for sure but when I was in my studio with my customers I was in the zone. I was king of my castle and I considered myself privileged to be in the position I'd made for myself.

I made sure I remained humble at all times; that's the most important thing. Some artists find the attention, praise and admiration too intoxicating and they begin to think and act like they are rock stars or celebrities. They turn to drugs, start dressing like they're going to go on stage and get into all sorts of weird shit. I used to see it at some of the shows. A guy would win a Best Tattoo award and the next year he'd turn up with a new wacky hairdo, dressed head to toe in leather and studs with a full entourage! Yes, you can become a little bit of a celebrity but only on a very small and local level because everyone knows the tattooist in town. Celebrity came with the job – it's like boxers – everyone wants to say they're your best friend. Well, that's great, but like I say, handle it with care because your reputation as a person is always at stake. Remember, no one likes a big head.

I did enjoy my time at Air Street and it was in a great position but I still wanted to find a place that had its own shopfront and a lease so that I would be more secure. There were a few more tattoo studios slowly opening up in Brighton but this didn't concern me too much as Brighton was a big town and there was plenty of room. I had a lot of people coming to me who liked my style. As I have already mentioned, I was a great fan of Japanese art and their style of tattooing: big, bold and colourful and I had a lot of regular customers with exactly that sort of work on the go.

One of the newer tattoo studios was situated down at the bottom of North Road. Somebody mentioned to me that they had seen a, Lease for Sale sign up on the outside. Obviously, business wasn't going so well. I went down to have a look and sure enough there was a For Sale sign.

Wow, this could be just the opening I was looking for. I hadn't even known it was there. I went in to ask about taking over the lease.

As it turned out, I knew the guy whose studio it was. I had tattooed him a few times in the past. He said he was having trouble paying the rent and had to try to get rid of the lease so he could get out of the agreement. We worked out a deal where I would take over the lease and he would come and work for me and pay me a percentage of his earnings.

No way was I going to have another partner after my disastrous experience with my brother. It would be MY studio and he would work for ME. His work wasn't that brilliant but it was better than Steve's. I also had another friend who had been practising tattooing and wasn't doing too badly. He wanted to start work at a proper

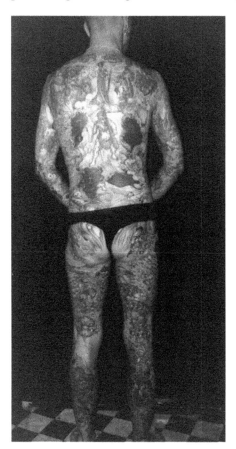

28a. Phil, my first bodysuit customer

studio so I said he could come down and also do a few days a week if there was any work going spare. So now that made three of us at the Blue Dragon.

I handed in my notice to Tony at the barbershop and after a few weeks, I had signed all the legal documents, said my goodbyes and moved the Blue Dragon down to the bottom of North Road. I finally had my own place with a lease and as long as I paid the rent on time, I could stay there for as long as I wanted. I also had my first staff members. Progress at last.

I was starting to do a lot of sleeve work and I also got started on my first bodysuit. It would be the first of five that I would complete in my career. Bodysuits are just that: they are when somebody gets tattooed – literally – from head to toe. The style originated in Japan – the Japanese Mafia – the Yakuza are known to cover their whole bodies with tattoos. Bodysuits are the ultimate in tattoo cool. When you actually get to see one in the flesh it is almost hypnotic.

120

It looks like a skin-tight costume that fits every curve and angle of the body perfectly. The guy I did my first suit on, Phil, only had a few old tattoos on him when he first came in. He started with sleeves, then progressed to a large back piece, then his legs were done and finally his ribs and stomach. All in Japanese style designs. He used up pretty much every dragon, flower, carp and geisha girl design that I had in the studio at the time and the rest I did freehand. It was great practice for learning how to fill in the gaps between designs which you have to learn to do yourself, because transfers won't usually be the right shape to fit the space.

Phil came in every Saturday, without fail, for two and a half years and had two to three hours of work each time.

We got sick to death of each other!

I'm joking of course. There's no other customer relationship that compares and you get very close. I can't remember him moaning about the pain ever. Some areas of the body, such as the ribs, backs of the knees, armpits and inner thighs can be a little bit tender to say the least. When I would be working on any of these areas, I would ask him how it felt and he would just say, 'Yeah, it's a bit hot.'

You can't help but admire human doggedness and sheer perseverance to get a job done.

He ended up being my *showpiece*, meaning whenever he was around and I wanted to impress someone with some of my best work I would make him strip off and show everyone.

Wherever we were!

He always got a great reaction and even though he was one of the shyest guys I've ever

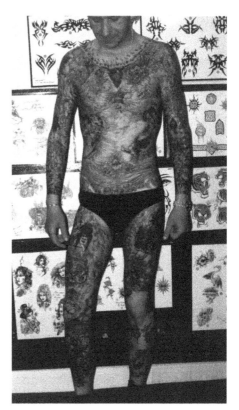

28b. Phil, my first bodysuit customer

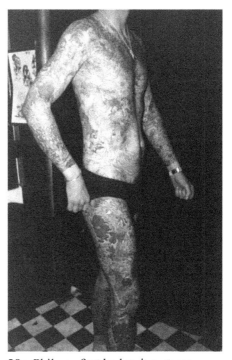

28c. Phil, my first bodysuit customer

121

met, I think he secretly enjoyed the attention.

There was one very bizarre incident though and neither of us could figure out why it happened. One Saturday when he came in, I was off sick; so he had a small piece done on his leg by one of the other lads just for a laugh.

While having it done, he only went and passed out, didn't he? Hilarious. I really ribbed both of them about that after all the work he'd already had done by me. I was obviously the gentle one of the trio.

There were lots of other regulars coming into the Blue Dragon by now – all having large pieces – and we were starting to get a very good reputation.

By now, it was the start of the 1990s; there were a lot of tattoo conventions, or expo's taking place. Always on a weekend and usually at the beginning or the end of the year; during the slower periods. Lionel Titchener, from Oxford, a tattoo artist and tattoo history fanatic and founder of the Tattoo Club of Great Britain, started running them regularly at different venues each year. I always tried to make sure there was a Blue Dragon of Brighton presence at every one, either with a tattoo booth or just a load of us travelling up to attend. They were always great fun and they gave me the chance to meet other artists and to make new friends and to show off a bit if I had a booth. Always with my faithful Phil as my right-hand man.

Tattoo expos are very nerve-wracking when you first do them because you know there are going to be an awful lot of other pro-tattooists walking around ready to criticise anything you do that they don't think is up to scratch or that they think they could do much better. The secret is obviously to bring along your A-game, be careful what tattoos you agree to do and put on an experienced professional air at all times. No getting rat-arsed and doing a striptease up on the main stage in front of everyone! Yep, I've seen that happen.

There's nothing worse than setting up your booth and then sitting there for most of the weekend twiddling your thumbs and not tattooing anyone. It makes you look inferior. I learnt a good trick early on – to take someone with me – there were always plenty of us from Brighton attending. Someone who would be my first customer as soon as I had set my booth up. That way – once you were in action and the machine was buzzing – it would draw lots of people over to watch. I always made sure it was a choice piece I really wanted to do, so then I could show off a bit and would always do it for free. Once you are up and running, this spurs other people on to want to get tattooed by you; especially if you are nailing it with your starter piece.

Pretty soon you'd have three or four people lined up and could find yourself working for the whole two days, which people love to come and watch. I enjoyed myself tremendously once I'd got my initial nerves out of the way. It was like performing on

a stage; particularly if you heard some high praise for the piece you were doing. Sometimes I would look up and the customers would be three or four rows deep around my little booth. All trying to get a look at what I was doing; wicked.

I also made sure that there was always plenty to look at to attract people over to start with. I would make a large banner before the weekend with: Blue Dragon, Brighton, in big, bold lettering with a giant Japanese style dragon airbrushed onto it, which I would hang up behind me. I would take up sets of my tattoo flash to sell and also have any nice canvases that I had painted propped up against the wall; some that would get bought. I had a large plastic model of the Cenobite from the *Hellraiser* film series, that I'd painted up on display one year and someone even bought that!

29. One of the cherubs I would sell at Expos

Sometimes if I'd had time to prepare, I would sell little tattoo painted plaster cherub's that you could hang on the wall. I always sold out of these and would often get people coming to my next show and heading straight to my booth to get another one. It could be a feeding frenzy sometimes if you did it right. Great fun.

Another great set of shows, which ended up being sell out affairs, were actually called, Tattoo Expo. Lionel's were more sober affairs like conventions.

The expos were run by a collaboration of four tattooists called, Tattoo Inkorporated. The four were, John Williams of Southampton, Ian of Reading, Brent

30. Business card, Ian of Reading

31. Business card, Lal Hardy

32. Edition 4 – 1991 – Tattoo Buzz, Secretary, Lal Hardy

Eggleton of Dunstable and Lal Hardy of London. They were held at the Queensway Hall in Dunstable near Luton, a very large convention centre. Most years there would be three to four thousand people attending over the weekend, with the queue to enter stretching around the building. I think these shows were the ones that really brought tattooing to the public's eye. They were the epitome of tattooing's Golden Age. There would be up to thirty tattoo booths from all over the world, entertainers of all sorts and rock bands. There would also be competitions for all different styles of tattoo with trophies for the winners and they were very popular. I managed to get a booth four years running so I got to know all of Tattoo Inkorporated quite well. Ian of Reading, in particular, was a bit of a hero of mine.

The last, Tattoo Inkorporated tattoo expo ever held was in September 1999, as the Queensway was due to be demolished. It was emotional for all involved. I was lucky enough to have a booth at that one. If the Queensway hadn't been knocked down to make way for a new Asda, I think they would have gone on for many more years; they were so popular. Happy days.

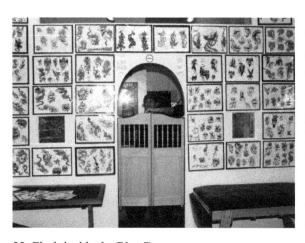

33. Flash inside the Blue Dragon

I haven't been to a tattoo convention for many years but they are now all over the country and still very popular. If you can win one of the tattoo competitions it is a large feather in your cap that's for sure. I still have a t-shirt from the 1991 Tattoo Expo which I'm wearing on a YouTube interview I did not so long ago. It's now over thirty years old! Quality merchandise, eh?

I managed to do a bit of travelling abroad with my tattoo gear at this time as well.

There weren't many tattoo studios in France at this time, only in Paris and some of the larger cities. Close to Brighton is Dieppe, a short ferry ride across the English Channel from Newhaven. As there were no tattooists in Dieppe, I would often get visitors from there to the Blue Dragon to get tattooed. I was very honoured that they would bother to take the trip. One young lad in particular, Henri became a very good customer of mine (Henri's tattoo photograph accompanies Chapter 9). He had missed the UK craze by a few years and he was a French skinhead. He would come over once a month with a few of his friends – they couldn't speak a word of English – and I could only manage schoolboy French. Regardless of the language barrier we always managed to have an absolute whale of a time and Henri ended up with two sleeves and a backpiece and we became very good friends.

It's amazing that tattoos can universally bond people without the need to even speak the same language. Henri is a perfect example of how powerful they can be. Another of my Dieppe customers was an English expat called John, he owned a cafe in Dieppe and was a fearsome character. He played rugby for a local French team, an Englishman playing rugby in France? That's how tough he was. His nickname was Le Hooligan, and I can imagine he was just that. He made a few trips over to get tattooed and one time he invited us out to his cafe for a tattooing weekend.

He got a load of customers ready for us and we went over and tattooed them all weekend in a back room of his cafe. I was a bit sceptical at first because I wasn't sure how it would go down with local officials if they found out, but he said not to worry it would be a great laugh.

Well, it turned out to be exactly as he said. We set up shop similar to a tattoo booth at a convention with banners and flash. There were loads of people waiting to get tatts off of *zee Englishmen* all weekend. We decided to stay a couple of extra days for a bit of sightseeing and to spend some time with our newfound friends. We even went to Euro Disney which had only recently opened. We ate and drank out every night; I hardly slept the whole time.

One incident of note certainly livened things up a bit though. It was our last night there, it was fairly late and we were in a bar having our usual raucous time and there were some locals looking over at us giving us some dirty looks, especially one greasy haired guy with a beard who was looking at me. They obviously weren't big fans of the English. Nothing came of it though and they eventually left. Not long after, me and my one remaining French drinking companion, decided to leave as it was getting late and I had to catch the early ferry in the morning. We headed back towards

my hotel and we had to walk through a kind of market square. There were still a few people about and suddenly I noticed Greasy Hair and a couple of his mates, oops. They saw me and immediately started shouting at me in French, mainly Greasy Hair. I didn't have a clue what he was saying but judging by his manner and his volume I knew it wasn't complimentary. He was spitting and screaming as he got up and came towards me.

I wasn't really up for it as I was a bit out of practice and had been having such a good time, but it looked like I'd have to do something pretty quick. Then – just as I was squaring up – there was a blur of movement past my left shoulder and somebody charged headlong into Greasy Hair; landing one hell of a punch and knocking him down in a heap. His other friends ran off as fast as their legs could carry them. I was pretty speechless but even more so when my guardian angel turned round. It was Henri!

What a coincidence; I couldn't believe my luck. I had thought it would be great if I could meet up with him while I was in Dieppe but had no way of getting in contact. He'd obviously been sitting somewhere in the square – heard the commotion and the anti-English diatribe – came over to have a look, recognised me as the one in possible danger and taken drastic action. I shouted with joy and we both laughed and hugged at our unexpected reunion with Greasy Hair laid out flat on his back, still out cold. My French friend and I ended up walking back to his apartment where we sat up drinking Pernod 'til God knows when, laughing and joking in drunken sign language. My head the next morning felt as bad as Greasy Hair's must have.

All in all, my trip to Dieppe was a brilliant adventure, especially my last night. But the ferry trip back to Newhaven in the morning was one to forget, rough seas and a Pernod hangover. I haven't drunk Pernod since.

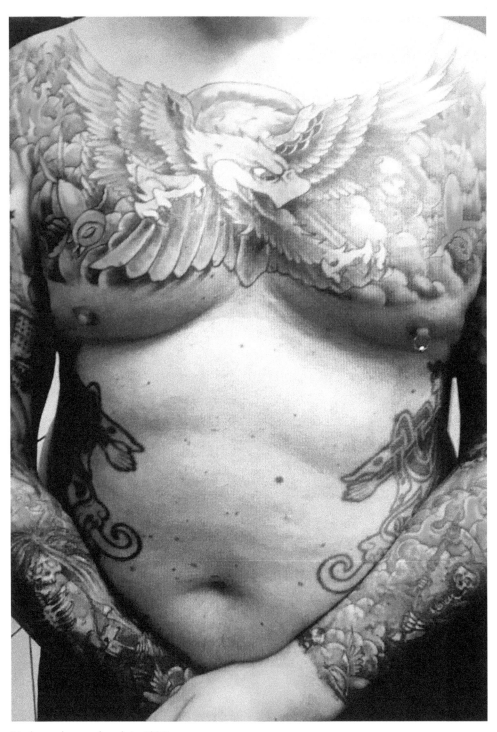

Various pieces, circa late 1990s

Chapter 10: *Taking it across the pond - America*

I've always loved America and I still do. It's the land of opportunity where everything is bigger. Even the sky looks bigger when you are travelling about because of the immensity of the open spaces. It's a strange phenomenon but true.

I've been all over the USA: holidays at Disney, New Orleans, New York, Arizona and sightseeing marathon drives from the East to the West coast. I even got married in Las Vegas, yes marriage number three. I am Ross from *Friends*! That's the last one though, I promise.

The people in America are great – well most of the ones I've met. If you are a Brit in America, you are usually welcomed with open arms. They love the English accent, especially where there aren't many English tourists and those are the parts I particularly like to visit.

'Oh, my Gaad, aah just luurve your accent!' I've heard it many, many times and it always makes me smile.

34. Business card, Micky Sharpz

Alongside Great Britain, North America was the only other country where tattooing was starting to get very popular in the 1990s. The styles were similar but the American colours were better than what we had over here at the time. They were much brighter than the UK colours and as coloured tattoos were very popular, people wanted the brightest colours available.

Tattoo colours at this time were still fairly basic. Apart from the black ink they came in fine powdered form and you had to mix them up yourself. The recommended dilutant was Vodka and a little dash of rose water. The early colours were very grainy with fairly large particles which made them hard to get into the skin, but manufacturers were gradually finding out that if you ground the powders down a few more times, you'd get finer particles. Then the mixture would be easier to get into the skin and the colours would be richer and more vibrant.

Micky Sharpz, the machine maker from Birmingham had brought out a range of inks which were the best around in the UK at this time. Along with soldering up my own needle sets, mixing up the colours was one of the worst jobs. Dust would go everywhere and if you didn't do the mixing outside, then every surface in your kitchen would soon be covered with a clinging film of multicoloured dust.

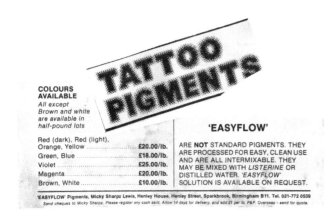

35. Mickey Sharpz, Easyflow pigments advert

Then along came pre-dispersed inks. As far as I know the USA was the first country to use what are called; pre-dispersed colours. A pre-dispersed ink is composed of pigments with much smaller particles, so these formulas tend to be thinner. The inks always come ready to use straight from the bottle which eliminates the need for mixing at home. You still had to shake the bottle well before using them though. The first time I got hold of some of these inks I noticed the difference straight away; they were excellent, finer particles of pigment and were therefore very easy to get into the skin.

It was possible to get hold of American tattoo equipment from companies like Huck Spaulding Enterprises and Guideline but delivery took a long time and sometimes they wouldn't ship stuff abroad. Where was Amazon when we needed it?

There were lots of tattoo conventions being held all over America, far more than over here of course. They even held one on the Queen Mary liner that was dry docked at Long Beach, California and I was desperate to get to go to one. After lots of research it seemed that one of the best ones, especially for Brits, was the Mad Hatter's Tea Party, tattoo convention up in Portland Maine. It was organised by a British fanatic called Lou Robbins. One of the most pleasant people I've ever had the pleasure to meet. He particularly loved Alice in Wonderland, hence the name.

On one of his visits to England, Ian of Reading had tattooed a full back piece on him of the Mad Hatter's Tea Party, a fantastic piece.

TATTOO INTERNATIONAL

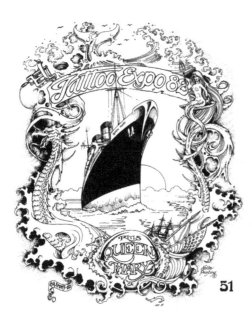

36. Tattoo International – Tattoo Expo 1982 – RMS Queen Mary

130

One year at our Dunstable expo, I managed to bump into Ian and I asked him if it would be possible to get a ticket to go to the next Tea Party convention in February. He said he would love it if I went along, so I gave him the money for two tickets and he said he would send them to me when he got back to Portland.

I heard that a few British artists regularly went to his show each year and had booths there. Having worked at an American convention and if you were lucky, it was very likely that you would get asked to do a guest spot in a USA tattoo studio. Once I discovered this, I was determined that one year I would have a booth and hopefully bag myself a guest artist spot somewhere in the States; I didn't really care where. My plan was to check the show out in February and see what it was like and then arrange to get a Blue Dragon booth the following year. If I could pull it off, I would have really hit the big time as far as I was concerned. Guest spots in the states were very rare indeed.

February eventually came around – I'm pretty sure it was 1991 – and my partner and I boarded our flight from Gatwick Airport to Portland Maine via Boston.

Excited wasn't a strong enough word to describe how I felt; I was finally going to do this. As we flew over the Atlantic Ocean and then over land, I looked out of the window and everything was pure white – of course it was wintertime. I'd only been to Disneyland and the hotter parts of the USA a couple of times before and as we came in to land the pilot told us it was -10° outside! I did have a coat, but -10° is really cold. My eyebrows and all of my piercings froze up and felt as if they were burning!

I eventually grew to love the freezing cold weather at the Mad Hatter's Tea Party because it was like a late Christmas; we hadn't had proper snow in Britain for years.

Everything went on as normal because they were used to being snowed in for months at a time. The piles of snow that had been ploughed up off the

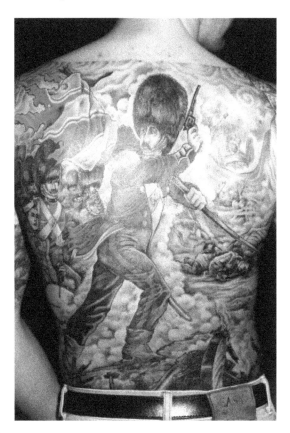

37. Inspirational back piece – show winner Tattoo Inkorporated Expo, by Ian of Reading

131

roads reached the tops of the lamp posts and if I walked outside for any length of time all my facial piercings would freeze up and burn my skin, cool, eh?

We were booked to stay at the actual hotel where the Tea Party convention was being held, so this was another excellent bonus. The hotel was full of tattooed men and women walking about. As soon as anyone heard us speak we drew quite a bit of attention. We got all sorts of invites to parties in hotel rooms and to eat in the restaurants and buffets. They were a very friendly bunch and made us feel very welcome. I loved it from the minute I got there.

I thought the best way for me to make a friend of an American artist and to get my foot in the door was to get a piece of work done by someone; that way we could spend some time together and get to know each other.

The Tea Party was three days long: Friday, Saturday and Sunday, so plenty of time to execute my plan. We weren't allowed in the actual convention hall before Friday morning but I had managed to get a few glimpses inside. I saw everyone setting up and it all looked really promising.

Friday morning came and we went down and took our places in the queue to get in. There were loads of people there already. I hadn't seen Lou yet but he was on the door as we walked in and he was very happy to see we'd made it; he said if there was anything we needed just to ask. Walking into the convention hall for the first time was fantastic. Like I said earlier, everything in America seemed bigger and it sure was. The booths were covered in gaudy tattoo signs: Lone Wolf from California, Psycho Ink from Detroit, Ed Hardy, also from California, Jack Rudy from Arizona, Guy Aitchison from Chicago and Eddie Deutsch from Philadelphia to name a few. Some I'd heard of, lots I hadn't. I was hypnotised and we just wandered around aimlessly for the first few hours soaking up the atmosphere. It was helpful that I had done quite a few nice tattoos on my partner and we were able to show them off at the show and they went down very well, so I was able to prove that I was an artist and not just a visitor.

There were a couple of Brits who had booths, Kevin Shercliff and John Sargeson from the midlands and Andy Neville an expat who had a studio somewhere on the west coast. They all seemed to be doing a good trade already.

After a break for lunch, I decided to have a look to see who I'd get to do my first USA tatt and – unbeknown to him – be my potential ticket to get myself a guest spot somewhere. I talked to quite a few artists – not giving anything away just yet – and finally decided to get Paul 'Bizarro' Massaro from Buffalo, New Jersey to do my first piece. He was pretty *out there*, but very relaxed about the whole tattoo scene and we hit it off immediately.

I decided to get a skull on my left middle finger as I had nothing on my hands

yet. It took him three hours! He only used a single needle so the going was slow but I enjoyed talking to him very much and learnt a lot about how things worked out there.

38. Mad Hatter's Tea Party, Portland, Maine, 1991

He told me that tattooing was illegal in some States such as New York and Massachusetts, which surprised me. When my tattoo was finished it looked very cool and I loved it, but my finger had swollen up quite a bit. Who cared? I now had my first genuine American tattoo made with the renowned pre-dispersed inks.

I spent quite a bit of time with Paul that weekend and we became good friends over the years but I didn't manage to sort out any kind of guest spot that year because he was in the middle of moving studios.

I also spent a lot of time over at the Brit booths, we all stick together and all that, don't you know? Kev Shercliff was hilarious and had been a few times and seemed to know everyone who walked past his booth. He is a very talented artist and was doing a roaring trade.

John Sargeson was also a fantastic guy; we hadn't met before but he said he'd seen my booth at the Dunstable Expo a couple of times and liked my work. John said that he had a few tatts booked in for the next day, the Saturday, but didn't think he'd be able to fit them all in. So, would I like to do a couple for him? He had some spare equipment I could use and there was enough room in his booth for me to set up.

Did I want to do a couple for him!? I

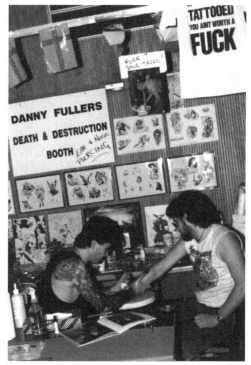

39. Booth at Dunstable Expo, 1993

could have kissed him. Damn right, I was itching to have a go. So, to cut a long story short, I set everything up and ended up doing five tattoos on American soil at my first ever USA tattoo convention over the Saturday and Sunday. Lou didn't mind at all,

'The more the merrier,' he said.

I was on cloud nine the whole time; it was a total adrenaline rush. Without a doubt and the best holiday I had ever had. My customers were great and loved what I did. I really tried to take it to the next level, seeing as I was surrounded by such inspirational people in such a fantastic environment.

I was really, really grateful to John for giving up some of his booth space and customers so that I could have the busman's holiday of a lifetime. It was so generous of him and I'll never forget that there are few people in this world who are willing to give you an opportunity like that.

So, all in all, my first Mad Hatter's Tea Party was an absolute blast; I didn't manage to get myself a guest spot in the America A pretty tall order looking back on it. But I never expected to do any actual tattooing out there on my first trip to a convention and now there were five Yankees walking around sporting Danny Fuller artwork. I couldn't have been happier.

Before I left, I booked a space for the next year with Lou and gave him a deposit. I was in – and next year was going to be even better – I was going to make sure of that.

When I got back to the UK I don't think I stopped talking about my week away for at least a month and I must have bored everyone to death, but I was buzzing.

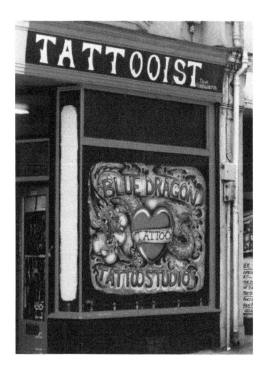

40. The Blue Dragon, 1991

My experience also helped add to my confidence as a tattoo artist, I had seen a lot of great work at the Tea Party which inspired me greatly. I started to work with much more vigour and purpose and that's what those kinds of trips are all about. I had also brought a set of pre-dispersed inks back with me from the show that I couldn't wait to use, and they helped take my work to a higher level than before.

Business was doing pretty well at the Blue Dragon now. We had a good system and a good bunch of regulars, so everyone was happy. There were so many characters in Brighton as you'd expect and I think we got to tattoo most of them. There were a few more tattoo studios opening up each year but they didn't seem to affect our

trade unduly as everyone knew the Blue Dragon in Brighton by now.

We and our loyal crew would go to as many shows as we could. We went to Birmingham, Bristol, Blackwood in Wales, Portsmouth, Derby and many other places. They were a great excuse for a weekend away and a chance to have a laugh and relax with some of our most loyal followers. We'd always make the most of it and we got to see quite a bit of the country.

There's nothing like being in a town or city when the tattoo convention is on; for once the local non tattooed people are in the minority. For that weekend every cafe, fast food outlet and pub are crammed with heavily tattooed fanatics. The streets are full of groups of wild-eyed warrior types walking around dressed up in their best warpaint and finery. People who knew they stood out from your average citizen were making the most of these rare opportunities to show off and to get together all in the same place at the same time. There was never any trouble and everywhere you went the atmosphere was incredible. It felt like you were part of an ancient tribe or culture that was visiting for a short while before moving on to peacefully conquer the next destination. You all had a shared interest, a look in common, the love of permanent body art. In some mystical way you felt a primal bond just by being around each other. A tribe. Even though you lived many miles apart most of the year round. There was comfort in the fact that wherever you went, you knew that someplace, somewhere you had brothers and sisters who had gone through similar, age-old rituals, to earn their place in that tribe. And for these brief gatherings you were going to celebrate your lives to the full and make the most of them.

It was a great scene to be a part of. Something the average person in the street couldn't comprehend.

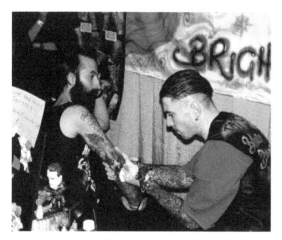

41. Mad Hatter's Tea Party, Portland, Maine, 1992

42. Tattooing Chris Achilleos' - fantasy artist - fingernail

I started to paint canvases on my days off. Even though the two styles of art were completely different, I found all the tattooing I was doing day in, day out helped me to become a better all round artist. I had always wanted to be able to use oil paints but they were very difficult to get on with. They take a long time to dry and if you try to do too much at once then you ended up smudging what you had already painted and that was very frustrating. I was heavily into fantasy artists like Frank Frazetta and Chris Achilleos, the Conan comics and of course Marvel and DC comics and I wanted to try to emulate their style.

I also admired the old masters, like Rembrandt and Caravaggio and would often take the train up to London on a day off and visit the Tate or the National Portrait Gallery and spend hours there just staring at their work and trying to decipher just how they had gone about creating such masterpieces.

Another summer passed by and then it was just a case of getting through the September blues, enjoying Christmas and then getting ready for my now favourite time of the year. February, and my next trip to the Mad Hatter's Tea Party.

It couldn't come round quick enough. It was 1992. This year I had my own booth booked. I had also tattooed a complete back piece on my partner, fantasy style which had turned out very well and we were going to enter it in the Ladies Large Piece tattoo competition, so that would be exciting.

This year's Tea Party was held at the same hotel in Portland Maine. Maine is a state in New England. This is a lovely part of America; it was originally settled by the British and most of the town and City names are old English: Dover, Portsmouth, Arundel and Wells to name a few. It's also by the sea and the town and seafront are a lot like Brighton.

Walking in through the hotel entrance was like returning home. There were a few faces we recognised and they all seemed to remember us and were very welcoming. By this time I had my signature two gold canine fangs put in, they are permanent crowns. So, what with those and my large flesh tunnels people did tend to remember me! Especially when I smiled.

The British, being a pretty reserved race of people, have never really said a lot about my fangs. Some people do comment if they're feeling brave, but on the whole, I tend to forget I have them. But the Americans, oh my God, that's a completely different kettle of fish! Their reaction went from mild recognition to a complete frenzy. I've posed for more photos and selfies than some of the royal family I would bet. It took a bit of getting used to at first because I never really thought about that side of it, they just seemed like a good idea to have done at the time. Being a tattoo artist, you can choose to look how you like, the madder the better at times. If you came into

my studio and I was sitting there wearing a suit you'd think I was a bit of a weirdo. Bizarre, isn't it? I also had my tongue pierced at the time and my labret, a lower lip piercing, so I was pretty recognisable and wouldn't get far if I ever had the misfortune to be featured on Crimewatch.

I couldn't wait to go into the hall and see where my booth was going to be. Walking around I eventually found it, there was a large sign on the table with: Doug Fuller, Brighton UK. Doug Fuller! There was a copy of the local Health Certificate stuck to the wall as well, with Doug Fuller on it. I had to laugh. Just at that moment Lou the organiser came walking past.

'Hey Buddy! You got here; everything okay?'

'Yep, no problem, but my certificate, it says Doug, I'm Danny I told him.

'Oh goddammit! I knew it was one or the other.' he said. I wondered if I had to show my passport as ID, which could have been tricky but he said not to worry about it, so that was all okay.

So, for the whole weekend, all the other Brits took great pleasure in calling me Doug whenever they could.

On Thursday night there was the usual pre-Tea Party meal and get together for participating artists, all complimentary which was great. There was a ton of Maine lobster which is very nice and a local delicacy and it sure felt great to be back amongst old friends.

Friday morning came and I soon had all my stuff set up because you have to travel fairly light if you are travelling by aeroplane. I just had a small carry case of equipment and some folders of tattoo flash. Looking around I felt a little inadequate, the Yanks being Yanks, had brought trailers full of stuff: every shade of colour available, computers, printers, transfer machines and hydraulic chairs. Everything they had at their studio they had brought to the show.

I was quite jealous but had to settle for being, 'Oh how quaint.' as one lady said as she walked by.

Oh well, I was still going to do my best and put on a good show.

I started with my usual ploy, I did a small delicate piece on my partner to get the ball rolling and as the public came in and started filling up the hall, I soon had my next tattoo booked in. They all wanted a souvenir piece from London, England. Being a foreigner never felt so good.

As expected, it was a fantastic weekend. I never had anything but a brilliant time at that show, thanks to Lou Robbins and his great organising. I did quite a few tattoos, made loads of new friends. Had a great laugh in the evenings when the work was done and we even got a Certificate of Merit for my partner's back piece. I was

definitely going to come back in 1993 and couldn't wait.

I still hadn't had the opportunity to get myself the guest spot I was hoping for, but that would happen sooner than I thought.

43. Me and Jack (US) in Dover, New Hampshire

44. Getting my leg tattooed by Jack, Mystic Dragon

I brought a load of stuff back with me from the States again. Tattoo flash, t-shirts and a load more pre-dispersed inks so we had a lot of things at the Blue Dragon that weren't available anywhere else in the UK. All the t-shirts soon got snapped up and the inks went down very well with my customers.

A few months into 1993 I got a letter from the States, it was from a guy called Jack, from Dover, New Hampshire. I had done a large Viking piece on him at the Tea Party and a small piece on him the year before when I was sharing John Sargeson's booth. He was a proper fan and loved my work.

He owned the Mystic Dragon Tattoo Studio in Dover, New Hampshire. He had got my address from my business card. He included a load of photos in his letter, of his arm all nicely healed, and his studio, general shots of his work and some of his locals. He was writing because he wanted me to do a guest spot at his studio and meet all his buddies the next time I was over in the States!

Wahey! This was it!

I remembered Jack and we had got on very well. He was a great big bear of a bloke, a biker and very amicable so I immediately agreed.

The way guest spots worked back then was: I would pay for the flights but everything else would be paid for by the studio i.e. food, board, and taxis etc. I would tattoo in the studio and they would keep

138

any money charged. Being a non-resident, I wasn't allowed to make any money for my services. It would be classed as an advisory role. Sounds posh, eh?

So basically, it was a free holiday apart from the flight. Well that suited me fine. I was more than excited. We wrote back and forth a few times and it was arranged that I would go to the Tea Party again the following year, work at the show and then go down to stay with Jack and his wife Stephanie for a couple of weeks and do my guest spot at the Mystic Dragon. It sounded brilliant. What an opportunity? I would never have had the chance to do anything like that if I hadn't made the big leap of independence and set out on my own. Why, even a lot of the established British tattoo artists hadn't had the bottle to go to another country and get stuck in among the locals and show off their skills. I was determined to make my country proud.

After all this excitement and positivity – with all these new opportunities opening up – I thought I really had to bite my lip and try not to go on about it too much at the risk of making everyone jealous and becoming a bit of a bore. I've always felt this way, but no harm ever comes from it. I've learnt that even though we make our own way in life, through our own endeavours, sometimes people get the wrong idea and think you have been handed everything on a plate and all your good fortune comes to you out of pure luck alone. Have you ever found yourself telling people about something you've been doing recently – where they're all ears at first – and then the more you tell them the less interested they become?

Yes, we all know that one.

Well, I've never had anything handed to me on a plate. I was the one that went off and got myself tattooed; a risky choice when I did. I was the one who left a steady job to go off on my own. I took on an extra job to earn the money to blow on a load of equipment when I didn't know I'd ever be able to make use of it. I took the gamble to embark on a far from ordinary career that was in no way guaranteed to bring me success or financial security. I could have just sat there at home doing the odd tattoo on friends in the evenings and making a few quid now and then and carried on my miserable life as a factory worker. It was me who had taken the decision to do things legally and properly and see how far I could go with my new idea. I was the one who had started out on my own – in a room not much bigger than a toilet – and had now got myself a studio on a busy main road in Brighton with a guaranteed twenty-year lease and two other artists working for me. I was the one who had got myself over to America and forged my way to end up being asked to work in an established tattoo studio there. No one did any of this for me. I went and did it all myself.

So why are some of us stupid enough to feel guilty for becoming successful? For getting up off our arse, grabbing the bull by the horns and getting on with life? We

all have limited time on this earth and the more time we spend thinking about things and putting them off, the less time we have left to actually do them. It's important to develop the strength of character to have confidence in your own decision making and once you've made your decision you must totally believe in it and push with every bit of energy you can muster until you succeed.

Or someone else will do it before you.

Once you go so far, momentum starts to build and you have to keep it going. Willpower is a hard thing to master, but you have to have the willpower to keep going and never give up unless you find out that the thing you're trying to do is either just too difficult or not really the thing for you after all. You do get thrown the odd crumbs here and there – John Sargeson letting me share his booth for instance – but it's you that has to put the effort in to carry on making more opportunities for yourself. And when things start coming together and you are beginning to reap some rewards you should feel able to step back and give yourself a pat on the back.

But best to do it quietly in the privacy of your own home!

All in all though, the rest of 1992 was pretty awful. Other than my partner became pregnant and in June of that year my son Charlie was born. That was the only other good bit! We had been together for a few years and seeing as she was pregnant, I decided to do the honourable thing and ask her to marry me. She said, yes and became Mrs Fuller number two.

Unfortunately, the less said about that marriage the better and things went decidedly downhill after Charlie was born. We separated very soon after getting married and both went our separate ways. It was another extremely upsetting time

45. The Blue Dragon – tattooing was my saviour

for me as I loved her very much and was really looking forward to doing the family thing. But it was not to be. Once again, I was in the deepest of dark places, but this time my tattooing was there for me and came to my rescue. If I hadn't been able to go down to the Blue Dragon during the day and spend all my time with my customers and friends, I don't know what I would have done. Tattooing was my saviour, my happy place. I could be in the deepest of depressions sitting there at home, but once I got to the studio and started

working on a tattoo, I would lose myself in the job. I would be in *the zone* and I'd forget about my troubles on the outside. Nothing else mattered. I am so grateful to have had that in my life. Imagine if I'd still been working at the factory? I don't like to think about what might have happened. It was one of the unhappiest times of my life.

They say these things are sent to try us and they sure did. Life goes on and just sitting there moaning won't get you anywhere, so I dug deep and put all my energy into the Blue Dragon, my tattooing and keeping my plans going to advance myself in the trade.

My third trip to the Mad Hatter's Tea Party in February 1993 couldn't come round quick enough. Unfortunately, there was a lot of shit going on between my partner and I over our break-up, she had found someone else immediately – hmmm – and had set up home with him. She was making it difficult for me to see Charlie and to have him with me over the weekends.

One weekend it all got a bit too much, so I decided it was too toxic to carry on down this road and it wasn't doing anyone any good. I decided as Charlie was only six months old, he wouldn't know too much about these times and eventually things would sort themselves out. Which of course they did. Her new guy disappeared and I was able to be a father to my son. All's well that ends well.

Now, before I get on with the story of my experiences as a guest artist working in America, I have to tell you about some worrying incidents that happened leading up to my departure for the States.

I was at one of the UK conventions, when there was an announcement over the PA. It was about the shocking story of a British artist called Peter, who had taken a similar path to the one I was about to take: working the Mad Hatter's Tea Party a couple of times and then being invited to work as a guest artist at a studio in America. This particular studio was situated in an area just outside Chicago called, the Badlands and the studio was owned by a biker dude called, Roy 'Boy' Cooper. He was quite a famous artist; he had brought out some of the first tattoo videos showing people actually being tattooed and loads of biker type fill in stuff. I thought they were really good and there was nothing else available at the time so I had bought most of them.

Peter had been working at Roy Boy's for a while and it was all going rather well. Until one day when a bit of trouble suddenly kicked off. Peter was in the toilet which was situated in an adjoining part of the studio. All of a sudden, an altercation started between one of the other artists and a biker customer, there was a struggle and the biker pulled out a gun. During the struggle for the gun, it went off. The bullet missed the artist but shot straight through the toilet door where Peter was sitting and hit him in the mouth, lodging in the back of his throat. Luckily for him the toilet door

took most of the momentum out of the bullet, otherwise he would have been killed, but he was still seriously injured.

The police and ambulance were called and Peter was rushed off to hospital and the biker, I would imagine, was rushed off to jail.

As if it wasn't bad enough to get shot in the face while you're a guest in a foreign land, Peter hadn't taken out any holiday insurance for his trip. So, the announcement was that there would be a collection going around for him and his family to help towards the medical bills for his stay in the hospital. What a nightmare for the poor guy! As far as I know Peter eventually made a full recovery but had to be flown back to the UK to finish his treatment as due to lack of funds, they wouldn't do anything more for him over there.

Well, that made me think a bit. People in the UK think that everyone in America walks around with a gun in their pocket and it now looked to me like they fucking well did! Peter had been working in a biker's shop and I was about to do the same. I've got to admit that it did make me a bit nervous, but I was too set on following the path and didn't really think that lightning would strike twice. I had also heard a few other rumours of guns and American tattoo studios. People just love telling you stories about things like that when you tell them you are off to work in an American tattoo studio for a couple of weeks. A worrying story, but I managed to put it out of my mind. I would get to see plenty of guns during my time in Dover, but more of that to come.

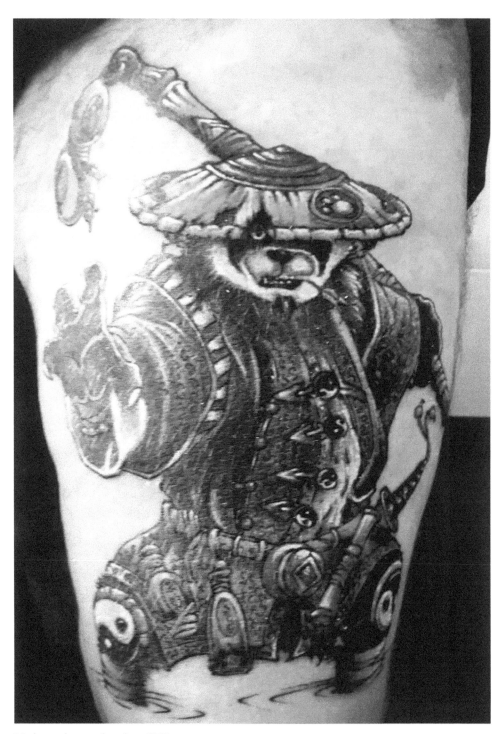

Various pieces, circa late 1990s

Chapter 11: *The wild, Wild West - Portland*

February 1993, touching down at Portland Airport – this time on my own – felt like a new beginning. It was now up to me to make the most of it and I was determined to have a good time.

I had never travelled abroad alone before so the sense of freedom was invigorating. I had packed everything I needed for my week in Portland at the show and for the following two weeks at the Mystic Dragon in Dover. I had brought a few English knick-knacks that I thought Jack would like. A miniature Bear in a Beefeater Costume and for Stephanie, a Tower of London Snow globe and a Union Jack tea towel. Perfect, the complete tacky tourist package. They would love it.

It was another great show, they'd got my name right on my Board of Health certificate too. All the usual suspects: Kev Shercliff, Andy Neville, Kev's mate Dylan Evans, a great guy from Rhyl in North Wales, who sadly passed away a few years back. By now we had got to know a few of the regular American artists as well, so it was a home away from home.

I had been able to do plenty of nice tattoos again, a lot of them on guys I had tattooed in the years before. I was amazed at their loyalty. They could have gone anywhere to get more work done, but they had waited to see if I was going to be at the Tea Party again so I could carry on with the tatts I had started. Tattooing is full of pleasant surprises.

I actually found time to get a new tattoo myself this year. I'd had Charlie's mum's name tattooed inside my lower lip a few years before and – seeing as that had now become null and void – I thought it would be a perfect opportunity to get it covered up. There was a lady who worked regularly at the Tea Party called Miss Roxy. We'd talked lots in the past. She was a Native American Indian, very pretty but rather on the large side. She had developed a bit of a soft spot for me and when I turned up this year on my own, I think she thought that meant she was getting a green light! Bless her.

We spent a lot of time together eating and drinking but nothing romantically as I wasn't really up for anything like that just yet.

I told her I wanted to get the name inside my lip covered up and her eyes lit up.

'Oh honey, I'll do that for you don't you worry!' Wink, wink. 'It'll be my pleasure!'

Gulp.

That was it then, I was going to get it done first thing the following morning.

Like I said, Miss Roxy was a little on the large side, a Native American and as strong as a horse. Was I nervous? I was shitting myself but I couldn't back out.

That night was a particularly messy one – so much beer. I somehow managed to lose my self-appointed chaperone, Miss Roxy, and us Brits all ended up in Shercliff's room drinking and playing poker until God knows what time. I eventually crashed out on his floor along with a few others.

I woke up with the hangover from hell. Silly really because I had a few tatts booked in for later, but you know what it's like. Oh, and then I realised I was getting my lip tattoo covered up by my friend, Miss Roxy in about an hour's time. Oh my God, what had I done? I reckoned it was going to hurt.

I staggered down to the buffet room, ate what I could and drank about four cups of coffee, went to the toilets and splashed cold water on my face. I still had a few hours to go until my first customer so that was okay but I was first in line at Miss Roxy's booth. I tottered to the tattooing hall doorway – took a deep breath – put on my bravest face and with my best foot forward I headed over to her booth.

'Oh, here's my baby! How are you this morning, honey? I lost you last night!'

'Yeah.' I whimpered.

'Now what are we doing again, sweetie?'

'Cover up … name … bottom lip.' Oh, my head.

I sat down. She grabbed my lip and pulled it down. I didn't know lips could stretch that far! Luckily, I had remembered to take my labret piercing out!

'What are we putting over it baby?'

'Charlie.'

'Chucky?'

'CHARLIE!'

'Oh, Chaaarrrlyy! And that's your suuun?'

I nodded.

'How sweet.'

In her iron grip, my lip was going numb and my eyes had started watering.

'I'm going to use a shading set-up so we can get a thicker line to cover it okay?'

Gulp. 'Okay.' Followed by my nervous laugh.

'Here we go honey!'

And off she went. Jesus, I thought it hurt when Frostie had done my *tattoo artist* tattoo on my wrist, but this was another level. I promised myself this was the last stupid idea I was ever going to have. It was soon done but boy, I learnt that my pain threshold was Empire State Building level that morning.

'There you go honey.' she grabbed me in a bear hug and gave me a huge kiss. 'No charge for you, my sweetie.'

'Thank you.' I spluttered.

I felt like I'd been punched full in the face by Mike Tyson, but at least I'd made it and hadn't been a wimp about it.

I hurried back up to my room to lay down for a while and see if I could soften my hangover before my first tattoo appointment that day.

As it was the last day of the convention, Jack and his crew were due to turn up, get some more work done and then drive me down to Dover, New Hampshire when the show was all finished.

Jack finally turned up around lunchtime on Sunday morning, it was normally an hour's drive but there was a blizzard which had made it difficult. A blizzard? Wow, they really got some weather over there.

The show finished a little early to give people more time to travel home. I had a fantastic time as usual and had been pretty busy again. I said my goodbyes to everyone and then packed all my stuff into Jack's giant pickup truck. Everyone has a pickup truck in America!

Unfortunately, it was dark when we set off, so I didn't get to see much of the beautiful New England scenery but I did see a wolf as it ran across the highway in front of the headlights!

Jack wanted to drop all my stuff off at the Mystic Dragon which would let me have a look at the place, so that was good. We got

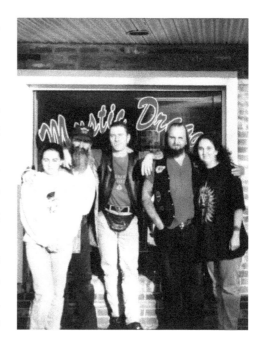

46. Mystic Dragon, Dover, New Hampshire, L-R: Donna, Butcher, me, Jack and Steph

Guest Artist

Danny Fuller

from The Blue Dragon

of Brighton , England

Working thru February 18th

Guest Piercer

Midnight Rider

"Butcher"

Working thru February 18th

Directions on back

47. Mystic Dragon, advertising leaflet for Danny and Butcher, AKA Lone Wolf Tattoo

147

there at about 8 pm. It was a very nice, clean studio on a shopping parade on Main Street. It wasn't out in the middle of nowhere which was nice. He showed me where I would be working and said they'd already booked me a couple of tatts for tomorrow, Monday. Fantastic, I was really looking forward to getting some work done here in the US and showing off a little if I could.

We sat and had a coffee; there was Jack, his wife Stephanie, their good friend Butcher an artist and Kerry their young apprentice. I loved Butcher and we got on really well from the minute we met. He had a massive grey beard and was a complete biker type. He knew everything about everything but not in a patronising way; he took no nonsense and his girlfriend was half his age. He'd done time in prison for murder a long time ago and had been tattooing on the road for most of his life. So, he was a proper character. His stories fascinated me and I could have sat and listened to him forever. He was like an old cowboy who'd roamed his way around the Wild West, just the kind of guy I was hoping to meet on my journey. I kept in touch with Butcher for many years after I stopped going out to work in the US and one year when my kids were old enough, we all travelled to the States and stayed briefly in his trailer in Arizona with him for a couple of days while we were touring around.

That night we all went out for something to eat and then Jack dropped me at the motel where I was staying, just down the road from the tattoo studio. I didn't sleep too well that night because I was very excited to finally be there after all the planning. I found it surreal to actually be in the position I wanted to be.

A guest artist in an American tattoo studio. Let's just hope my customers liked me!

I had a great two weeks at the Mystic Dragon. All the people I met were very friendly and my English accent went down very well because there were no tourists in that part of America. So, I felt like I had it all to myself. Jack was the perfect host and when we weren't working, he took me out all over the place to show me around. His wife Stephanie could be a bit hot and cold though which could be awkward at times, but he said she was a bit of a jealous type and usually liked to be boss. I told him not to worry.

The Mystic Dragon opened five days a week from 10 am to 10 pm; everything had to be booked in and paid for in advance. Opening until 10 pm was unusual, but there were a lot more people out and about over there at that time of night so it didn't matter. I loved experiencing the different culture and way of life. It was something not many people got a chance to do. I also loved the fact that after I had been at the Mystic Dragon for a week or so, I got to know some of the other shop owners on Main Street, especially the grocery store where I used to go every day to buy crisps – my weakness

– and all the different sodas that you couldn't get in the UK. They would ask me how the studio was doing and was I busy? Just as if I normally worked there.

My two weeks went by in a flash. On my last night we all went out for a slap-up meal on the house; about fifteen of us, customers as well. Great big cowboy steaks and plenty of beer. Jack asked me if I'd like to go out again in the summer of the following year but this time for longer – maybe for two months?

I told him that would be great, but the summer at the Blue Dragon was too busy to miss. So, we arranged for me to go out there on the 1st of September until the end of October 1994. This was perfect for me because I would miss the September blues in the UK and be out amongst friends in my second favourite place in the world. Jack informed me that work stayed busy all year round at the Mystic Dragon so I wouldn't be bored.

I went out to Jack's studio twice more: September 1994 and February 1995, both visits after trips to the Mad Hatter's Tea Party. Each time I stayed a couple of months so I really got to know the area. New Hampshire was a lovely place, boiling hot in the summer and freezing cold in the winter. Autumn was my favourite time of year. The colours of the leaves on the trees were the brightest reds and yellows you could imagine.

Jack and the other guys had a very good sense of humour and we were constantly taking the piss out of each other at the slightest opportunity. Usually over the way we spoke. They loved the way English people pronounced some of their words – mostly swear words. It's easy to do a fake American accent but they just couldn't do a proper English one, especially to say, bollocks. I'd be giving them swear word pronunciation lessons everywhere we went, we got a lot of funny looks when we ate out! They were also convinced that it was always foggy in England.

It was absolutely hysterical on one occasion when I arrived at the airport. You know how drivers stand there waiting at the gate holding a piece of paper with the name of their passenger on it? Well, as I walked through the gate with all the other arrivals, Jack and some of the guys were standing there waiting for me and they were holding up a banner that must have been two foot high by six feet across with WANKER written on it. I nearly died laughing. What a welcome. The looks on some of the other passengers' faces was priceless.

I travelled all over the place whenever I could. We went to country fairs, bike rallies, custom car shows. I saw Stephen King's house, which was fantastic. You couldn't go inside of course, but just standing outside was a treat. I'll say one thing for the Yanks, they sure know how to build houses!

We went to Salem in Massachusetts, the site of the famous witch trials. It was

really funny when we were walking around on a guided tour there and I made some remark and the guide, noticed my accent and quickly said, 'Oh, it looks like we have someone here with a little more experience of these things than you or I.' He was referring to our own witchcraft shenanigans from the 15th century. Salem was a very cool place, even the police cars had a silhouette of a witch flying on a broomstick for their door badges!

Jack bought me a bike to ride while I was out there which was fantastic. So, I did plenty of miles with him and his biker friends; much to his wife Stephanie's annoyance.

There was only one real downer during my time in New England – Jack's wife. It had all started off fine – all fun and laughter – but the more time Jack spent with me the more Stephanie seemed to resent it. Jealousy is a pointless emotion if you're all trying to work as part of a team. You can't blame him; we were two of a kind – almost like brothers in the end. We were both completely into our craft and had a lot in common. He told her so many times that he couldn't just leave me to amuse myself all the time as I was their guest. I would have been fine but it was nice to have someone to take you to the local places. At first, we all went everywhere together but in the end, it was just Jack and I and some of the guys, which I didn't mind at all.

They began to argue a lot, at home and at the studio. It really started to get on my nerves. On one of my visits, I was due to stay with them in their trailer, a massive caravan, but the atmosphere became so bad I decided to go back and stay in a motel. Jack was all apologetic but I told him not to worry about it. I had been getting on well with the studio apprentice, Kerry, and we started to go out a lot. Platonic of course. It was just nice to have a female friend with no pressure.

Jack booked us in to work together at quite a few American conventions, under the banner: The Meeting of the Dragons; Mystic Dragon, US and the Blue Dragon, UK. These were fun. I liked the American expos because they were such massive affairs.

One particular convention that stood out was a biker convention that Jack had booked us to work at. I can't remember where it was exactly but it was in the middle of some woods, out in the middle of nowhere. While we were packing our stuff up for the trip I walked into Jack's office to get something and saw he was cleaning and loading a handgun that I didn't even know about! They had a lot of guns – I eventually found out – there was even a case with a couple of rifles in it under the bed I'd slept in when I stayed at their trailer!

'Are you going to take that?' I asked.

'Oh sure.' he replied.

'Would you ever use it?' I asked, nervously.

'Oh God, yeah, if need be.'

What the fucking hell was this convention going to be like? I thought. I was getting a little nervous and started asking him all sorts of questions about our upcoming trip and whether it was really necessary that I went.

48. Biker Tattoo Convention, New Hampshire

'Don't worry about it,' he said. 'Steph's taking hers as well.'

Oh my God.

In our lives, we sometimes find ourselves caught up in the raging rapids of circumstances that you can't do much about. You just have to duck down, hold on tightly to the oars and hope you don't strike a hidden rock and find the whole thing capsizes. I had to sit down and think for a minute. I have to admit, I really wasn't keen on going to this place. A biker convention out in the backwoods in the middle of nowhere. With me being the only foreigner there? The more I thought about it the less I wanted to go. Kerry said she was going to go and didn't seem too concerned, so in the end I just thought, What's the worst that could happen?

I'll leave you to think up your own answers to that because I don't want this book to be *Lord of the Rings* in length!

We packed everything into Jack's pickup: tents, generator, tattoo gear … guns! And off we went. By this time, I was feeling a little calmer and even Steph seemed in a good mood.

It was a couple of hours drive to the campsite. I hadn't a clue where we were and when we got there, I was amazed. Of course, I should have known; it was America and everything is bigger. We pulled through the entrance gates and there stood the biggest marquee I'd ever set eyes on. To me it looked as big as St Paul's Cathedral, with more stars and stripes flags than you could count. The place was packed, hundreds and hundreds of bikes, bikers and biker babes. Every one of them wearing motorcycle club (MC) colours or back patches of one kind or another.

I think me and Kerry were the only ones without a beard too!

My nerves started to play up again. Don't forget, I wasn't getting paid for all

151

this. Just free burgers and beer. I looked around in awe at where I was.

Well, to cut another long story short, it turned out to be a great weekend. The little guy from England – yes, the ONLY foreigner there – went down very well and by the end of the weekend there were a whole load more US bikers and their women walking around with English ink on them than when I got there.

It was a surreal weekend, lots – and I mean lots – of the guys were walking around looking like real-life Wild West characters. Great big hats, great big coats, cowboy boots and guns in holsters on their hips. My first customer was a Sergeant of Arms for some crazy bike club, The Psycho Veterans Devil's Disciples Widowmakers, or something like that. You get the idea. He had a great big western style coat on and when he took it off to sit down, I could see he was wearing two holsters crossed over his hips with a beautiful pearl handled Colt sitting in each holster. No pressure, better not muck this one up then Dan! I did a great big eagle right across his chest which took a few hours and towards the end he was grunting and groaning and obviously feeling it.

Sometimes it's strange being a tattoo artist, you get to do things to some people that nobody else could get away with, and then they pay you! It did get a little hairy on the first evening though – after most of them were well oiled to say the least – suddenly outside there was this terrific volley of gunshots. They were all whooping and hollering and firing their guns off into the air in some sort of salute. I nearly jumped out of my skin and found myself ducking down as low as I could get in my tattoo chair. The side of the marquee didn't seem like a particularly effective bullet shield to me, but no harm done.

Another time we drove up to Vancouver in Canada for a show and I didn't realise the kind of enmity that sometimes arises between the two countries. Jack told us they usually had trouble with the border guards every time they went over into Canada, so to be ready for it. Sure enough, when we got to the border the officials turned the whole of Jack's pickup inside out and searched all the American's luggage. When they saw I was from England they didn't even look at mine, much to my amusement and everyone else's annoyance.

But, sadly, like all good things they usually come to an end. The last time I went out, my fourth visit to the Mystic Dragon, I was due to stay for my usual two months. I'd only been there a couple of days and things had obviously become worse between Jack and Steph while I was away. The atmosphere was pretty toxic. Jack said he wanted to open a studio down in Tampa, Florida where it was a lot warmer in the winter, Steph would have none of it. He told me he wanted me to be a partner with him and said he'd found a place and had booked a couple of flights for us to go down

and see it the following week. Whoa! Hang on a minute. This sounded like a bad idea to me, not what I wanted to get into at all. I'd have to go legal and sort out a green card and all sorts of stuff. I liked things as they were and besides, I had my own studio in England, what was I supposed to do with that? It was very flattering but I think he forgot that I wasn't an American citizen and couldn't just start up a tattoo studio over there.

We did talk about me getting a green card at one point and Jack said it would be easy, as either he would sponsor me or there was a girl they knew who said she would be prepared to marry me to help me get it! Ha ha ha ha ha ha ha! That was exactly what I said!

I didn't say anything there and then because I'd only just arrived, but I didn't like the way this visit was looking. Jack also said he'd arranged to loan me out for a fortnight at some other guy's studio somewhere in Pittsburgh. Whaaat?! Loan me out? Pittsburgh? What was I, a fucking horse? I'd never even met the guy. Oh, no, no, no. I wasn't signed up for that. I mulled over it all for a couple of days and decided I had no choice, I had to get out of there as soon as possible.

I still had about seven weeks before I was due to fly back home and I felt I couldn't just say no because he had it all planned. He had gone to so much trouble organising everything, albeit without me knowing about it. I had to get away, but how?

I was gutted as I loved my visits to America so much. Well, I came up with the most ridiculous plan, but it was all I could think of – I'm sitting here chuckling as I'm writing this. I decided there had to be some kind of emergency at home, one where I would have to go back and deal with it. I decided my dad had suddenly been taken seriously ill. I was staying at a motel because of the situation between Jack and Steph in the trailer. I left early one morning and called the studio from a phone box before anyone would be there to answer so I could leave a message on the answerphone. I pretended to be Phil – my bodysuit man – who was house sitting for me while I was away.

'Allo, it's Phil' in my best Phil impersonation! 'Tell, Danny there's been an emergency … it's his dad. Okay, bye.'

I went and had a coffee and some breakfast and then I walked up to the studio. I wasn't feeling very confident at all but I'd started the wheels in motion so I had to go through with it. I was desperate to get out of there. When I walked into the studio, Steph was already there.

'Hey Danny, Phil called, there's been some kind of emergency at home … it's your dad.'

I put on my best shocked face. 'Oh no, what's happened?' She played the

recording, and to me it just sounded like me with a stupid voice. Inside I grimaced to myself; no way was this going to work.

'You can use the phone to call home.' she said.

I pretended to be all confused and panicky because I actually was. I didn't really know what I was doing, this was turning into a joke and I was now into it up to my neck. I went into the office and dialled home but left the last number off, I pretended to have a talk with Phil, 'Hello. What? No. Really? Emergency? Oh shit … come home?' It's really hard talking to no one on the phone; you have to give movie actors credit when they do it so well.

Well, they fell for it – sort of – but I had to keep it going. I told them dad had had a heart attack and was seriously ill in hospital, so I'd better arrange a flight back to the UK straight away to see him. Then when I knew he was okay I'd fly back and carry on with everything back here as planned. Simple. I said I'd leave all my stuff, clothes and tattoo gear and just take an overnight bag.

I managed to get a flight for that afternoon. Steph was really being weird and asking me all sorts of awkward questions. Of course, she didn't believe a fucking word. Jack drove me to the airport, all concerned; bless him. While we were driving, his mobile rang, it was Steph. There was a bit of an awkward conversation and he looked over at me. I'd been rumbled, I knew it. But he rang off and we carried on. We ran into some really heavy traffic; it was some sort of holiday in the US. Typical! Time was running a bit short, my take off time was drawing near.

We finally got to the airport, by this time I was a complete bag of nerves. It felt like I was running on pure adrenaline. And then he drove straight into the arrivals! Nooo! I want departures!

'Oh, they must have changed it.' he said.

Oh, for sure, yeah. They're always doing that at airports, changing stuff around to catch everyone out at the last minute. I thought he'd done it on purpose to make me miss my flight. So, we had to go all the way round the perimeter again in that fucking holiday traffic. My heart was pumping and my knuckles were white holding onto my bag.

Please, please, please just let me make this flight, I prayed. I couldn't bear to go back and have to try again the next day. I was now sure that Steph had somehow found out. She'd probably redialled the number I had dialled when I pretended to call Phil. The traffic was still awful and time was really running out.

Finally, we made it to departures. I gave Jack a hug, said goodbye and said I'd see him in a couple of days. I ran to the ticket desk, then ran to passport control, then ran to the gate and made it onto the plane with minutes to spare. I was the last one onto

the plane. It was that close.

I couldn't believe I'd actually made it onto the plane, after all the bullshit, the rushing around and with Steph breathing down my neck. I'd escaped and there was no way I was ever going back. It had all run its course as far as I was concerned. Okay, I'd left a load of stuff there but I would call them in a day or two and say I couldn't go back because dad was really bad or something like that and could they send it all over to me.

I sat there in my seat, my head in a spin and just played everything back in my mind. It felt like some weird *Keystone Cops* adventure but an enormous burden had been lifted off of my shoulders. How the hell had I got away with it? The awful Phil accent, the fake phone call back home, the rush to get a flight today, the nail-biting drive to the airport and then only just making it to my plane in time. I'd never been so relieved in my life. I had actually pulled it off, who cared whether that bitch Steph believed me or not? It didn't matter now anyway.

During the mad dash to the airport, I'd remembered I had an ecstasy tablet in my pocket that someone had given me a few days before. I had meant to throw it away at some point on the journey in case customs found it, but I'd forgotten it in the blind panic. Ooh, so it was still there? I only ever took ecstasy a couple of times but if now wasn't the perfect time to drop that tablet, then I didn't know when was. I dropped that sucker as soon as the wheels lifted off the tarmac. It was one hell of a flight!

I did feel a bit bad about everything that happened though. Or the way it ended at least. I really did like Jack and we had had some great times together. I couldn't help feeling that I'd just run away and left him to his fate with the evil Ice Queen, but then hey, he'd married her. Looking back, I think trying to get me so involved in the Tampa studio was some kind of desperate call for help. They'd grown to hate each other, so when I arrived on the scene, he'd felt he had an ally. An escape. Apparently, the plan was for me and him to go down and work in that studio and leave her up in Dover at the Mystic Dragon with other artists they would employ. Well luckily it never came to that. I was sure I did the right thing because that would have been a nightmare scenario and was bound to have ended in tears. Mine most likely.

When I landed at Gatwick the first thing I did was to call Phil and everyone at the Blue Dragon and tell them what had happened and the great escape I'd just pulled off. They all thought it was hilarious, what a situation to get yourself into. Another Danny Fuller classic. Well, if you don't embark on those sorts of capers then you never get the chance to have such an adventure. I'd made it back home in one piece so I didn't really give a shit.

Regarding Jack and Steph, I'm sure if I'd just told them I couldn't bear being

a referee in a domestic every other day and I wanted to call it quits and go home it would have turned out okay. But maybe not, she had a gun.

The trailer park where they lived was miles away from anywhere and backed onto swathes of secluded woods. Quite often on days off, we all used to go and target shoot Jack's guns deep in the forest and it wouldn't have taken much for an *accidental discharge* and the Limey wanker might never have been seen again. Brrrr! You never know. Although, Steph was a terrible shot.

Back in the safety of home, I left it a couple of days while I built up the courage to phone them at the Mystic Dragon and perfect my story. I called a couple of times but couldn't get an answer. How strange.

I called a few more times but still couldn't get through to anyone. I thought maybe they'd blocked my number. This was annoying, as I had quite a bit of tattoo gear I'd left there, five or six Micky Sharpz machines that we intended to sell at the conventions because they were very sought after in the US at the time. These alone would have paid for my flight. I had also left a brand-new set of six sheets of tattoo flash which I had drawn up especially for my trip and had planned to sell copies of at the conventions. I didn't have any copies at home, so I really wanted to get them back. I wasn't too worried about the clothes and other bits but I didn't like leaving anything behind really.

A few days later a letter arrived from Dover, New Hampshire from the pair of them. Oh boy, they weren't happy. It was definitely penned by Steph. She went on about how she'd redialled the number when I called Phil and there was no connection. How she had known from the beginning that it was all a hoax. Yeah, I had already figured that out. How rude I was to just leave the way I did and how I'd abused their hospitality and loads of other bollocks that was totally unfounded. She said I owed them money for all the travelling to shows, food, and lodging that I'd had! How the fuck do you work that one out, I thought. When I worked in their studio I had earned them at least $300 to $400 a day. I also earned them a load doing the shows we went to. They had also blocked my number, so don't try to call the letter concluded. How convenient.

Well, you know how these things go: you can never win. But I was pretty upset after reading all this and I thought it was very unfair. So, I wrote back telling them my side of it and asking if they could at least send the tattoo machines and flash back to me. I got an answer back by return. They said they were going to keep everything and didn't want to hear any more about it. That really annoyed me. I really wanted my flash back, but it wasn't going to happen. I was determined to get some revenge, especially at her. But how?

One morning I woke up and came downstairs and my cat had killed a blackbird right there on the living room floor during the night. There was a bit of a mess and I was annoyed at having to clean it all up first thing in the morning. Although, to be honest there wasn't much to clear up, all that was left were its two lower legs and a bright yellow beak. God knows where the rest of it went. I remembered that Jack and Steph were heavily into the witchcraft and the voodoo scene, especially her. They had all sorts of books on the subjects: charms, crystals, potions and candles and were deeply superstitious in all sorts of ways. Suddenly, I had a brilliant idea. Examining the claws and beak, they sure looked to me like some heavy witchcraft shit: the bright yellow beak and the gnarly feet looked like something out of a horror movie. I didn't wash any of the blood off!

I decided to put them in my final letter to Jack and Steph along with a few other dodgy looking bits. I found a couple of dead dried up spiders and put some plant stalks in as well, to look like special herbs. I didn't say anything about these extras in the letter, they could take their own guesses about what it all meant! It all looked great when I sealed the letter up and I knew it would make them think. It certainly cheered me up and I was giggling as I posted my letter of DOOM. Of course, I never heard anything back and for a long time it was a mystery whether my letter had even arrived.

I often thought about my time in America and the more time went by the more I forgot about the bad ending. Looking back, it had been a fantastic time and had only really been spoiled by one person's jealousy and inadequacies. I would have done it all again at the drop of a hat. In one of the usual twists of fate, I finally found out how things had gone down a few years later. I was at the Tattoo Inkorporated tattoo expo at Dunstable and I had my usual stall there. I looked up and to my amazement saw a familiar face looking at me – it was Kerry – Jack's apprentice! I dropped what I was doing, jumped up, rushed over and gave her a great big hug. We couldn't have been happier to see each other.

She told me she was over with a studio from the US and she was now fully qualified and an artist in her own right. Great news. I said I'd finish what I was doing then come and find her.

We went and sat in the cafe; I was dying to know what had happened after I'd left the Mystic Dragon. She told me she didn't blame me at all for the way I left and when I explained the whole story she thought it was very funny. She had also left not long after because of the arguments and the atmosphere. I asked if the dodgy witchcraft letter had arrived safely and she laughed.

'Oh my God,' she said. 'Steph completely freaked out. She didn't know what it all meant and spent weeks trying to look it all up and decipher the spell you had put

on them.' I told her about my cat killing the blackbird and that I'd just made it all up to look good. It certainly worked a treat. Far better than I could have imagined.

I asked what they were up to now and she said they had split up after one particularly nasty argument. Steph had pulled her gun out of her handbag and stuck it into Jack's crotch while he was sitting in his office and threatened to blow his balls off!

Oh my God, what a nutter. Unsurprisingly that was the last straw. They parted ways and sold the studio. Jack had joined a travelling circus but had got sacked for tattooing there without a licence. She wasn't sure where Steph had gone. She also told me that Steph had once said to her, 'I could have had Danny if I wanted but we never got the chance.'

49. Kerry, Jack's apprentice

I nearly died laughing, damn right you never got the chance. Where women are concerned, if there's a possibility of anything happening between us, I have a couple of rules of thumb that I like to stick to: One, they don't have a husband they're still married to in the background. And, two, they don't weigh twice as much as I do and carry a gun in their handbag!

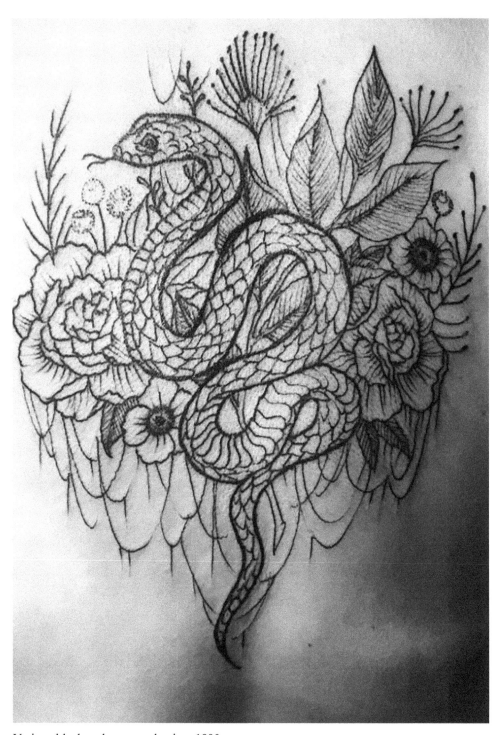

Various black and grey work, circa 1990s

Chapter 12: *Good times and then a bad time*

So that was the end of my international tattoo efforts. I thought I'd done enough travelling around, at least for a while. I still liked to go to the British tattoo expos. One good thing that came about after losing my set of tattoo flash to the robbing bastards at the Mystic Dragon was the kind of *I'll show you then* mentality that I've developed. I decided to try to redraw the flash set from memory, but better.

Once I'd done that, I just carried on drawing more and more tattoo flash. One thing I'd seen at the US shows was people selling flash, not by the set but by the sheet. I thought this was a really good idea and made perfect sense, because when you have to buy sets of designs there are sometimes a few sheets that you don't like but you can't pick and choose; you have to buy the whole lot. Buying flash by the sheet made much more sense because then you could just choose the ones you liked.

I loved designing tattoos almost as much as I liked actually tattooing them. I would come home after work most nights and sit and draw up all kinds of stuff. Japanese, Celtic, traditional old school or fantasy styles. I found it very relaxing and it was good practice for the real thing. I realised that I'd have to get quite a collection together before I started to sell them individually, but I figured fifty sheets would be a good start.

I decided to call it, Goldfang Tattoo Flash Company – because of my gold canine crowns – and registered it as a limited company. I got it all registered at Companies House. I don't really know why but it seemed like a posh idea at the time and I got to be a company director. I liked the sound of that.

A friend of mine had a printing company around the corner from the Blue Dragon and he did me a good deal on good quality A3 size colour copies of every sheet I drew. I soon had fifty sheets drawn up. Most had four or five designs on them, so it was a lot

50. My gold canine crowns

of work. I put the originals into a couple of display folders, all labelled and numbered and then there would be a corresponding envelope full of colour copies. I thought it would be a good idea to keep a record of what I sold, so I could see what was popular.

That year when I booked my place at the Tattoo Expo, I thought I wouldn't tattoo there any more, I would just have a booth selling flash. Groundbreaking or what? It had always been quite an effort transporting all my tattoo equipment to Dunstable and

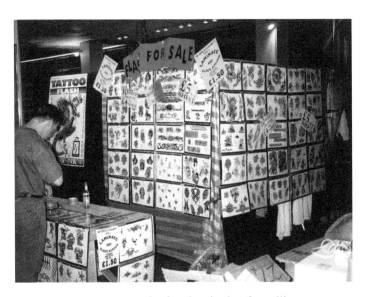

51. New Orleans Expo – the first inspiration for selling tattoo flash by the sheet

setting it all up. It was fun to work there and meet new people, but it was difficult to work in unfamiliar surroundings compared to your studio which you knew like the back of your hand. You also had to be on your best behaviour the whole time and you tended to be fixed in one spot for the whole weekend, so you sometimes felt you were missing out on some of the fun.

That year, 1995, I took Goldfang Tattoo Flash Company Ltd on the road. The Tattoo Inkorporated expo was the first stop. I was the first person at a UK convention to have a stall selling tattoo flash by the sheet. I wasn't sure how it would go down but I was confident people would like the sheets because we were doing a lot of the designs already at the Blue Dragon. But would I sell much? Tattooists are a notoriously tight bunch!

We set the stall up. I had sprayed up some large, colourful and eye-catching signs to hang in the booth. Then, I fixed the two A3 display folders to the table on top of a big black sheet to make them stand out. I had planned to sell by the sheet and in sets of ten for a discounted price. In addition, I had brought along a load of little notepads and biros and put them out on the table for people to write down the numbers of the sheets they wanted. Then I sat back crossed my fingers and waited for the hall to start filling up with eager flash buyers.

I was amazed. My idea of selling flash by the sheet went down like a house on fire. People were flicking through the display folders and reaching for the notepads to write their ten best sheets down and then handing them over to me or my helper to sort out and put in an envelope to take away. I had made all the line drawings of the designs as well, so people could easily make up transfers of the designs and this went down very well. Seeing as I wasn't tattooing, I was so chuffed that I went up to the bar a few times and bought us some beers. I was having the time of my life.

By the evening I had sold out of quite a few of the most popular sheets so I rang my friend at the print shop before they closed and she said she'd open up early

on Sunday for me if I wanted to go back down and get a load more copies. Fantastic, it was quite a journey back but bound to be worth it.

So that expo was my most successful one yet, financially. I made about five times more than I would have done had I been tattooing and I had a blast doing so. And now there were a whole bunch of Tattoo Artists with my designs on display in their studios. This was obviously the way forward for me from now on and I couldn't wait to get back and start drawing up more and more sheets for the collection. I was never short of ideas. It's funny, if I hadn't lost my original set of flash I would never have come up with the idea. It just goes to show – even if you don't realise it at the time – everything happens for the best. I had been gutted when Jack and Steph wouldn't give me my flash back, but it spurred me on to far better things and through hard work and determination I'd easily made all my money back with the machines and equipment I'd had to leave behind. That felt good.

All the conventions I went to after that, I just sold Goldfang Tattoo flash, it was great fun. I'd get people coming up to my stall at each show to see what new stuff I'd drawn up and then they'd just buy it all. It was great. I'm not saying it was the best flash around but most of the designs were just what people liked at the time and they weren't overdrawn, so they were fairly easy to do. A couple of the sheets with dragons ripping through the skin sold out at every show for a long time so there were definitely favourites.

I eventually had a full collection of 200 sheets I'd drawn, that was a lot of designs and I was very proud of that. It got to be a monster task though, making sure I had enough copies to take to the shows. The whole lot weighed a ton and it took two cars to transport it all in the end.

After about five years of selling tattoo designs, the business began to drop off a little because obviously by then other people had started to do the same thing. I had an offer from a tattooist from up north who said he'd like to buy the whole business. It was quite a difficult decision to let them all go because I had spent a hell of a long time drawing them all up. It had almost become a habit and I loved to sit down and look through the originals just to big myself up a bit if I was feeling down at times. I decided I probably wouldn't get another offer anytime soon. It wasn't an awful lot of money but it came in handy, so I agreed and he came down and picked up the whole lot … in his red Rolls Royce! That certainly got the neighbours' faces at their windows.

I'm not sure what he did with them in the end, I've looked on the internet to see if there are any still for sale but no luck. It was good fun while it lasted. Kept me very busy, was good practice and was another string to my bow of *firsts*. Most of my tattoo work after that was freehand because I could pretty much draw anything after

all the practise I'd put in.

The Blue Dragon was ticking over nicely but I wasn't totally happy with the position we were in. We were situated right at the bottom of North Road, which is a very busy road, traffic wise. Also, there weren't many people walking down that way as all the shops were further up. Another tattoo studio had opened a few years earlier at the junction of North Road and Kensington Gardens and it was down Kensington Gardens that most people walked when they came to the North Laines area which we were only just part of. I'd often look up the road when we were quiet and there would be a constant stream of pedestrians walking past the other studio into Kensington Gardens and that bothered me; I mean we were there first! Not much I could do about it though.

There was a barber's shop a hundred metres or so up North Road that came up for rent one day, the owner was moving elsewhere. It was in a much better position. Nearer where all the pedestrians walked so, I decided to see if I could get it. I still had a little while to go before I could get out of my lease at the bottom studio but I didn't want to miss out on this much better opportunity. I managed to get permission to take it over and decided to set it all up and get it running. It meant that I would have two studios to pay rent on but with three of us working I should be able to manage okay. There were about eight months to go before I could get out of the lease on the bottom studio.

The new studio was really nice; it had a flat above and a basement so there was plenty of room. I got it all decked out and it looked great, so for a while there was the Blue Dragon I and II. I was going to work the top studio and the other two guys were going to work the bottom studio, until it was time to all move up with me. Sounds like a good plan, yeah? I had no idea at the time but there were storm clouds forming on the horizon. Big ones.

Well like all good plans, unfortunately there are human beings involved that can fuck them up. They say two's company and three's a crowd and it might have been a case of that but at first, we all used to get on very well. I was the boss, even though I didn't really act like one or tell them what to do, so that was that. I was also the busiest artist of the three of us simply because of the workload and dedication I put into the job. I was a tattoo artist first and my other life came second. I also paid the rent and all the bills. The other two paid me a chair rent each day. Most places where you pay a chair rental you have to pay fifty percent of what you make each day, but as we were mates, I just charged them a small fee. And if they didn't make anything they didn't have to pay me anything. Very generous indeed, too fucking generous, because usually you have to pay a chair rent whether you do anything or not.

We had often gone out drinking and socialising together, but at that time not so much. I had been very close to one of the guys particularly, we had lots in common and had some wicked times over our past few years together at the Blue Dragon. I could feel things weren't the same between us. Maybe because of my American trips and also because I now had a steady partner and my daughter had just been born. I trusted them both though and I didn't go down to the bottom studio very often because I was busy at the top studio.

One day a guy came into the top studio, it was a day when the bottom studio was closed for the day. He said he'd had a tattoo done the day before but the guy had left something out.

Had he now?!

As far as I knew my soon to be ex best friend had said he hadn't done any work the day before so he hadn't given me any chair rent. This wasn't the first time I hadn't been paid. Not good. I made sure the guy had definitely had it done the day before. He said absolutely and it did look very new, so that checked out. I was very disappointed, let's just call it that. I'm usually very easy going and am used to putting up with all sorts of crap, but you don't steal money off me. Not when you have the best deal around and because we're supposed to be mates.

I phoned him at home straight away and told him what had happened and he immediately went into whining mode, saying well, he had only done the one and he was very short of money. Short of money? What the actual fucking fuck? I had two studios to pay for and he was short of money? I was so angry, I was shaking. I told him that was the end of it, he could go off and find somewhere else to work. I wasn't going to put up with that kind of crap from a so-called mate and I wasn't going to meet up and talk about it like he suggested because I knew it wouldn't end well. For him. What a prick, it was over, just like that.

So now there were two of us left, but that was okay, I could still just about cover both rents and survive the next few months until there was just the new Blue Dragon left to run. Nothing else could go wrong, surely.

Saturday, 16th of August was a very busy day. It was the height of the summer; the most popular tattoo time. I was on my own as usual, as my other guy was down the road running the bottom studio. Tattoo Studios were still operated a lot differently back then, they were mainly one-man operations. There was no one to answer the phone or properly sort out the customers, take bookings and deposits and generally make sure everything ran smoothly. If you were a tattoo artist you were self-employed. A sole trader and that meant you had to handle everything yourself. Sometimes you might have a close friend or trusted regular who would help you out in a limited way

by answering the phone or asking what people were after. When you arrived at your studio in the morning there were usually a couple of people waiting for you, so these would be your first customers and then as people arrived during the day, they would get in line in the waiting area and take their turn to be next.

Once you started your first tattoo that was it, you couldn't really stop for a cup of coffee or have much of a break because as the day wore on your customers would have been waiting for quite a length of time. I was conscious of the fact that if I farted around too much and they couldn't see the queue getting shorter then they might get bored, give up and head off somewhere else. So, I used to make sure that I dealt with everyone as quickly and efficiently as possible. As soon as I finished one tattoo I would turn around and wash everything up, change all my equipment over for the next one. The minute I turned back around the next customer would be standing in my face, ready to go. Sometimes I would be bursting to go to the loo but I would forget and not get around to it until a couple of hours after I'd initially felt the need!

I got used to it of course and was very grateful to have the business. But some days it could be exhausting and when I finally finished my last customer of the day I just wanted to get out of there and get home.

When people make up their mind that they want to get a tattoo that day they are usually determined to succeed, that's the draw of the tattoo. The only real trouble or arguments I ever had with customers was when I said I couldn't do their tattoo, either because it was getting too late or I was just too tired. Understandably, people can get quite upset if you tell them they can't have something they've set their heart on that day. I've even had people offer to pay me double the price because they really wanted to get the tattoo they'd planned, but even that didn't persuade me. Some days I was so knackered I couldn't bear to even pick the machine up. I could quite easily do nine or ten tattoos one after another on a really busy Saturday. What with all the bantering and calming of the nerves and the sheer concentration involved, I often felt like I'd just ran a marathon by the end of the day.

This particular Saturday had been one of those days, it was boiling hot, about four o'clock in the afternoon and I had been going at it hammer and tongs since I got to the studio. I was working on my last tattoo of the day – thank goodness – a large piece on a local guy and still had about an hour to go. So, when a woman poked her head through the door and asked me if she could get a tattoo I told her, no way, and that when I had finished the one I was doing that was me done for the day. She acted upset and asked a couple more times, trying to persuade me, but I told her I was done for the day and off she went. About an hour later she poked her head in again and asked me again. But I said, 'No.' She seemed a bit drunk this time, standing in the

doorway, pleading with me but nothing could persuade me and she was beginning to annoy me. I certainly wasn't going to tattoo her if she'd been drinking. She finally left in a huff. I was used to scenes like that so I wasn't really bothered. Me and my customer just laughed and carried on.

I finally got out of the studio around six o'clock and was really glad to get home but it had been a good day, so everything was good. My partner and my daughter and I all went out for a quick dinner at a Charlie Chalk's restaurant. My partner was off out with a load of her friends that night and I was staying at home to babysit. That suited me fine. I was knackered after my long day.

After a nice relaxing evening watching TV with a few cans, I was just about to go up to bed when the doorbell rang. It was past eleven o'clock but I thought it was my partner coming back early and that she'd forgotten her key. I opened the door and standing there in front of me were two large guys in suits.

'Hello?' I said, a bit shocked.

'Danny Fuller?' one of them asked.

'Yes.' I said.

'There's been a report of a rape at the Blue Dragon tattoo studio'.

'Whaaat?' and I laughed.

'Who was working there today?' one of them asked

'Well, I was,' I said. My head started to spin. 'But …'

'We have to ask you to come with us to Brighton Police Station. Are they the clothes you were wearing today?'

'Yes.'

'Go and change out of them, we need them for DNA examination. My colleague will accompany you upstairs.'

'Whoaa! Hang on a minute,' I said, completely flummoxed. 'I haven't got a clue what you're talking about.'

They told me a woman had come into Brighton Police Station a few hours ago and said that she'd been raped at the Blue Dragon that afternoon. I was in complete shock by now. I told them nothing of the sort had happened. I'd been to work, had a busy day as normal and then came straight home. Was this really happening? Everything started getting a bit blurry. They said I had to go with them now. I told them I couldn't go with them now; I was alone in the house with my baby daughter asleep upstairs and my partner was out and wouldn't be back for a few hours. They said they'd get someone to take her off to Social Services and she could be collected from there later. NO WAY! No fucking way. I started to panic, ten minutes before I was getting ready to go off to bed and now I was suddenly taking part in an absolute

nightmare. Obviously, I really hadn't a clue what they were on about.

I had to go with them – there and then – with my clothes in a bag. And they wanted to put my poor little girl in some fucking Social Services house for the night because I had to go in for questioning immediately over something I had not the faintest clue about. This was too much; it really was. You can't imagine how I felt. I briefly got my brain working long enough to ask if I could ring a couple, who were close friends, to come down and sit with my daughter until her mum got home. They agreed. I phoned them up, what the hell was I going to say? I couldn't say why the police were here, it was complete bollocks. I told them apparently there had been someone tattooed underage at the studio that day and I had to go in for questioning.

I just felt sick to my stomach. The couple arrived and saw the look on my face. I briefly apologised and said I'd explain properly in the morning. The coppers put me in the back of the car and off we went. I'll never forget that ride in the police car; my mind was just scrambled. I asked what the hell was going on again and they repeated what they had said earlier; a woman said she'd been raped at the Blue Dragon. I was speechless. They weren't as hostile as you would expect with a possible rapist sitting in the back of their car. One of them told me that this woman had said the guy who did it had blonde highlights and a nose stud? That made me feel a tiny, tiny bit better.

Er, I say, look back here: dark hair, goatee, massive flesh tunnels in each ear and gold fangs, oh and a labret piercing! Fairly recognisable I'd say. They weren't really interested though. They said they would be taking a statement at the station.

As we got down into the town one of the cops said to the other, 'Fancy a kebab?' They agreed and we stopped outside a kebab shop while one of them went in and bought a kebab for each of them. This wasn't happening? Surely this was some kind of joke? I'm sitting in the back of a fucking police car shitting myself, while they both sat there eating kebabs.

I thought it was only going to take an hour or so maximum. I'd go to the station, explain it was all a gigantic mistake and be back home before anyone knew it. It started to dawn on me that this was serious shit. I realised it must have been that last woman who had poked her head in through the door, the one I'd I said I couldn't tattoo. Okay she was upset, but why say she had got raped? Who on earth would make up a story like that? I never did find out. But for now all I could think of was the trouble this could get me into. Rape – one of the nastiest, most heinous crimes a person can commit. If word got out that I was being accused of rape then I would be finished. Never mind if I was guilty or not. What the hell would people think? No smoke without fire was what they would think. All my hard work destroyed on the stupid fantasy of some fucked up bitch. At that moment my life literally flashed before

me, it was almost too much to bear. I felt completely helpless.

'What are you going to tell your missus?' One of the coppers asked.

'Whaaat!?' I said, shocked. 'I'm going to tell her exactly what happened – nothing. What do you think I'm going to fucking tell her?'

I was questioned at the Police Station, they took my DNA: pulled hairs out, took blood and swabbed my mouth. I told them what had happened all that day and what they told me in return made the woman's story look absurd, it didn't make sense. She said she went into a tattoo studio; she wasn't sure which one but thought it was the Blue Dragon. She hadn't had a tattoo done but the guy had taken her downstairs into a basement and raped her wearing a condom to hide any DNA. Then he took her back upstairs and threw her out the door onto the pavement, where she fell to her knees getting scratches all over them. She then went off to a pub to calm her nerves and have a few drinks before going to the police station.

Was she for real? I hadn't got within ten feet of her. I hadn't even got out of my chair. She wasn't exactly a small woman from the fleeting glimpse I had of her, and I was supposed to have taken her down to the basement: put a condom on, raped her and then taken her back upstairs and thrown her out onto the street? What the hell was she supposed to have been doing while all this was going on?

North Road is a very busy road, especially on a Saturday afternoon. Someone – more than likely a lot of people – would have seen her being *thrown to the pavement* outside a tattoo studio. She could easily have got help and I'd have been banged to rights there and then. But no, she went off to the pub.

I was starting to feel a little bit better by now and I could sort of tell that the coppers interviewing me didn't believe much of her statement at all. They were just going through the motions. But the wheels had been set in motion and procedure had to be followed and it was still as scary as fuck. So, I spent a horrendous Saturday night in the cells with drunken screams and shouting going on mere feet away from me. It was a madhouse and I couldn't sleep a wink. All I could think about was, what would happen if someone I knew was in one of the other cells and found out I was there and suspected of the big R.

I was let out early in the morning. No charges were brought – of course – but I was told there would be more questions and they would be visiting the studio to check out her description of the premises.

I walked home which took about an hour. I still couldn't believe what I'd just been through. It felt like I was the one who'd been raped, mentally at least. It just wasn't fair. How could someone who I had done nothing wrong to – who didn't even know me – make up such a ridiculous but possibly damaging story? God knows what

had gone through her mind, but at that moment I wished to bring all the fury of hell itself down on top of her.

I obviously didn't tell many people about the nightmare ordeal I'd been through. My partner of course didn't believe a word of it and was as upset as I was. I did, however, tell the guy who worked for me and I told him to be wary of anything like that ever happening to him. He was also shocked and said he felt for me.

Then the next morning he rang me and told me that while he didn't believe a word of her story, he was leaving the Blue Dragon to go and work at the studio that the other robbing bastard had just opened up, as he thought that would be best. Oh my God, thanks mate. How very fucking nice of you. That really hurt me. We'd known each other probably ten years and at the first sign of any trouble he ran away and left me.

Now, through no fault of my own, I had once again entered into the most trying time of my life. My workmates had deserted me. The trumped-up rape accusations were still to be sorted out and I had to carry on working to pay for two studio rents and a mortgage by myself. Working was the last thing I wanted to do. I was at my wits end for a while. I lost all my drive. I didn't want to go to work. I didn't want to see anybody. I just wanted to sit in a darkened room all on my own and I couldn't seek my usual comfort in my tattooing. After the allegations, I didn't really enjoy being there because I couldn't help thinking of the lying bitch. It was the first time I had actually felt the *black dog* of depression hanging over me. I did my fair share of crying and it was an awful time. My kids cheered me up bless them. They knew nothing about the stress Daddy was under, and my partner was very understanding. I still had a lot of friends outside my tattoo life but I think they could tell I wasn't my usual cheery self. I was on pause until I could clear my name.

Gradually I managed to get myself back to a functioning stage with the help and support of my partner and family, but not a day went by where I didn't think about that awful Saturday night. I only had one more visit from the police, they came to the studio to look downstairs and check the woman's claims of the description of my basement. This also helped to calm me a little because she had said it was an L-shaped room with a weights bench, which was where it was supposed to have happened. My basement was a plain rectangle shaped room with no weights bench! The sergeant was kind enough to say to me that as far as they were concerned it was pretty much done and dusted.

The whole thing took about three months though before I finally got a visit at the Blue Dragon from a Sergeant in the CID, who told me the woman had changed her story. She HAD been raped by someone that day but couldn't remember who!? He

also brought my clothes back and said that they'd never bothered to send them off for DNA examination because they hadn't believed her story in the first place. I put them straight back on, there and then.

I can look back at that time and manage a wry smile now as it was such a long time ago. But there was nothing to smile about at the time. I wouldn't want to go through that again for all the tea in China. It was a very sobering experience highlighting how things can be going so well – then out of the blue – someone comes along and, through their own pathetic actions, almost ruins someone else's life just by getting themselves into a situation that went beyond their control. You can't help but think the worst. I thought about it a lot and I wondered how someone could just throw those kinds of accusations without any thought of the damage they were causing. I couldn't get my head around it.

My own conclusions were that she'd come to Brighton for a day out and started drinking, then thought she'd go and get a tattoo. She'd tried a couple of tattoo studios, but as it was late, she couldn't get it done. So, she went back to drinking, somehow got herself into a situation with a guy or guys and ended up in some seedy back alley free for all. Unable to satisfactorily explain the subsequent damage to her knees and possible damage to her clothes and realising that if her boyfriend found out what had really happened it would be all over between them, she made up the ridiculous story of having been raped at the tattoo studio. The Blue Dragon obviously came up due to her boyfriend having visited there and it was the best-known tattoo studio in Brighton at the time. Simple really, but a complete waste of everyone's time.

Trying times indeed, but I needn't have worried because things were about to turn back in my favour. Life does have a way of levelling out. You could be down in the gutter one minute – all hope abandoned – but you must never give up. There's always a way out. When it looks like there is no light to be seen in the never-ending tunnel of fate, all you need is a faint glow to head towards. If you can put the bad times behind you and find the strength to carry on, good times can be just around the corner. You just have to keep plugging away. Believing in yourself and acting quickly when opportunities arise. So, I did.

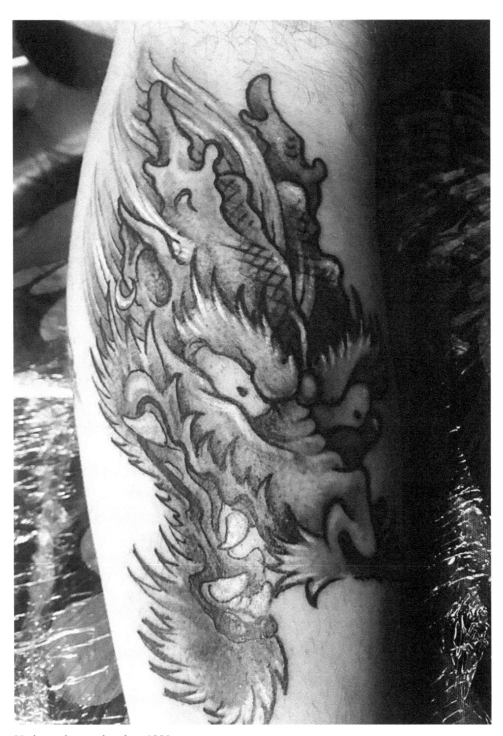

Various pieces, circa late 1990s

Chapter 13: *The Red Dragon*

With that weight off of my mind, I had to do some re-thinking. A new chapter had begun and I was back to being a one-man operation again. I had moved premises to a better position, but I still had a few more months to go on the old studio before I was free of that burden. I had finished travelling around as an American guest artist and I had also run a successful flash sales operation.

Also, I had been selling the American pre-dispersed ink for a while. I had bought litres of the stuff when I was over in the States and had brought it all back with me to re-bottle as Regency Pigments. I would take them to the conventions with me and sell them there. They went down very well because they were the only ones available in the UK at that time and there were a lot of people using them in the late 1990s. The only trouble with selling bottles of ink is that they last for a long time and so once someone had bought a set, they didn't need to re-order any more for quite some time. I initially sold a lot, but once people had got their inks it slowed down to a few bottles here and there and I lost a bit of interest in it.

A guy called Barry K who had a studio near Cambridge really liked the inks and we got talking at one of the shows and I told him I was thinking of winding it down, he said he was interested in taking it over. Sounded good to me, so we came to an agreement on a price and I said I'd give him all the stock that I had left and all the addresses and the name of the supplier where I got them from, he readily agreed and so Regency Pigments carried on for another few years. They eventually became Starbrite Colours and as far as I know they're still available.

That was another first I'm proud of; selling American pre-dispersed inks in the UK. Whenever I was at a show, for years after, I would get people coming up to me asking if I still sold them – especially the white – as it was the absolute best available. So, after unloading that, I decided to end my entrepreneuring for a while and just to concentrate on my tattooing, to keep trying to better myself and get a better name for myself.

By this time, most studios had more than one artist, so this was definitely the way to go. I liked having other artists working with me and I was looking for new recruits, but this time I would be more selective and have a good quality artist, someone more comparable to myself. No more favours for friends.

It's funny how things take on a direction of their own, it wasn't very long before a young New Zealand guy called Shaun poked his head in the studio and asked if I had a vacancy for a guest artist.

Well, whaddya know?

Shaun Buttling was a young New Zealand tattoo fanatic who had dual citizenship, his mum was English and his dad was Māori so he was brought up learning all the Māori traditional artwork. Māori designs were proving very popular thanks to Robbie Williams and a few other celebs. Shaun could do the real thing though. Those designs aren't just random shapes; they actually tell a story. Each design is unique to the customer. If you are going to be tattooed in the proper Māori style it must be drawn up for you personally. So, I had the *real deal* working at the Blue Dragon.

It was great having Shaun around to help and his genuine traditional Māori style went down very well. I also met another great guy and artist through him. Gordon was a little older than me, he had been tattooing for a long time and had travelled all over India tattooing and enjoying a hippie lifestyle. He was a genuine free spirit and I never saw him panic or get in a flap about anything. Gordon had been back in the UK for a while and had been working at a friend's studio in Harrow, London but it wasn't going well so he was looking for somewhere more suited to his character. It was funny how we met, Shaun and I were going to a show somewhere up north, just selling flash, not tattooing. Gordon arranged to meet us at a hotel nearby where he had arranged to stay for the duration of the show. We got to the hotel and found Gordon's room and a friend of Gordon's let us in. Gordon was nowhere to be seen.

'Where's Gordon?' Shaun asked.

'Oh, he's in the toilet having a whitey,' said the friend.' He just harvested some of his home-grown and it was stronger than he expected.'

We all cracked up laughing and from that moment on Gordon Couser and I became very good friends. After he recovered that is.

So, I now had plenty of help at the Blue Dragon and it was all going along nicely. I finished with the lease on the old Blue Dragon, so that was a big expense I didn't have any more and there were three of us working at the new studio up the road.

I knew Shaun wouldn't be staying too long because he had two daughters living in London and he'd said he would eventually be looking for work closer to them. No problem at all, it was great while it lasted.

Aaron Soffe was another great guy. I love Kiwi's. They are very laid back, honourable people and so easy to get on with, it must be the Māori influence. He was very keen to come to England and get a guest spot, much like me and America. When Shaun contacted him and told him that I would love to have him guest artist at the Blue Dragon, he got straight on a plane and arrived on my doorstep within a few days. I opened the front door and there stood a big guy with a Mohican haircut, covered in tattoos, with a smile from ear to ear and a backpack the size of himself on

his shoulders.

'Good day, Danny.'

He stayed at mine for the first night while we got to know each other. Of course, I had to take him to The Grenadier and show him off! We got on like a house on fire and the next day we went down to the Blue Dragon where he took one of the bedrooms upstairs and that was his home for the next couple of years. Aaron loved Brighton. He soon made many friends and I think he would be the first to agree that up until this point his first trip over to England was the time of his life. He really was my right-hand man and helped me tremendously all the time he was with me.

A couple of months after finishing at the old Blue Dragon, word came back to me that someone had applied to take over the lease and turn it back into a tattoo studio. What?! Oh no, that wasn't what I thought was going to happen. That was really bad news. Another tattoo studio in North Road, which would make three altogether and to rub salt into the wound, it was MY old studio! I didn't like that at all, but there wasn't much I could do about it. A few days later there was even worse news to come. The new owners were … Hell's Angels!

Well, that's that then, I thought, it was fun while it lasted, but that's the end of my tattooing career. I was devastated. What on earth was coming next. I knew the reputation of these guys and I couldn't see them putting up with any competition only fifty yards up the road. It had all been going so well.

I went to the studio each day and sat there with bated breath waiting for *the visit* to warn me *to get out of Dodge* if I knew what was good for me. Well amazingly, it never came. Aaron had worked at a Hell's Angel owned tattoo studio in New Zealand and he had contacted the guy who had told him not to worry, that wasn't how they did things. It was purely business and they were just out to make a living like anybody else. I could have kissed him. I even ended up speaking with the guy who owned the new tattoo studio and we got along fine so I didn't have to worry about anything untoward happening. Eventually, I even took on one of the guys who worked at the Angel's tattoo studio when his chair there stopped being available. The owner called me up one day and asked if I could let the guy have a chair at the Blue Dragon, which I happily agreed to.

So that was another bullet dodged as far as I was concerned. Their presence didn't seem to affect our business at all because we were two totally different studios and had different types of customers. So that was fine.

I carried on at the Blue Dragon for another year or so. I really enjoyed it there with all the guys. We were like one big happy family. There were a few other artists who'd come and go. As it became easier to get hold of a set of equipment there were

lots more people tattooing by this time and studios were taking on apprentices and trainees; although these positions were still extremely rare.

It seemed to me that people who weren't in the tattoo trade had completely the wrong idea about tattoo apprenticeships. Apparently if you are good at drawing, you can just walk into any tattoo studio with a few scraps of paper with your best efforts on and they will instantly take you on as an apprentice. Not true. In fact, it couldn't be further from the truth. Tattooing is a completely unique industry. Other than the Environmental Health regulations and the Under 18s rule there are no regulations. At the time of writing this book, there was no official tattoo organisation or governing body, there was no union representation and most importantly, there was no recognised official way to become a tattoo artist via schools or colleges.

More of that later; another Danny Fuller first!

It always has been and still very much is: every man or woman for themselves. You can't go and study somewhere and earn yourself a GCSE or a degree in tattooing. Consequently, there was no officially recognised tattoo artist apprenticeship. They simply did not exist. Most other trades like law, architecture, plumbing, electricians, engineering or even hairdressing and catering have them, but not tattooing. I would imagine it's because you would need to have *live* models to work on, which would probably be against some kind of human rights or something equally ridiculous. Who knows? I've heard stories of different types of apprenticeships being offered where you have to pay the studio to be taught the ropes for a certain period of time whilst making the tea and doing all the menial jobs like sweeping up and fetching burgers. But who in their right mind is going to let someone they don't really know come in and learn all the secrets of the trade and then let them *have a go* on one of their valued customers? Can you imagine the scenario?

You walk into your favourite tattoo studio.

'Okay, this is Kevin, our new apprentice. He's going to be having a go at doing your sleeve today because, well, he's gotta start somewhere.'

'Erm?'

Three hours later.

'There you go, that wasn't too bad. Okay, some of the lines are a bit dodgy and okay it is bleeding a bit more than usual. Don't worry, I can make the Carp look less like a penis when you come back in next time, no problem and we can cover over that bit of writing with some dark clouds: bread, coffee and milk, where he was on the phone and his mum asked him to get some bits from the supermarket on the way home. Let's just call it a oner?' – £100!

Not going to happen.

There's also the possibility of teaching your apprentice everything he or she needs to know and then a week later they fuck off and open a studio two doors down, taking all your customers with them. The only way I can see a genuine tattoo apprenticeship being offered is if you are actually related to or married to the artist.

As I said, I carried on at the Blue Dragon for another year or so, but more changes in my personal life took place and I had to do another rethink. My daughter's mum and I decided to split up. Well, I wasn't too keen to split up, but there you go. Being a single dad again was exactly the thing I wanted to avoid. There was no animosity between us though – just heartache – so it wasn't as bad as my last split. And we weren't married so that made things a bit simpler.

The Blue Dragon was busy enough but I started to feel the strain of having three tattoo studios in my road, The Wizard of Ink, the Blue Dragon and Angelic Hell. I got fed up with people coming in and asking how much a piece would cost, then saying they could get it for less up or down the road. I'd always priced my work reasonably as I was pretty fast by now. So, I began to take this as a personal affront, losing it on a couple of occasions, 'Well go on then, fuck off up the road and get it done!' Not my usual style at all but there must have been more mitigating factors going on than a quarrel over price.

I'm never usually short of ideas and I wasn't short of people wanting to work with me, so I thought it might be time to get another studio. Somewhere well away from Brighton. When I was living in Horsham, I had briefly had a little studio in Horsham with 'Dodgy' Dave before I moved everything down to Brighton. Horsham was a very small town when I lived there but there had been a lot of expansion going on while I had been away and it was now considerably bigger. I had to sell my house in Brighton to pay a settlement to my daughter's mum and at this time houses in Horsham were cheaper than in Brighton. So, I thought I'd move back up there and would get more for my money. I found a suitable premises in East Street which was above an Indian takeaway. This was okay, but boy did it make your eyes water when they had *Garlic Day* if you didn't close the windows quickly enough!

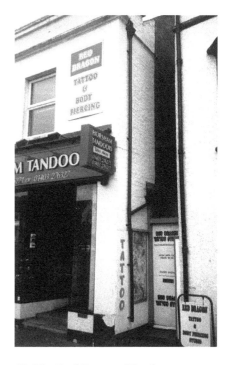

52. The Red Dragon, Horsham

177

I was a little concerned that I might not get planning permission for a tattoo studio in Horsham, seeing as it was ultra-conservative at the time. I thought the Council might not approve, but I had been granted permission before so I wasn't too worried.

Fortunately planning permission was granted and off I went with studio number two, the Red Dragon. I was the first person to open a full-time tattoo studio in Horsham. Another first which I am very proud of. The Red Dragon was a big place; there were five rooms on two floors, which was a bit more than I needed. Luckily this would come in handy a few years later. My new landlord had originally run a gun making business from the building, complete with a firing range on the ground floor but he had moved everything up to Cambridgeshire. Hell's Angels and now a gun maker, you have to believe me when I tell you I'm not making this up! No chance of me being late with the rent then.

After my recent upset, all in all I was feeling pretty pleased with myself. I now had two studios, one in Brighton and one in Horsham. I had two guys working the Blue Dragon for me and there was me and another guy working at the Red Dragon. I also had a couple of other part-time guys who would fill in at either studio when the full-timers had a day off. I stuck with the Japanese theme because I thought that if the chance came up, I could carry on opening studios named after different colour dragons.

When you get momentum going you have to go with it, as any successful business person will tell you. I still had people coming in to see me who were looking for work, all experienced artists and mostly very nice guys. So, it wasn't too long before I decided to go for studio number three. I didn't fancy getting another studio in Crawley as I had done that before and there were a couple already there. I thought I'd stick with towns where there weren't any tattoo studios, so my next best bet was Horley, in Surrey. A few months later I opened the Black Dragon tattoo studio. I was on a roll. This was a nice premises above a car parts sales business.

After receiving the usual change of use for the premises, it didn't take me too long to set it up with a waiting room and studio room. I didn't know much about Horley but I had gone out with a girl from Horley for a year or so when I was eighteen. For some reason, it did have a bit of a reputation for trouble and I had got into a bit of an altercation with a local guy one night at a place called the Chequers Hotel, but that was a long time ago. One evening after finishing decorating the Black Dragon, I popped into a nearby pub for an early pint before driving home. It was busy and noisy for that time of day but I found a seat okay. I thought I'd have one more pint before I went home, when all of a sudden a bunch of six or seven young lads came in and approached one of the guys already in the bar. There was some pushing and shoving

and the atmosphere turned decidedly hostile. Then all hell suddenly let loose! The whole place turned into a Western style bar brawl; glasses and bottles were flying through the air and people were punching each other and grappling all over the place. I'd never seen anything quite like it.

I decided this wasn't the place for me. Luckily, I wasn't far from the exit so I abandoned my pint – it must have been bad! – and ran out the door, annoyed and shocked at what I'd just seen. Horley didn't seem to have changed much. That was my only visit to a pub the whole time I was there.

Unbelievably, even on that occasion, everything seemed to happen for the best. As I got near to my home, there was a police checkpoint set up with a handheld speed camera. It was almost Christmastime and they were checking drivers at random. I didn't see them because it was dark and of course, I was pulled over for speeding. The copper smelt alcohol on my breath so I was breathalysed, but fortunately due to the fracas in the pub I'd only drunk one pint and a couple of mouthfuls of my second so I passed okay. Wow, that was cutting it a bit fine and for a while I was worried that I might not pass. I'm pretty sure that if I'd stayed and finished my second pint I'd have been over the limit as I was drinking Stella Artois. That would have brought my studio expansion scheme to an abrupt end. I thanked my lucky stars for just the three points on my licence and it scared me so much that I vowed never to drink if I was driving ever again.

Three tattoo studios was quite an achievement. I had the Blue, Red and Black Dragons. It was going okay but travelling to each one took all of my time and there was a lot of juggling with staff to keep them all running smoothly. Aaron and Shaun – my two Kiwi's – didn't drive so I had to taxi them about each day which I didn't mind but it shortened my working day. Horsham was my favourite studio; Brighton was my next favourite but Horley was proving to be a bit of a beast. The landlord was a nice guy; he ran the car parts business on the ground floor, but he was always moaning about how bad business was. He started telling me he thought he might set fire to the place to get the insurance and be done with it. I was sure he was joking but it did make me a bit uneasy.

Also, on a couple of mornings when I had arrived for work and gone to our entrance at the rear of the building, I could see there was some drug paraphernalia. Needles etc. left by my door where someone had obviously been jacking up the night before. I didn't like this at all. There had also been a couple of dodgy customers, not really causing trouble, but let's just say they were awkward. We had to forcibly eject them. This wasn't what I was used to dealing with because 99.999% of my customers until then had been as sweet as. I had another Kiwi called Bernie Carroll doing a bit of

work for me at the time. He was more what I'd call a *super Kiwi*. He had come over to the UK on a temporary visa to play rugby league for the London Broncos and the guy was as hard as nails. He also worked as a part-time bouncer at The Church. This was an Aussie and Kiwi drinking haven in central London where on most weekends he saw plenty of action. Most Monday mornings he'd turn up with scratches and bruises and tell me about the epic run-ins he'd had the weekend before. He absolutely loved a scrap, the more the merrier. But he was the only member of staff who didn't really mind working up at the Black Dragon. So, when he told me that his rugby season was due to start again and he'd have to cut back his hours, followed by another *possible imminent arson* conversation with the landlord downstairs one morning, I thought, fuck it I've had enough of Horley. So that night, myself and Aaron loaded all the equipment into my car and I posted the keys back through the landlord's door. There would be no more Black Dragon.

I was quite disappointed to be back to just two studios, as I fancied myself on a bit of a world takeover bid, but it was not to be. It was actually a weight off my shoulders more than anything and my life became a lot simpler after that. You can't flog a dead horse; and if things look like they aren't turning out as planned you have to be ready to adapt to the situation and react accordingly.

Through the tattoo grapevine, I heard that someone else came along and took over the studio and renamed it. It is still going to this day. So, I needn't have worried about the landlord setting fire to the place. But I also heard a chilling story that made me certain I had made the right decision; a guy walked into the studio one day and asked if the piercer was in. He was told the piercer was out the back, so the guy walked through took out a rounders' bat he had hidden under his jacket and set about the piercer with it and put him in hospital! Obviously, the piercer had pierced the wrong piercee!

Funnily enough, I'd been doing the piercing at the Black Dragon while I had run it, so that could have been me in the ambulance. Fuck you, Horley.

I ran the Blue and Red Dragons together for about a year afterwards. Until about 2002, when I decided it was all a bit much. The money was nice but it was a lot of accounting and I was getting close to the dreaded VAT figure. So, after one of my guys left the Blue Dragon and there was only one guy left there, I decided to call it a day. I offered to just give it to my good friend Mick 'J' Jackson if he would take over the lease and the running of it. He agreed and I'm very happy to say that he still runs it successfully to this day. It is the longest running Tattoo Studio in Brighton and has been voted *Best Studio in Brighton* a number of times. Well done, Mick, I obviously made the right decision. Wahey!

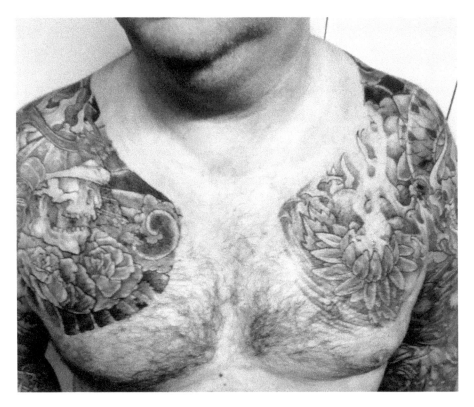

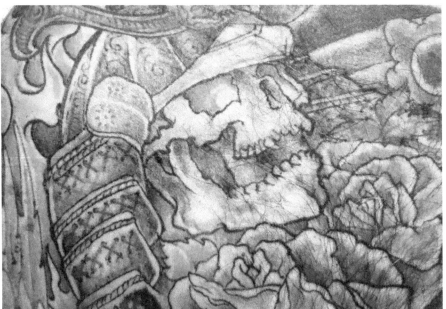

Various pieces, circa late 1990s

Chapter 14: *The Professional Tattoo Academy*

So, after breaking all ties with Brighton, both professionally and home-wise, I now settled down to just being a tattoo artist in the lovely countryside of West Sussex. I now lived and worked in Horsham.

It had been quite a ride since my humble beginnings in a tiny studio in Crawley. I had now been a professional tattoo artist for twenty-two years. Half my life. To me it was amazing, I could never have guessed that I would still be doing it after all these years. I had only had two jobs in my lifetime. An achievement in itself. Never one to rest on my laurels and always looking for the next opening, I was sure that I wasn't finished yet.

I had been contacted by a publishing company in Lewes who were interested in doing a book of tattoo designs, nothing too unusual there but it had a new twist. The idea was a good one. Basically, it was going to be full of outlines of popular tattoos i.e. hearts, scrolls, flowers, dragons, Japanese fish, tribal shapes, Celtic knotwork and everything you could think of. The idea was that you made up your own combinations on your computer at home. So, you might wrap a scroll around a heart and add a couple of flowers or swallows and then print it out to the size you wanted and take it into your favourite tattoo studio for them to ink onto your skin. All the outlines were stored on a CD that came with the book and there were instructions on how to colour your design in, so you could see the finished article. I thought it was a great idea and agreed to start work on it immediately. They gave me about six months to complete all the outlines. We had about ten different subjects or categories, there were a lot! And I had time limits to complete each section. I didn't have a share in any of the profits but they paid me a fee which was paid in parts as I completed all the sections.

I managed to complete all the sections, but there were a lot of late nights, especially as the deadlines drew near. The book was called, *Tattoo ClipArt* and was released in 2009-11, apparently it sold quite well but there was a problem with the CD on the early editions. Oh Great! – but not my fault – Where people had trouble printing their finished design out. But it's still available on Amazon and seems to be quite a collector's item as the price has gone up substantially from when it was originally published.

While I was working on this book another idea began germinating in my restless brain.

As I mentioned earlier, when I started up as a tattoo artist it was a very difficult trade to get into because it was so difficult to get hold of any tattoo equipment.

Well, like just about everything else this all started to change with the advent of the internet which started as an academic research project around 1969 and became a global commercial network by the late 1990s. Mail order companies were springing up all over the world, so of course companies started selling tattoo equipment online. No need to publish an address, so therefore no possibility of anyone knocking on your door to stop you selling the *holy grail* that was tattoo equipment.

It started off in America with large companies such as Spaulding and Rogers making websites with all of their products in the studio, and then you would fill your shopping cart and pay at the checkout, simple. All you had to do was sit back and wait for your brand-new shiny tattoo machines to arrive.

This started the avalanche, and soon there were countless tattoo suppliers online; trading from a website and selling to anyone who had the funds in their bank account. Originally, tattoo suppliers would only sell equipment to you if it was being sent to a studio address, not to your home. Admirable morals indeed, but they soon found themselves trailing behind others who didn't have quite the morals they did and would sell to any Tom, Dick or Harry.

Another reason prohibiting a lot of people from starting to tattoo was the fact that you had to make up your own needle sets. Other than making your own machines, this was the hardest part of a tattooist's daily routine. If you hadn't been taught how to solder properly, it was almost impossible to put the needles together into groups for outlining, shading and colouring. You could buy the needles loose, in packets of a thousand, but you could go through them all in an evening trying to get the arrangements right. It really was that difficult. So, the final development that brought tattooing in as a possibility to the general public was the advent of pre-soldered needle sets, ready sterilised – fortunately – and ready to go.

Nice one, China! Ask any old-time tattoo artist what they think about that and be prepared for some very colourful language!

All of a sudden you could buy boxes of fifty ready-made needles, all in their individually sterilised pouches, of any combination you would need. And a lot you didn't. Liners, shaders, single stack magnums, double stacked magnums, curved magnums and flat shaders. You would never have to solder up another set of needles in your life, never mind learn how to do it.

Now I know some people aren't fans of goods made in China, but I grudgingly admit that the tattoo needle sets they make are second to none. Probably because they are only used once and then destroyed! But this was the final piece of the jigsaw. It opened up the floodgates for an absolute torrent of wannabe tattoo artists who thought that just because they could draw a decent funny doggy face or some shit, that they

would be tattooing all their mates within a week.

I started to see a lot of these homemade efforts coming into the Red Dragon, people who were regretting letting their mate have a go after a few pints down the pub. They ranged from bad to fucking awful. I never saw a good one and that's not just sour grapes. A tattoo is not something you can just have a go at, leave half-finished and then it will go away. Any mark and I mean ANY mark made on the skin with a needle and ink is there for life. If you got a fucked-up tattoo effort on your arm when you were sixteen and lived until you were ninety-five, that sucker would still be there when they put you in your grave. That's seventy-nine years! Seventy-nine years of people laughing at you, but a lot of people don't realise that at the time.

Tattoos are almost impossible to remove successfully and what can be removed is done with a great deal of pain. More pain than you felt to have it put on. So, think about it first. If you have a bad tattoo done you have a big problem. And who has to sort it out and save you from a lifetime of embarrassment? Your local pro, someone who has taught himself properly and has had years of practising on pig's skin or his own skin before he finally feels ready to mark someone else for life.

Covering up old tattoos is not easy, it's a crap job but we do our best to save you ending up hating tattoos in general because you've had a bad one at your first attempt.

I used to laugh to myself when people would tell me they wanted their dodgy, crooked homemade tattoo covered over with a portrait of their newborn child.

'Yes mate, what can I do for you?'

'I want this Panther's head covered over with a portrait of my two kids.'

'Let's have a look … Oh, where did you get that done?'

'A place in Crawley.'

'You mean your mate's kitchen?'

'… Erm yeah. Well, he's usually a really good drawer.'

Tattoo artist, starting to lose patience a little, 'You can't cover it with a portrait, a portrait is too light. You'll have to go even darker to get rid of it or it will show through.'

'No, my mate said you just go over it.'

Tattoo artist, now losing all patience, 'Fuck off!'

Okay, so I never had that conversation in real life but there were so many times when it could have ended up like that and it probably did in less patient studios. Covering an old tattoo is not like painting a new colour onto a living room wall where the new layer of paint just goes over the top of the old one and covers it up. You are actually putting the new ink into the skin WITH the old ink that will always be

there. Yes, the skin is made up of layers, but they are all interactive and not separate structures so the ink penetrates all the way through each basically transparent layer. Darker colours will show through lighter colours, so really all you can do is cover the whole area over with black or with the very dark base colours.

It was probably after the third or fourth conversation like that in the space of a few days when I finally thought something had to be done about this. I actually remember one instance where an old customer who I hadn't seen for a few years came into the studio. He'd had a tribal style sleeve done by me in about ten sittings. He had been one of the fussiest people I had ever tattooed. All the curves had to be exact and the points razor sharp. Symmetry was very important which is hard on an arm that is not symmetrical in the first place. Each sitting had taken twice as long as it should have, due to me having to redraw or redesign stuff. I'm a very patient guy and very rarely get flustered. You have to be like that when you work with the general public. But I came close a few times to throwing my arms up in the air, leaving him sitting in the chair and walking out so that I couldn't reach his neck to throttle him.

We exchanged pleasantries and he told me that he hadn't been around for a while because he'd changed jobs and moved away. Then he pulled up his sleeve and showed me a sleeve that his mate had started for him. I was flabbergasted, I couldn't even make out what it was. It was one of the worst home-made efforts I had ever seen. It was just outlines but they were shaky, crooked, weak and just embarrassing and now the fussiest bastard was standing there proudly showing it off to ME?! I muttered some excuse about being busy and just turned around and walked out the room in disgust, and thankfully that was the last I saw of him.

I thought, for fuck's sake, if it carries on like this the trade that I loved and devoted my life to was going to end up turning into a laughing stock. There would be so many people trying to get laser removal done that it might end up swamping and bankrupting the National Health Service. The government might become involved and even ban tattooing like they had in America in some states in the 70s and 80s.

I thought I had to do something, however small, to try to help straighten things out a little.

People needed to be able to go somewhere to be taught how to tattoo properly. The trouble was that there was no official tattoo education system in place anywhere. It was every man or woman for themselves. There were a few videos on how to tattoo, but only American ones and some of their methods didn't apply in the UK. There were no books on how to tattoo and there weren't any courses available at any colleges or art schools. Disgraceful when you think about it. It was pretty much one of the only trades you couldn't officially learn.

So, it was around this time in 2002 when I began to think maybe I could come up with a way to offer apprenticeship help to people in some way. People who genuinely wanted to learn under proper supervision and were serious about it. Very serious about it. I didn't like the idea of making instructional videos because they could easily be pirated and I didn't have the cameras, equipment or experience needed to make them. I was more of a hand's on, people person anyway. So, my mind turned to offering some form of classes and personal tuition.

I had two spare rooms at the Red Dragon that weren't being used for anything at the time so I thought I could make one into a classroom and the other into a *mock studio*. The more I thought about it and moved stuff around to get an idea of how to set things up, the more I liked it. I needed a title for my brainchild. If you look up the definition of the word, academy it reads: a school for special instruction, and: an institution or society for the advancement of Literature, Art or Science – perfect! And thus, the first ideas of creating, The Professional Tattoo Academy were born. I wanted to call my project an academy rather than a school because I wasn't anticipating having large numbers of students on each course. I reckoned I had room for up to three people at a time. I was sure I could handle these numbers and I would be able to give everyone enough time and attention for their money.

I made three spaces in the classroom around a large circular table with a large whiteboard fixed to the wall, this was for drawing practice and machine instruction and any of the small lectures I was busy writing. I also made three workstations in the mock studio. I tiled it all out to make it look and feel like a real studio and this would be where the actual tattooing would be done. Not on any live subjects just yet! But on suitable practise material. All tattooing would be done following environmental guidelines as if it was a real studio situation.

I spent a lot of time trying to work out some form of syllabus so that things could be done in a proper order and wouldn't be too overwhelming in the first few days. I wanted to make everything run smoothly, so students would be guaranteed to get their money's worth. I had plenty of ideas and the more I thought about it, having just completed the *Tattoo Clip Art* book the more I liked the idea of having a sheet of pre-drawn outlines of designs that the students could trace and combine to make their own tattoo designs. As the course progressed, they could make their own tattoo flash sheets. It was starting to look good.

All I had to do now was look up what any of the other Tattoo Schools or Academies were doing and maybe pinch some of their ideas to help me finalise my plan.

One problem.

There weren't any other tattoo schools or academies! Anywhere. I searched the internet high and low, typing in combinations of search words, looking for instructions, courses, classes. I couldn't find anything. All I could find were a few videos or DVDs. There was absolutely nothing on offer where you could go and spend time with a professional who would show you the ropes and answer all your questions. Not even in America. I was astounded.

So, this is how I came to the proud conclusion that my tattoo academy was going to be the first one of its kind in the world. Wow, I didn't expect that. Once again, I could find no help or guidance, I'd have to do it all on my own.

The enormity of the task began to sink in. I wanted to make it something that people would think was worthwhile and value for their money. Obviously, I was going to charge for the course. I would be giving away all my secrets. I thought that two weeks would be ideal, not too long but enough time to cover every aspect of the trade. I was also prepared to make myself available on the phone if any queries arose after they had completed the course. So that was my guarantee, which I thought was a good deal. A student would have a mentor for life who was just a phone call away. This turned out to be a very good move because I couldn't foresee everything that would arise after a student had left, so I would often get calls or emails asking for advice which I readily gave.

It felt a little strange to realise that if I was going to become a teacher, I would actually have to teach everything. I couldn't hold anything back or keep any secrets because that would defeat the object. It meant being prepared to answer any question that arose and to provide the answer honestly and fully. Everything I had learned through trial and error, blood, sweat and tears had to be passed on.

When I was learning to tattoo – especially in the very early years – I would gladly have paid anything to have some of my many questions answered by someone who had been through the same dilemmas and knew what to do and how to resolve them. It would have saved me months of pain and frustration. What I was preparing to offer was exactly what I had needed myself in those days. I realised that as long as I taught students properly, I would be helping people in a way never before possible. Surely my little contribution to the trade would make some kind of difference? All my sacrifices and sleepless nights would have been worth it because now that knowledge could be passed on. I began to feel I had a purpose. A way of repaying my beloved trade for all the good times it had given me.

I was going to do this, and I was going to do it properly, no matter what happened or what difficulties I may face.

I wasn't too bothered about what all the other tattoo artists might think of me

for preparing to hire myself out as a tattoo information whore. If they didn't like it, well fuck 'em. I would deal with it if it came up. As it happened, I hardly got any criticism for starting up a teaching outlet, which surprised me. You know what people can be like if you have a great idea before they do. The only criticism I got was from people who said that it wasn't possible to teach someone to tattoo in two weeks.

You don't say!? Right from the beginning I had never said that I could teach someone to tattoo in two weeks. I was just going to show them how to go about it and teach them the basics. Then after that it was up to them to put in the work and practice to become confident enough to take up the trade. You can't learn to play a guitar in two weeks either, but you can learn the chords. Then if you practice and work hard enough, you'll eventually be able to play a song. So, I just laughed at such stupidity. If that was as bad as it was going to get then that was fine with me.

There was one experience that I didn't expect and it shocked me when it happened. I thought I would have to start the ball rolling by taking out some advertising. *Skin Deep* magazine was the best-known British tattoo publication at the time so I thought that would be the best place to start. I took out an advert for six months and paid the fee. I waited excitedly for the first issue to come out with my ad in it. Sure enough, the next issue had my tattoo academy advert in it, I was off and running. Committed. There was no turning back now. I had no idea of the kind of response I was going to get. Would I be inundated? Or would there be no interest at all?

I had a few emails and a few phone calls and after a week or two I had my first three students lined up for the very first tattoo instructional course. It was rather encouraging. I set the date for about a month's time and set about getting everything ready.

To tell you the truth I was absolutely shitting myself. Especially after I had received all the fees. It was actually going to happen. I had to keep three strangers happy and occupied for ten days. I'd never met any of them before and didn't have a clue as to the standard of their drawing ability. Nonetheless, I wouldn't teach on the weekend.

There were two girls and one boy and they came from all different parts of the UK, so I had to arrange accommodation for them for the two weeks. Horsham isn't a seaside town so there are limited B&Bs available, but I managed to find three places for them for the duration. I worked extremely hard, working out what I was going to teach them and the order I was going to do it in. I wrote out lists and schedules for each day and just prayed there wouldn't be any major mishaps that might turn the whole thing into an embarrassing farce that I could never live down.

The only thing you could practice on was still the trusty old pig's skin and I

was concerned that I might not be able to get enough and store it properly before it went off. So I bought a small fridge to keep it in and bought about three pigs worth of skin. Plenty, I was sure. I wrote out a selection of handouts that I could give out for each of the subjects I was going to cover and bought three A3 size sketch pads for them to draw on along with all the pens and coloured pencils, tracing paper, rubbers and rulers.

I even ordered three brand new machines and all the accessories from Spaulding and Rogers in America which were very posh and bound to impress them. As the day drew nearer the tension was almost unbearable. How would I go down? Would they be happy with what I taught them? Would they even like me? Would they ask for their money back? It was almost too much. I was more nervous than at any other time in my life. Even more than when I did my first tattoo.

The big day arrived, by now I was almost a blabbering heap of jelly but I managed to find the strength to get myself out of bed and put on my bravest, *don't worry, I know what I'm doing* face. I opened up the studio and my three students arrived one by one, all very nice, all very pleasant. I showed them around the Red Dragon, the classroom and the mock studio and they were very impressed. We went upstairs to the classroom where I was going to start teaching. The idea was to get them to follow me as I traced out a swallow to start with and they would copy what I did line for line.

We all sat down at the table where I had set out all their equipment, pens, pads and sheets of outlines etc.

'Okay, open up your pads. We're going to start with something nice and simple so just try to follow what I do.'

They opened up their sketch pads and got out their pencils and tracing paper ready to go, I looked down at where I was sat … I did not fucking believe this, with all my last-minute panic I had forgotten to get myself a set of writing, drawing and tracing equipment. It just hadn't occurred to me. I had got three sets of everything, but of course I needed four sets. Not the best start. We all laughed and I managed to find enough bits to tide me over at least until lunchtime when I could run down to the town and get myself a set.

The rest of the morning went pretty well and when we broke for lunch, I ran down and picked up everything I needed. Panic over for now. I was looking forward to the afternoon, when we were going to fire the machines up and I was going to do the big reveal and bring out the sheets of pigskin they'd be working on for the duration. After the lunchbreak, they all trooped back upstairs and I told them now was the time – we were going to fire the machines up and have a go at doing a very simple design

just to get them started and appease their curiosity.

I reached under the table and pulled out my plastic bag containing the pig skin, and proudly said, 'Meet your first customers.' Boom, that was bound to get them excited. As I pulled a piece of skin out of the bag and handed it over for them to pass around, one of the girls turned a sickly shade of green. When the other girl went to pass the skin to her, she looked like she was about to throw up.

'Are you okay?' I asked.

'I can't touch that,' she gasped.

'Whaaat?' I said, puzzled.

'I'm a vegetarian!'

You couldn't make this up. Day one and she wouldn't be able to use the tattoo machines on a ten-day tattoo instruction course. My heart sank. I apologised profusely. Inwardly I was starting to panic. I think I made a mental note to include a question on the booking form: you wouldn't happen to be a vegetarian by any chance, would you? I was staring failure fully in the face. It couldn't be any worse.

I'd got myself out of worse situations in life surely? I'd just have to work around it somehow. Never give up, even when it looks like you're up that creek without a boat let alone a paddle! Thinking quickly, I remembered that I'd also practised on fruit when I was first using my machine. It's far from ideal but you could at least use your machine without ripping anything up too badly. She wouldn't be able to use the colours because they wouldn't really show up on the coloured fruit skin but we could have a go. When I mentioned working on fruit instead, such as oranges, melons and large apples, her face brightened up and she was eager to have a go. Bless her. I cancelled the machine work for the afternoon and we just concentrated on drawing for the rest of the day. We talked about the trade in general and what they could expect to encounter along the way.

That first day at the Professional Tattoo Academy was a very long day. I had gone through every emotion from panic to ecstasy. Tattooing is like that though, so I should have been used to it by now. The day finished as a success, they all seemed happy enough with what we'd done. They were just happy to be talking tatts all day with a professional. I was happy but completely knackered. I'd turned the situation around and we were

53. Tattoo Academy, 2007

all looking forward to the next few days. But of course, the tattoo Gods being their usual mischievous, playful fucking selves had one more trial left for me to face before I could sit back and start to enjoy myself.

Day two: we were all a bit more relaxed as we'd broken the ice of a first meeting. Even though day one had been a bit awkward, we had at least had a laugh, which has always been one of my strong points, thanks to the terror of public school life I would imagine. If things are going a bit wonky – never panic – try to make light of the situation. A laugh can diffuse any situation. I'd bought a wheelbarrow full of different fruit for the vegetarian to slaughter and the other two were quite happy with their pig skin. We were using latex gloves for realism as if we were tattooing in a *live* situation so that was great. Come to think of it, I had told them I'd had customers with similar cold, slimy skin that I'd worked on in the past, so it was more realistic than they thought, this of course got a laugh.

I made them make up a selection of transfers of the little designs I thought would be suitable for them to start with. They could choose the ones they wanted to do. We all trooped into my brand-new gleaming mock studio and they sat down at their stations. I was impressed with the set-up, three tattooists all in the same room preparing to tattoo away happily for the rest of the morning. It was very moving and I couldn't help but get a little emotional. I'd done it. We were up and running.

So off they went, I moved around from station to station offering advice and encouragement, a great big smile on my face. Soon the room was filled with the noise of three tattoo machines happily buzzing away.

Then all of a sudden there were only two machines buzzing away, and then one! Oh my God, what's up now? Two of my brand-new, shiny, made in America machines had become so hot they had seized up! I took hold of one disbelievingly and nearly burnt my finger in the process. This couldn't be happening? Another day, another disaster. I had forgotten that American mains electricity is set at 120 volts, while ours in the UK is set at 240 volts. It was fine to run UK machines on American mains electricity but not the other way round. I'd wasted a load of money by ordering three machines from the States. I'd been showing off really because they did look awfully nice, but I could have bought three UK machines for half the price. My heart sank again, how much more of this could I take?

Thinking quickly again – can you see a pattern forming here? I explained the problem and told them that everything happens for the best because they would now have the honour of actually holding in their hands, a working professional's tattoo machines. Mine.

I rushed out to my station in the Red Dragon studio room and frantically

plugged in all my machines, trying to find some that would be suitable. I had a couple of favourite machines – ones I always used – which would do, but I couldn't find another one. I went back into the mock studio.

'Early lunch?' I suggested.

I explained the problem and told them that I would get everything sorted for when they came back from a break, they'd be using my machines from now on and everything would be fine. They couldn't see my fingers crossed behind my back! Off they went.

I managed to separate my throbbing fingers, sat down, got out my box of spares and managed to put together another three machines, so five in total for them to use. I made sure I had enough to counter any more technical disasters that might arise.

Thankfully the rest of the course went pretty smoothly, no more major dramas. The pig skin proved satisfactory albeit messy, and the fruit served its purpose adequately. She even got to use a bit of colour on the yellow melons. One time an apple she was tattooing had rolled off of her table and I told her she'd just had her first customer pass out on her. Yes, I can be hilarious at times! Groan.

On the last day I suggested they might like to have a go tattooing each other with a small memento piece. They enthusiastically agreed and I told my vegetarian girl that I would let her do her first one on me, on my leg, as she had been such a sport and stoically got on with all the tasks I gave her. This went down very well.

All in all, apart from the initial teething troubles, it was a fantastic first effort. It was a learning experience for all of us and they all felt it had been worthwhile and money well spent. I, in particular learnt a lot and made mental notes the whole time on how I could improve things and make the courses even better in the future.

Going back to work in the Red Dragon felt a little strange as I had really enjoyed my time as an instructor. This confirmed that I was definitely going to carry on with my tattoo academy as long as I had students eager to come and learn.

I have to say that if it wasn't for the internet and my website, I could never have made such a success of my academy. I had a counter on my website which gave me a breakdown of all the visits to my site and where they were from. I was amazed, after a few years running I had thousands of hits from pretty much every country you could name. Some I hadn't even heard of. It was fantastic to be able to reach out to so many people and it showed the worldwide interest that tattooing was beginning to attract. Yes, thank God for the Internet, because I didn't get any help from anywhere else.

After my first month of advertising in *Skin Deep* magazine, they contacted me and told me that they would no longer be able to run my advert in their publication.

What?! I wrote back asking for the reason and they told me they'd had a number of complaints from artists who thought it wasn't right to teach people to tattoo if you weren't a qualified teacher. Any teaching should be done by obtaining apprenticeships in a studio. How many complaints? And by whom? I had only run the advert for one month, this was utter bullshit and it reeked of jealousy and politics. I was furious. Someone on their staff had obviously thought my tattoo academy was a bad idea and must be stopped. Really? Well, have a word with my three satisfied students who had just spent two weeks with me and had the time of their lives. I immediately contacted the three of them and told them what had happened, they were as shocked as I was. They promised to write to the magazine and tell them about their experience. It did no good though. I suppose the publisher's minds were made up.

I had expected a little bit of negativity but getting it from this supposedly esteemed magazine was infuriating, especially the reason they gave me. It just didn't make sense.

It wasn't okay to teach people to tattoo? Had they seen the train wrecks that people were creating because they weren't being taught?

A magazine is supposed to keep up with the latest events concerning its chosen subject. To bring to its readers anything that might help to further their understanding of that subject. In an unbiased format. Not to deter people from genuinely trying to help others and making false judgements about someone's ability to do so.

As I saw it, the tattoo trade was always a fringe activity and hadn't really been taken all that seriously by the public. Therefore, I believed it needed all the help it could get from anyone trying to dispel certain myths about it and thereby helping it to become more accepted by society. Guaranteeing its growth and further longevity.

The UK's top tattoo magazine – gag – had no qualms about running adverts containing tattoo equipment for sale but it objected to running adverts from someone prepared to show you how to use said tattoo equipment properly! I took it as a personal kick in the nuts. But as usual when people try to derail me from acting on ideas that I think are good ones, it made me more determined than ever to succeed.

People did ask me why I even wanted to teach others how to tattoo, was it about the money? No, it wasn't that at all. Weren't there enough tattoo studios about now to cater for everyone? Who knows? There's nothing wrong with a bit of healthy competition to keep you on top of your game. You can't run a marathon with just one person, you have to have others to make a race of it. If tattooing was going to keep growing then it needed lots of other artists doing their thing and bringing different ideas and styles to the table. Look how it's grown, nowadays people are doing 3D tattoos and portraits of the kind of quality us old timers would never have dreamed of.

This would never have happened if tattooing had been confined to three or four selfish seaside scribblers.

Obviously, I wasn't going to teach people from just my own area because that wouldn't make good sense and might eventually put me out of business if I did too good a job. The internet is also known as the world wide web and that was where I was hoping to look, worldwide. So, no more advertising for me.

As the weeks went on, I didn't need to bother, the hits on my website started to grow and I was amazed at how many people really were into tattoos and tattooing. People's interest over the last six or seven years had gone off the scale. Europe hadn't really got into it before – apart from countries like Holland and Germany – but now I was getting enquiries from all over the world: Italy, France, Eastern Europe and especially Malta. It was fantastic.

Luckily for me – and this was my real saving grace – a company brought out sheets of *latex practice skin*. This was what absolutely guaranteed that I would be able to carry on providing my courses. No more slimy, yukky pig skin. The sheets were about A5 in size and 3mm thick, so the needles wouldn't tear through it, you could work on both sides, it took colour well and it would keep forever – unlike the pig skin which would go rancid after a few days. Another good thing about

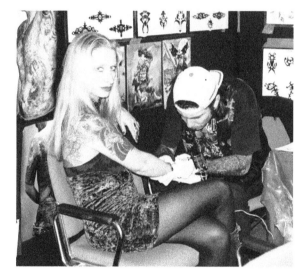

54. Tattoo show, Hameln, Germany

the latex, something I found after testing it myself was that it was a little harder to work on and get the ink in, so when you came to tattoo on real skin it was much easier. If it was the other way around it might not have been so good. So, I bought a massive box of about 300 sheets and that was me set up for the foreseeable future.

I aimed to do about five courses a year because I still had lots of customers wanting me to do their tattoos. I was mainly doing large freehand pieces now – sleeves and back pieces – and that was what I enjoyed doing the most. I let the other guys who worked with me handle the day-to-day stuff, this was mainly walk-ins but gradually people wanted to book in, so we had to move with the times. I would arrange a couple of courses early in the year and then one just before the summer rush and then a couple more courses at the end of the year. I liked to do the last one of the year just before

Christmas because that had traditionally been my slowest period but if I was lucky enough to have a full course then that would be a nice Christmas bonus for me. When I began teaching, not all the courses were full but there were usually at least two people signed up. I did a couple of courses for just one person and that was pretty intense: one on one for ten days for the lucky student. I managed to do them okay, strength of character pulled me through.

I had a nice girl, Giselle, come over from Trinidad and Tobago. My first Black student, which was great, she was the only one booked for that course but I couldn't cancel it as she had arranged to come all that way. We got on like a house on fire and she thoroughly enjoyed her two weeks and went home with a free *demonstration sleeve* from me. I had to change tactics to suit each situation.

Another one-person course was with a young Mormon lad from Salt Lake City, Christian. Despite coming from such a strict upbringing, he was surprisingly open minded and did very well. He learnt a lot and went back to the States even more of a rebel than when he came over. We kept in touch afterwards and one year –when I went for a holiday in Vegas – he came and stayed with us for a couple of nights. We had a great time but I couldn't persuade him to drink any alcohol, his faith still shone through now and again!

There were a couple of sixteen-year-olds who took the course. They couldn't actually be tattooed of course, but they could tattoo others. My own son Charlie being one of them – we got on fine apart from him breaking two chairs by leaning back on them! The other lad was from Margate who came along with his mum and she also did the course. They fought the whole two weeks but it was great fun. The other guy on their course was a CIA employee from Chicago who was about to retire, so he helped keep them in order. I really did have a mixed bag who signed up, that's for sure.

Other students of interest were a guy from Madagascar, two Sikhs from India, a fully dreadlocked lad from Grenada, an actress from an ITV soap opera, a rapper from London, a pimp from London, a sex worker from up North, an Irish guy with the most savage stutter you have ever heard, a female German pig farmer – luckily for me the pig skin days were long gone! A Maltese guy and his dad – who I got to repaint the Red Dragon while he was over, two deaf girls and a colour blind retiree with an MA in art!

Looking back over my records I had students attend from fifteen different countries, absolutely amazing. I had no idea this would be the case when I originally thought up the idea. It proved that tattooing was a truly international pursuit and from the make-up of my students it was multiracial as well. I couldn't have been prouder to have been involved in that way and to have done my little bit towards furthering

the art.

For those of you who might be interested, I'm going to outline a quick description of how my tattoo course ran and what you could expect if I was still running them. If there's any potential instructors out there then you may find it helpful! This is how the final, polished version went down after I had tweaked and perfected it.

The main aims of the course were:
1. To teach a positive attitude towards the Art and appreciate the history of tattooing and those artists who have gone before you.
2. Gain a full understanding of the tools used and how they work.
3. Maintenance or repair of the tools used.
4. Teach basic drawing and colouring of tattoo designs.
5. Teach basic tattooing techniques.
6. Teach all up to date hygiene regulations.
7. Complete two tattoo design sheets of your own using samples provided.
8. Complete a number of tattooing exercises increasing in complexity each day.
9. Complete a tattoo on a live model.

Students would arrive in Horsham, preferably on the Sunday before we started. I would pick them up from the airport or train station and take them to their accommodation. On Monday morning we'd meet at the Red Dragon for a 10 o'clock start. I had a great trick to start everything off on a good note. And to make me look good! He he!

I had an outline of a Swallow and an outline of a Rose that I asked them to trace and then colour in, thinking about how they would go about doing it. I would watch as they all traced the outlines and then coloured in each design. Some were good and some not so good, but that was unimportant to me because I was about to show them the proper way to go about it. I then brought out my two pre-prepared, fully coloured in examples for them to see. There were always a few umms and ahhs at this point. Then we would redo the two designs with them copying me line for line, showing them the proper way to draw a tattoo. Even a simple thing like a rose or a swallow has an order, if you are going to do it properly. Then we'd colour it in with them following me piece by piece until they were complete. Afterwards, they could compare their two efforts and be amazed at the difference – hopefully. This initial exercise instilled a great deal of confidence in them and always got things off to a great start.

55. Tattoo Academy – practise sheets

I would always try to get them to use the machines on the latex by the end of the first day. It was just a very simple exercise which most of them would not expect to be doing so soon, so that was good also. Another novel idea was to get them to make up two A3 sheets of their own tattoo flash: five designs on each, a different design each day. I made a list of ten designs but just listed what each design should consist of, for example, a heart with a scroll wrapping around it with two flowers behind and a swallow flying above. They could use the sheet of example outlines I'd made up, which was similar to the clip art book and saved the rigmarole of drawing it all up themselves. At the end of the first week, they would have a completed sheet of five designs. I'd make them sign it or put their artist's mark on it and then I would get it laminated over the weekend break. There were some very good efforts. I'd always stick their sheets up on the walls of the mock studio for extra effect. By the end of the second week their second sheet always looked very impressive, especially once it had been laminated.

No two courses were ever the same. I had such a random selection of students, so I didn't have a rigid structure, but we always got all the tasks done by the end of the second week. On the weekend in between the two-week course, I didn't teach so I could work a normal day in the Red Dragon. If any students were still around – mainly the ones from far away – I would let them come to the studio on the Saturday and generally get involved with helping and feeling a part of the team. This went down very well and they were thrilled to have the chance to be in a busy, working studio. The other guys who worked with me also enjoyed this because they had a chance to show off a bit.

I did eventually end up taking on a couple of guys straight after completing my course because I had a vacant chair and they had done so well. So really, I suppose it does disprove the disbelieving wankers who said, you can't teach someone to tattoo in two weeks!

It was just a question of starting off slowly. Ninety-nine per cent of my students had never even held a tattoo machine before and the importance was on being patient with the emphasis on positivity and encouragement. I found I was very good at encouraging people who found tattooing skills difficult at first. I never criticised

anyone's efforts because you could see how they bounced off each other. They all tried really hard. It was amazing how everyone got on and the bonds they formed over the two weeks. For me, it was a fantastic human experiment. I think we tend to have a blinkered view of the things we do as only being done in our own country and nowhere else, but I really enjoyed watching people from all over the world get stuck in and produce equally as good and sometimes better efforts than our homegrown talent.

The combinations of the different characters on each course made for some amazing moments. You could tell that we all had a common bond which grew naturally as each course progressed. It confirmed to me the power that tattooing holds. The depth of feeling that it can bring out in all sorts of people. It really is that important to people's lives and to their wellbeing.

After my initial dread and nervousness before embarking on my career as an instructor, I came to relish and look forward to each new challenge. I think it was the highlight of my career. I loved showing people how to do things and it was great to be able to answer every query that cropped up. It helped to show me how much I'd learnt along the way. If I could inspire someone to greater things then it was bound to be good for the future of tattooing.

The final exercise of the fortnight – the grand finale – was the chance to do a *live* tattoo on either a friend a relative or even someone else from the course. And even a couple of times, ME. Yep, I wasn't afraid to jump in if there was no one else! This really was where people's true character showed through. Emotions ranged from stoic determination to complete panic! Hilarious. I told them not to worry, I could always step in and help if things went disastrously wrong. But I never once had to. You could feel the electricity in the air as the budding artists set about their first tattoos, the excitement was incredible every time. Normally confident and competent people who until then had done very well on paper and latex would suddenly become trembling head cases, questioning their own sanity. A few choice words of encouragement and a quick reassuring cuddle would always bring them back down to earth though.

After each of them had finished their first real tattoo on the last day of their course – almost without fail – you could see something happen. Something in their eyes gave it away. That and the smiles on their faces. It was like they'd finally conquered Everest or something equivalent. There would often be cheers and tears from everyone in the room, myself included. I was so fortunate to have been a part of their experience. Thinking about it now still brings a lump to my throat.

I ran my courses at the Professional Tattoo Academy for ten years, from 2003 until 2013 and had nearly a hundred people take part. I would have carried on a lot

longer but like everything in life, once someone starts something good then everyone wants to jump on the bandwagon. Within a few years tattoo academies were springing up all over the place, from people who'd previously said you shouldn't be able to teach people to tattoo. All of a sudden, every fucker wanted to do it. There was even an Official Tattoo Academy, which started up in London. I thought that was a really cheap shot and a pathetic attempt to outdo me, as there was nothing fucking official about it at all. But that's to be expected of course. I found that I was getting less interest from around the world as most countries now had their own teaching establishments. Ranging from artists opening up their studio for a day, to purpose-built establishments similar to mine. Therefore, I was reduced to getting enquiries from more local people. This wouldn't have been so good for me and for the Red Dragon if a multitude of studios had opened on our doorstep. The last course I ran had all three students from a short drive away, still good fun though!

As far as I know and at the time of writing, there are still no schools or colleges teaching the art of tattooing on a full-time basis. I might be available under the right terms! But to get a licence in some areas you must pass a government run health and hygiene course, so at least there's that. I suppose anyone can claim to be a bricklayer without passing a bricklaying course, so it isn't that unusual.

I wouldn't say that my courses changed the face of tattooing to a great degree but I know they helped quite a few people – the right people – get their foot in the door and these people are now successful tattoo artists in their own right. So, I raise a glass to you and say, 'Thanks, it was a hell of a time wasn't it!'

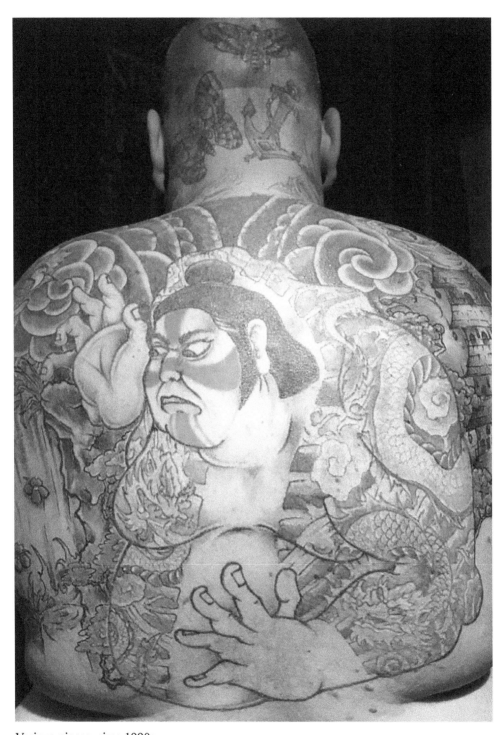

Various pieces, circa 1990s

Chapter 15: *Red Dragon and beyond*

When I reluctantly folded my tattoo academy in 2013, I was fifty-three years old and had been tattooing for thirty-three years nonstop. I racked my brains to try to think if there was anything else I could do in the tattoo trade but I couldn't come up with anything to match what I'd already done.

So far, I'd opened up twelve different studios in four different towns. In three of those towns, I'd been the first one there. I'd been the first person to import American pre-dispersed tattoo inks to the UK, the first person to sell tattoo designs by the sheet and the first person to open up a tattoo teaching establishment to the general public. I also taught both of my kids (Charlie and Scarlett) to tattoo, thus ensuring that the Fuller family iron will carry on for the foreseeable future. Not a bad CV I think, for someone acting alone. If you are going to go into business for yourself it is most important that you go into something you already know a lot about. You have to be the one with the knowledge to make it a success. I think a lot of people often make the mistake of ploughing money into things they don't really know anything about. So, they end up paying someone else to run the business for them which immediately eats into their potential profits.

I know I took a gigantic risk in starting my tattoo business by choosing something I didn't know much about, but at the time there wasn't any other way to do it. On the plus side though, I didn't have to invest too much money into it. Although it took most of what I had at the time. I didn't put myself into debt, which another business might have done. So, I think I was lucky in that respect. Imagine if I had wanted to start up a fashionable clothing store, think of all the stock I would have had to buy. It would have taken thousands of pounds that I didn't have and so I'd have had to borrow heavily to be able to start off, then choose all the right gear in lots of different sizes and who's to say that people would even like it enough to buy it? So, then I would have to have a sale to get rid of the stuff which would lose me profit. It might seem a good idea at first, but that's not good business sense.

Once I had been successfully tattooing for a few years and learnt my trade properly, I felt I could explore it a bit more and try to better my position. Hence, I looked for better locations, like when I moved down to Brighton where there was probably more trade. I would have liked to have got myself a barbershop or hairdressers as another business. That would have been fairly easy to set up and there are lots of people you can employ, but I realised I knew nothing about that line of business. So, I would have had to employ someone to run it for me, which would give me very little

control over the day to day running of it. A cafe business also crossed my mind, but again I knew nothing about it and I'd have had to get someone to run it. I know I could soon have learnt how to fry bacon and make cups of tea, but I'd have had to work a lot harder and longer hours to earn anywhere near what I could in a tattoo studio. Also, as it was a separate business, I'd have to cut down on my hours at the studio to make ends meet at the cafe, so that wasn't a good idea either.

That's why each time I tried another business venture I stuck with what I knew best. That way I was in complete control and knew what to do to make it work. And that is a small business lesson for everyone to remember: don't get drawn into things that are going to take a lot of your hard-earned money unless you really know what you're doing. Someone else will reap the rewards of your investment. I've heard many sad stories. Pubs are another classic temptation to invest in, but unless you actually know how to run a pub and the work involved, keep well away.

So really for me it was just a case of hanging in there and enjoying my tattooing as best as I could. I had definitely got into tattooing at the best time. It was just on the upsurge of its popularity. The 1980s and 1990s were what I consider to be the *Golden Age* of tattooing. The rise of the shows, the advance in the quality of the designs on offer and of the equipment used, all helped push its popularity forward to what it is today. The gorgeous work on show anywhere you went, brought in men and now women of all classes to their local expert to join in the rising artistic revolution. Brightly coloured masterpieces of all sizes were available across the country and when you went to one of the tattoo shows you never saw the same design twice.

Gradually as time went on, I felt things starting to change and they weren't changing in a way I liked. Social Media undoubtedly had a hand in that. Love it or hate it, social media is here to stay. All of a sudden everyone is an expert in things they really know nothing about. It's created a kind of herd mentality. Don't get me wrong, I know that social media has many uses and advantages, but some of it can have a negative effect on things that no one could have originally foreseen. Stars were the first things that people were coming in to get tattooed en masse. This was when I first started to notice that tattooing was starting to get a bit samey. It was unbelievable. All of a sudden, your working day consisted of fifty per cent star designs. People don't understand, a star is very difficult to do properly by hand, it is a very technical design. You have to get the five or six points exactly the same or it will look shit. To have to do this many times one after the other is extremely demanding and laborious.

I think after a year or so of this I gradually began to lose the will to live. Then after this craze came the writing craze. Some of the most ridiculous phrases or statements, the type you read every day on any Facebook account and people were

wanting to get them inked onto their skin:

If you don't live life on the edge, you will miss the view – What the fuck is that supposed to mean? And they were having stuff like that inked permanently onto their bodies. I would estimate that over the forty years I've had tattoos on my body, the ones I can see must be ones I have looked at, say, ten times a day? So that's ten times three hundred and sixty-five. That's 3,650. Multiply that by forty and that means I've looked at them at least 146,000 times. Nothing wrong with that, I love my tattoos. Now can you imagine reading a stupid statement like that 146,000 times? You get my drift. You're going to be sick and tired of reading it and eventually grow to hate it. I don't want to come across as a bearer of bad tidings because in general I am a complete fan of anyone who gets tattooed. All I'm saying is, please, please pick wisely. What you choose to tattoo will be with you for the rest of your life. It can define you as a person. A tattoo lasts for life but your opinions will change.

So, I reached the grand old age of fifty-five, which being a type one diabetic had originally made me have doubts about my longevity. It's a very difficult illness to live with and control properly. I was originally told that the older you get the more things can go wrong with your health. My thyroid had to be removed and I was very ill for quite a while. There were a few other things that weren't as good as they used to be, I'm partially deaf in my left ear from holding my noisy machine in my left hand for all those years. Oh, and I have a bit of a carpel tunnel in that hand too! Mentally I still felt okay though.

Also, around this time, there was another social catastrophe, divorce number three, which finally killed off my passion to continue at the Red Dragon. We'd both been working there and the situation had become too toxic for me to carry on. My brother-in-law expressed an interest in taking over the running of my beloved studio, which I had successfully run for sixteen years.

After much thought and soul searching, I agreed to sell it on to him and let him take over the day to day running. It wasn't how I'd meant to finish things, but I wasn't too bothered. I knew that if I ever felt the urge to tattoo full time again, I could always work for one of my many friends in the trade. Or get another studio of my own. In the end, I just couldn't get out of there quick enough.

I also had a lot of hobbies which I wanted to spend more time doing. Painting, sculpting and travelling in my campervan. I wanted to enjoy the freedom of riding my motorbike whenever the weather was nice. I knew I wasn't going to be bored. As far as money went, I still had my house, just! And I had put some of my academy money away as a pension fund. If that started to run out, I could always downsize to a smaller place somewhere cheaper and put the difference in the bank to live off.

As it turned out I found it hard to let go of my machines because I was constantly getting people asking me to, *just do one more*, or just *finish this arm off* so I ended up doing sporadic guest spots here and there which were just for old regulars. Always with the kind of work I really liked doing. It became a very part time pastime without any of the worry and I thoroughly enjoyed myself. I was painting canvases regularly, some of which I sold and I taught myself to sculpt small figures and busts. So, I made sure I kept myself busy. The money wasn't very good but who cares you, just have to spend less.

When Covid hit it was a bit of a worry. Being diabetic and nearly sixty I was classed as high risk. I've never been too much of a worrier but when it all started and they said shit like that, they really put the wind up me. No one knew how bad it was going to get and people were dropping like flies. It really was a worrying time for people like me. Those early days of the Pandemic were surreal. It was like walking through a minefield with a blindfold on every time you went out to the shops. Let's just pray we never have to live through another one of those.

I was very lucky in the end because my daughter had been living with me for a few years. We get on so well that lockdown was actually one of the better times I have had. Especially after the final days of the Red Dragon, so I can't really complain. We all know how we were told in 2022 that Covid was eventually finished, so it could have been worse. I ended up making the most of being stuck indoors, and of the opportunities offered by Amazon! I started up a collectibles company called, devilfishcollectibles.co.uk. Check it out. It features hand-sculpted fantasy busts. I just worked on those most of the time until I had made all the products I'd originally set out to. There's even a miniature old-time tattoo vignette which I'm hoping will go down very well. It's a small business – still in its infancy – but I'm forever hopeful.

56. The old-time vignette on my Devilfish website

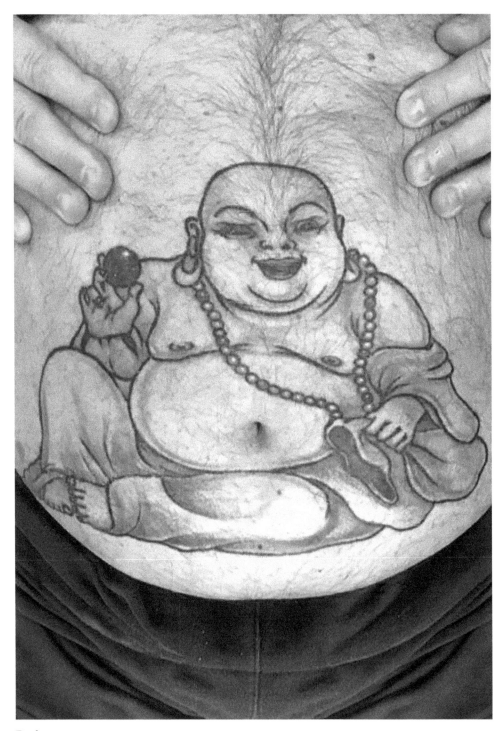

Basher

Chapter 16: *The good, the bad and the ugly – twenty tattoo stories*

Finally, I thought I'd share twenty of my most interesting tattoo stories in no particular order, some are funny and some not so, but they're all worth a read.

1. Little guy versus big guy

I would imagine that there isn't a tattoo artist out there that hasn't heard this story, and if I had a pound for every time I'd heard it then I'd be a very rich man! It always goes like this: a guy either comes into my studio or I'm in a pub talking about tattoos and he says, 'When I got this one done here,' he points to a tatt on his arm. 'It was pretty busy in the studio and there were a couple of people before me. This great big biker bloke went first and he had a little rose done on his arm and he was screaming in pain and then all of a sudden, he passed out! Flat out on the floor he was. Blimey, we had to pick him up and put him back in the chair. Then this little guy went next and he had a great big one done all over his back and he didn't even flinch!' Hilarious. I still hear it and can't help laughing. I've heard it so many times that this particular studio must have had about one hundred people in it that day and I've met them all! It's bollocks when you think about it, okay the big guy may have passed out, but there's no way he would be screaming in pain over a little rose. The tattooist would have kicked him out sharpish. And if the little guy had a great big one all over his back that would have taken at least ten to fifteen hours, so that must have been a long day!

2. Grey shading an important tribal piece

The first tattoo expo I ever worked at was the Tattoo Inkorporated, tattoo expo in Dunstable, around 1991. This was THE premier tattoo show in the UK at the time. It was always packed and all the top artists were usually in attendance. So, I was very nervous to be tattooing in front of all those experts. When I got there and had set everything up, I couldn't find my bottle of black ink. I'd only gone and forgotten to pack it hadn't I? Not the best start and the first guy I had lined up to tattoo wanted a black tribal piece, brilliant! Luckily there was a trade room upstairs selling equipment, so I sent my mate up to go and buy me a bottle of black, sorted.

The guy wanted it on his back so I made up the transfer and put it on, set the machine up and got everything ready and off I went. I did a couple of lines and then wiped all the excess ink off and saw nothing, just a couple of thin, weak lines. Strange,

I went over them again, wiped the ink away and there it was again, nothing. Oh my God what's happening, I thought. I checked the needle; it was still attached and was coming out far enough. I turned the volts up a little on my power pack and tried again. Nothing, just a few red scratches by now. This really wasn't going well at all and now there were quite a few people watching me. I changed the needle for a new one, to see if that might solve the problem but nope, still not a nice black line. I was starting to sweat and wishing I was somewhere far, far away. This is when a tattooist has to really show his mettle. I wanted to shout and scream or cry but I had to look as cool as a cucumber because I had an audience who would not show the slightest amount of pity for my desperate situation. There was also a band that started playing really loudly on the stage nearby and I could hardly hear myself think.

Well for the next ten minutes I tried everything I could to get this fucking tribal piece started but it was just getting redder and sorer, the poor guy. I thought, I'm going to have to say I can't do it. Unimaginable. I'd probably lost a stone in sweat by now. It was horrendous. I picked up the bottle of black and thought maybe I needed to give it a really good shake. As I did so I noticed the label, Kuro Sumi Black Shading ink. It suddenly dawned on me, my mate had bought the wrong ink. He'd got grey shading ink instead of black outline ink, the twat! Grey shading ink is just that, grey. It's grey because it usually has a 1:1 ratio of ink to water! I grabbed him and told him to go and change it before I murdered him in front of everyone.

A lot of people were still watching but I made up some poor excuse about needing my favourite ink and put on my best *of course I'm a professional* face while I waited for my twat mate to come back with the outline ink. He finally got back with the black and off I went and there they were, nice bold black lines. It only took me about half an hour to finish the piece in the end, but what a start to my expo tattooing career. I made sure I never forgot anything after that.

3. Rasta!

A young white lad came in one day, I asked him what he wanted and he said, 'I want *Rasta* written on my wrist.' Obviously, a reggae fan. 'No worries, mate,' I said. 'Sit down.' He sat down and I tattooed it in capital letters on his wrist and told him it was £10. He paid up and off he went, good as gold. The next day he came back in, I said hello and asked him what was up? He said, 'I didn't pay you for my tattoo yesterday.' I said, 'Oh yes you did, that's fine.'

He insisted he hadn't and gave me another tenner. I was shocked, I told him he

really had paid and not to worry about it and tried to give him his tenner back, but he wouldn't have it and hurried out of the studio! We all laughed and thought it was very weird. A couple of days later he came back again and told us he hadn't paid for his tattoo and insisted on giving me another tenner despite our protests and walked out. This happened five or six times, I kid you not. So, in the end we just agreed with him and took it. It was obvious he was either extremely rich or winding us up.

We hadn't seen him for a week or two, then one day a man came in and asked if we'd had a lad come in who had *Rasta* tattooed on his wrist and kept giving us money. I thought we might be in some sort of trouble that he might think we'd forced him to hand over the money, but he said not to worry, the lad had a mental illness where he kept wanting to give his money away! He'd also been going into the Virgin Megastore and telling the staff he'd stolen their CDs, when he hadn't. He'd also been giving them money as if he was paying for the stolen stuff! Wow, that was a first. Mental illness comes in many forms but that was just unreal. We never saw *Rasta* again; he'd obviously found somewhere else to get rid of his money. I sure did miss that lad during the slow winter months though!

4. Who did that shit?

When I was at Duke's Arcade with my brother Steve, there were very few dull moments. One morning, I was busy tattooing away when a guy came in, chose his design and sat down to get it done by Steve. As he took his jumper off Steve saw he had another tattoo on his arm, looked at it and said, 'Who did that shit on your arm?' He was subtle like that!

The guy looked at him and said, 'You did.'

I immediately looked over, biting my lip and stifling a laugh.

Steve, completely unfazed said, 'Let's have another look.' The guy held out his arm and Steve stared hard at it, 'Actually, that's really good. Yeah that's bloody good that is. Here Danny, come and have a look at this one. I did that!' He was just unbelievable at times.

I just roared with laughter and so did the guy. I went over and had a look and actually it wasn't too bad at all. He'd just forgotten he'd done it and was trying to set himself up to look good when he'd done the next one on the guy.

Another couple of people came in while he was working on the guy and he made them have a look at it too, talk about going overboard to cover up for where you've made a twat of yourself.

5. Seeing the future

Before I became a tattoo artist, I thought long and hard about whether it was really a good idea to give up my safe job at the factory to try to do something that I wasn't too sure I could make a success of. One day, I thought it was a great idea and the next day I thought it might not be. I was undecided.

One weekend I went down to Brighton for a day out with my girlfriend and walked along the seafront, we passed a door that had a little sign saying, *Palmist £5 per reading*. My girlfriend said we should go in and get our palms read. Well, I really wasn't a great believer in all that kind of stuff, it was just a con surely? So I wasn't too keen at all, I mean five quid? She finally convinced me.

She went in first and came out with the old, *you will meet a tall dark stranger and you will soon be travelling*, kind of story. Then it was my turn, I went in and there was this little skinny old Indian chap who looked about eighty. He motioned me to sit down and then he took my hand and sat examining it for a while.

'I can see you are not one to be tied down by the clock card.' he said.

Whaaat!?

I was stunned, what the hell made him say that when he could have said anything? I was so caught out by that, that I didn't really hear what else he said. He smiled and said the reading was over. I thanked him and I walked out the door with this dumb, puzzled look on my face. My girlfriend asked me if I was okay and I told her what he'd said, still not believing I'd heard him right.

I had to clock in and out every morning and night at the factory and I hated it. I was thinking of leaving but there was no way on earth the Indian guy could have known that because I hadn't told him anything about me. I could have been a builder for all he knew. The more I thought about it, the more I thought fate was guiding me and had made me go to Brighton and walk past that palm reader's room that weekend. It wasn't very long after before I decided to hand my notice in and leave the factory. I was never tied down by the clock guard ever again. Some things are meant to be.

6. We know each other well enough by now

A middle-aged couple came into the Red Dragon one day, the guy already had a couple of tattoos and he said he wanted to get his wife's name tattooed on his arm.

'We've been together over sixteen years, I think we know each other well enough by now,' he announced with a smile on his face. His wife wasn't looking so enthusiastic.

He chose his design, sat down and had it done. He was happily chatting away, they'd met as teenagers. He was telling us some of the things they'd done, the kids they'd had and the places they'd been. All the while he was holding her hand and looking at her admiringly. When his tattoo was done, he got up, looked in the mirror and a great big smile lit up his face, 'There you go darling,' he said, 'No getting rid of me now!' Off they went out the door.

The next day I came into work a little early and as I got near the studio, I could see someone standing outside already, great, I thought, could be a busy one today. As I got closer, I saw it was the guy who had come in and had his wife's name tattooed the day before. He wasn't looking too happy.

'Morning mate,' I said, 'everything alright?'

'No, it's fucking not!' he said, 'I need a cover up.'

Oh dear.

We went upstairs to the studio and I asked him if he was sure, he said absolutely. After he'd got it done, they'd got home and she'd burst into tears and told him she'd been having an affair with a friend of his for the last ten years. I was shocked and asked why hadn't she told him BEFORE he'd had his tattoo done. He said she told him she couldn't find the right time. Ha ha, well I'd have thought the right time would have been anytime in the ten years BEFORE.

I told him it might be a bit sore tattooing over something he'd had done the day before, but he said he didn't care. He just wanted it gone. I did feel sorry for the poor guy. He was heartbroken. I didn't have the heart to charge him for the cover up and he did go through a bit of pain because the skin was already sore from the day before. The air in the Red Dragon was pretty blue that morning, I can tell you. A one-day old cover up! That was a record hardly likely to be broken, don't you think?

7. *Foul play in Saltdean*

I tattooed a young lad one day at the Duke Street studio. He can't have been much older than eighteen. He wanted to get a Grim Reaper with a scroll underneath it, with RIP GRANDAD in it. Aah, how sad, everyone loves their grandparents. He told me his grandad had died the day before. I thought, wow, he must have loved him a lot to come in so soon after to get his memorial tattoo. It was quite a big piece, so it took me a couple of hours and I wanted to make it look nice. But I did find it a little morbid that he was having a Grim Reaper. We spent the whole time chatting away pleasantly as was usual. He paid me and I remember noticing one of the ten pound notes was

covered in some big, weird brownish marks.

A few days later, I was at work tattooing a guy when all of a sudden, down the stairs came two big, official looking, guys in suits. I hate it when official looking guys in suits walk into my studio, it's almost certain to be bad news!

'Can I help you chaps?' I asked.

'Yes, we're from the murder squad and we need to talk with you.'

MURDER SQUAD?! Oh, my God, what now? I couldn't remember murdering anybody in the last few days. My customer now had a very funny look on his face, I'm not surprised. God knows what he thought. I finished his tattoo and out he went, rather quickly. The two suits were standing watching and waiting. I was feeling a little uncomfortable by now.

I asked them what was up and one said, not to worry they were investigating a murder up in Saltdean and they had the guilty person in custody. I thought, thanks a lot but you could have said so when you fucking walked in and announced yourself to everyone! It turned out that the lad I had tattooed with the Grim Reaper had a drug problem and used to visit his grandad and grandmother up in Saltdean and would pester them for money all the time. His grandparents decided during one visit that they were no longer going to pay for his drug habit and had refused to hand any more money over. So the lad had picked up the nearest heavy object and battered both of them to death with it! I felt a bit sick.

The cops told me it was standard practice after a murder had been committed, to investigate the perpetrator's actions before and afterwards, so they could determine if he might plead insanity. The fact that he'd come into my studio and had his RIP Grandad tattoo the day after he had bludgeoned his grandparents to death meant he was feeling some sort of remorse and therefore was responsible for his actions. By now I was feeling REALLY sick.

So that meant I had been sitting tattooing for a couple of hours within a foot or so of a lad who'd just beaten his grandparents to death the day before. I'd been feeling sorry for him and happily chatting away and trying to make him feel a bit better. This was too fucking weird.

The money he had paid me with must have come from his grandparents! Then I remembered the brown marks on the tenner. I felt sick to my stomach – really not well. One of the coppers noticed and got me a glass of water. I told them about the tenner and they asked me to bring it down to the Brighton Station for examination. After they'd gone, I shut the studio for the rest of the day and walked along the seafront for a couple of hours trying to get it out of my head. The fresh air helped a little but I was in complete shock.

When I told Steve and everyone about it, they were as shocked as I was. Steve was actually speechless for once.

The next day I found the dodgy tenner and took it to the police station in a plastic bag. I could hardly bear to touch it. I never got it back and believe me I didn't want it!

This story is another perfect example of the power that tattoos have. After the horrific way the young lad had got his drug money through his desperate actions, one of the first things he thought afterwards was to get a tattoo to try to compensate in some way for what had done. Psychologists could have a field day debating that one.

8. Roll up, Roll up! Get your Pablo Escobar numbing cream here!'

One morning at the Red Dragon, I had an interesting phone call, it was from the Serious Organised Crime Agency (SOCA). God, I hate getting phone calls from places like that! They told me they had busted a guy who was in possession of a very large quantity of the chemical that is used to cut cocaine with. I'm not sure what it was called but it is normally used as a numbing agent, possibly lidocaine. Whatever it was, it was illegal to have so much and SOCA thought it was obvious that he had something to do with the cocaine trade.

He had told them that he used it to make numbing cream for tattoos! And he used to sell it from roadside lay-bys! I laughed when they told me that, clever, but no way. They told me that was exactly what they had thought but they wanted to get the opinion of an expert on the subject. They asked if they could come down to the Red Dragon and get a statement from me, I said that was fine.

A man and a woman came down a week or so later and took a short statement and then asked me if I'd be prepared to make the same statement at his court case. I wasn't keen but said I'd think about it.

After they'd gone everyone said I must be mad to even think about going to court. I had thought so myself but I hadn't had the balls to tell them so to their faces. I think it was their use of the word *expert* which may have attracted me at first! They contacted me again later to ask if I would still go to court but I told them that I wouldn't do it. If the guy had that much cocaine cutting agent, then how much cocaine would he have stashed elsewhere? He must have been pretty high up in the hierarchy and would know some very heavy people. Can you imagine my day in court as an expert?

'Your honour, we'd like to bring our first witness, Mr Danny Fuller of the Red

Dragon Tattoo Studio, Horsham.' I'd have been wiped out before I got back home! I think that was a good move on my part.

A few months later I was watching the news and a story came up about a guy who had just been found guilty of possession of the numbing agent and gone to prison for a long time, they had used a doctor as their expert witness. Poor guy, I hope he's still breathing!

9. A tough break!

Whilst tattooing, it sometimes happens that the customer will pass out, in the trade we call them, flakers. Not really their fault but sometimes just the thought of a needle can send some people over the edge. I was quite lucky, but I think I'm quite gentle and can take a nervous person's mind off of the situation with a bit of banter and a laugh. So I didn't get many over the years. Getting them breathing is the secret! I have had a few though. Funnily enough my worst flaker wasn't even being tattooed!

A girl and her boyfriend came into the Blue Dragon one day, the girl wanted a tattoo done. We sorted it all out and I put the transfer on her back. Her boyfriend had a look and then quickly stood back in front of her a few feet.

'He doesn't like needles' she said.

Fair enough, I thought, he's not having it done.

I fired the machine up and got on with the outline. After about ten minutes he suddenly crashed to the floor, completely unconscious! He hadn't even been watching what I was doing. Shit. I asked one of the other tattooists to help get him up and onto a chair. It proved really difficult and he was having a lot of trouble getting him to stand up, he was all over the place.

'Open the door and stand him in the fresh air.' I said, thinking it might help.

The girl was really embarrassed and kept apologising. I told her not to worry but I was getting pretty annoyed with the guy who we were all having to nurse when I was trying to get on with my tattoo.

My tattooist managed to stand the guy up, but he was swaying badly. He managed to get the front door open, but as soon as he did the flaker went unconscious again and fell forwards smashing his face on the pavement outside the studio! The noise as his face hit the floor was awful.

As I have mentioned before, North Road in Brighton is a very busy road.

'Jesus!' I shouted. 'Get him back in here!' I really didn't want anyone driving past and seeing what was going on. By now my patience was gone. My tattooist just

dragged the bloke's limp body back into the studio, leaving a nasty blood trail. He quickly shut the door.

'For fuck's sake, what's going on?' was all I could manage. The girl ran over to her unconscious boyfriend and turned him over. Oh my God, the guy's face was a mess, he had fallen flat on his face and obliterated his nose! I've seen a few broken noses but this was the worst. It was as flat as a pancake and blood was going everywhere. Luckily for him he was still unconscious.

We had no choice but to call for an ambulance. When you own a tattoo studio the last thing you want is a fucking ambulance pulling up outside lights and sirens blazing. Not good for business! The girl was so annoyed with her bloke – we all were to tell the truth – but he was still out cold.

'Can you just finish my outline before the ambulance comes, please and I'll come back in another time to get it coloured in?'

'Keep an eye on him.' I told my tattooist. 'I'll finish the outline.'

The ambulance duly turned up about twenty minutes later. Sirens and lights going of course!

They stretchered the poor guy out. By now he was groaning and had only just regained consciousness. I thought, oh my God this will be in the papers tomorrow, dammit!

That was my absolute worst flaker, and the guy hadn't even been getting tattooed. He hadn't even seen my needle! The girl did come back in a few weeks later to get her tattoo coloured in, minus her boyfriend. Pretty obvious what happened to that romance, I reckon.

10. Boot Hill connection

I've done an awful lot of travelling around in America. I'm very interested in American history, so on one occasion I drove down to Tombstone in Arizona, the scene of *The Gunfight at the O.K. Corral* between Wyatt Earp and the cowboys. Fantastic place, it's like visiting an actual Wild West town. I strongly recommend it.

One of the attractions is called, Boot Hill. It's a cemetery, where a lot of the old-time outlaws and gunmen are buried. So, of course, I had to go have a look.

As we were walking towards the entrance across the car park, I suddenly heard a guy shouting, 'No way, dude. No fucking way!'

I looked around and there was a young American guy with his girlfriend, running towards us. He had a smile on his face so I thought, okay, what's this all

about? He ran right up to me, stopped and pointed down at my inside right calf, I had shorts on because Arizona is hot.

57. Getting my Hannibal Lecter tattoo at Basildon Tattoo Expo 1988

'Dude, same tattoo!' he pointed to his inside right calf.

I'd had a really good portrait of Hannibal Lecter wearing his hockey mask tattooed there many years ago at a tattoo show in Basildon by Nigel Kurt and this young guy had exactly the same tattoo in exactly the same place! What are the chances of that? We had a hug and a laugh and we all ended up walking around Boot Hill together and then all going to have something to eat. So, I made a friend in Arizona for the day, all because of our tattoo connection! How cool is that?

11. Staffies on acid

A bloke down the pub told me this one. Honest.

A long time ago, there was a street in Brighton where there were two tattoo studios. One had been there for ages and a new one had opened up in a much better position. This annoyed the old studio and they would often look out and see lots of people walking past the new studio when they should have been walking past *their* studio.

The other studio thought the new studio was run by a bit of a wally and the owner would sometimes say naughty things about the old studio, that his studio was the best etc. When they heard about this, the old studio were also annoyed because they thought that was a bit cheeky.

The naughty owner of the new studio used to have a couple of Staffordshire Bull Terriers lazing around in the studio which didn't really comply with the strict Health Regulations that the old studio adhered to. This also annoyed the old studio. In fact everything about the new studio annoyed the old studio.

Apparently – and I'm not sure if this bit is true – someone at the old studio, thought that the poor Staffies must be bored sitting in the silly new tattoo studio all day and not going out to play on the beach. So, the owner thought it would be nice to

218

treat the Staffies to an acid trip each because then they could run around and have lots of fun in the new studio all day. Or do whatever they liked really.

Apparently, someone at the old studio said, 'Why not put two trips in two chocolates to give to the Staffies. He said that Staffies like chocolate so this would be an extra treat for them.

A friend of the guys at the old studio said he would volunteer to go and give the Staffies their special chocolates because he loved dogs. If anyone from the old studio tried to do it then the naughty owner of the new studio might recognise them, so the plan wouldn't work. The friend put the two chocolates in his pocket and off he went to the new studio, to give the Staffies their treats.

The guys at the old studio, were very excited at the chance to watch the Staffies having a good old run around and a play in the new studio after eating their special chocolates. So after about an hour they all peeped out of their door to see if anything was happening, but there was nothing much going on up there. A long time went by and still nothing happened. The old studio got very worried that the Staffies might not have got their presents, so they sent someone else up to the new studio to see that the Staffies were alright and not too upset.

When the friend came back, he said that it was all quiet at the new studio and the Staffies were laying in their baskets. Hearing this, the guys at the old studio were very disappointed that the Staffies weren't running around and playing happily but never mind, something must have gone wrong.

The guys from the old studio never saw the special chocolate gift bearer ever again. Apparently, he told someone he had eaten the chocolates himself!

12. The Eagle hasn't landed!

When I was at my first studio in Crawley, one of the first big chest pieces I did was a great big spread eagle flying across this lad's chest. It was very big and went from shoulder to shoulder. Tattoos on the chest can be quite painful and I think because I wasn't as experienced as I am now, it took me longer than it should have.

The last part to complete were the eagle's feet and claws, which were right in the middle of his chest just on his solar plexus. He was in quite a bit of pain by now – bless him – and he said he couldn't hack the feet being done that day as he'd had enough. He would come back the next week to get them done and also the outline coloured in. I said that was fine and was quite glad because it was a very difficult piece to do and I wanted a rest.

Well, I never saw the lad ever again. I suppose he couldn't bear the thought of having the feet and claws done on his solar plexus. I often thought about this lad and his eagle whenever I was tattooing people's chests and would tell the people that somewhere there was an eagle that had been flying around for decades but couldn't land because he had no feet!

Then one day many years later. About thirty years actually! I was tattooing this young lad at the Red Dragon and we were chatting away, he told me his uncle had a tattoo on his chest but he hadn't had it finished. I said, 'It's not an eagle is it?' and he looked at me in surprise and said yes. I burst out laughing and told him I'd done that about thirty years ago at my studio in Crawley. He told me his uncle still hadn't had the feet added and had never had another tattoo! And that's the story of the eagle that hasn't landed … yet.

13. Suicide in the bathroom

A guy walked into the Red Dragon one lunchtime, a bit worse for wear and pretty drunk. I hate drunks coming into my studio, because they can be a bit of a handful and just plain awkward to work on. He said his girlfriend had just dumped him the day before and he was really upset. Nonetheless, he wanted to show her how much he loved her and wanted a rose on his neck with her name written below it.

'I'll show her,' he kept saying. I told him I didn't want to do it because he had been drinking and he was carrying a half bottle of whisky. He was very insistent and told me he had to get it done because he wanted to *show her*.

As there was no one else in the studio and I couldn't be bothered to argue with him I thought, I might as well do it quickly just to get rid of him. He sat down and I drew the design on his neck. He was moving about all over the place and stunk of whisky and kept saying, 'I'll show her. I'm gonna show her.'

Yes, mate shut the fuck up, I thought.

I finally finished his tattoo. I have to admit it wasn't one of my best bits of work because he had kept moving about, talking crap and taking swigs from his whisky bottle. But I was glad it was over and done with. I told him it was thirty-five pounds, so he gave me two twenties and waited 'til I gave him the fiver change. He thanked me and told me that now he was going to show her how much he loved her. I was pretty sick of hearing it by now and thought the tattoo wouldn't make any difference if she'd dumped him. He obviously had other issues, so off he staggered with his nearly empty whisky bottle.

A month or two later a guy I knew well came into the Red Dragon for a social visit. He asked me if I'd tattooed a rose with a girl's name under it on a guy's neck. I said, yes and told him what a pain in the arse the guy was. He told me he lived in the same flat as the guy and the girlfriend had dumped him because of his drinking. He said that after he'd had his tattoo, the guy had come home briefly and then went straight round to his girlfriend's house, broke in while she was out and hanged himself in her bathroom! Oh my God, shocking. I'd been one of the last people to see him alive. So that must have been what he meant when he had said he was going to show her how much he loved her!? I had taken an instant dislike to the guy, but I did think it was very sad. But what an idiot, he hadn't even let me keep the fiver change!

14. A return trip to Motherwell

I love going to Scotland and in 1997 I took my Goldfang Tattoo flash stall up to the tattoo convention there in Motherwell, not far from Glasgow. It was run by a decent guy, a biker who I'd got on well with in the past. I'd first been there in 1995 and done very well with my flash stall, because there were lots of Scottish artists who hadn't had the chance to come down to Dunstable expo to buy my stuff, so it was worth me going all that way to try and make a killing.

The 1996 show hadn't gone so well because it was held on the day of the Celtic vs Ranger's football match. These two teams are notorious rivals and the fans absolutely hate each other and at the 1996 show a load of rival fans had turned up at the hall and began trying to murder each other. It was complete chaos; people were fighting everywhere and there were bodies all over the place. The table on my stall got broken when two guys were pummelling each other and fell onto it. Even a guy in a wheelchair got stabbed! That's how bad it was. To cap it all the Glasgow police turned up and immediately closed everything down and kicked everyone out. Not the best show I'd been to, but I had made some money so it was worth it and luckily, I hadn't got hurt.

I arranged to go back up the next year – 1997 – because the guy swore it wouldn't happen again as they had better security and I'd be silly to miss it.

The night before the show, I left Brighton early and drove the 450 miles to Motherwell in my Vauxhall Astra van, maximum speed, sixty mph. It was a long drive but as the show was only on for one day, I had planned to stay the night after the show at a nice hotel somewhere using the money I'd made that day. I finally got to the hall at about nine o'clock in the morning and it seemed a bit quiet. I thought they'd be busy setting up by now. I walked about to stretch my legs and then sat in my van and

waited. Won't be long surely.

It got to about ten o'clock and still no sign of anyone, I checked the flyer I had and I definitely had the right date. I was beginning to get a bad feeling about this. A really bad feeling. I gave it another half hour and there was not a soul to be seen. I thought the best thing to do was to go to the police station and see if I could find any information there.

They were really helpful. I told them I'd just driven all the way up from Brighton and there was no one at the hall. They found the phone number of the key holder – the guy who organised the show – and rang him for me. When he answered they gave the phone to me, 'Hello mate,' I said. 'It's Danny Fuller, I'm at the hall. Where is everyone?'

There was an awkward silence for a moment and then he said, 'Oh Danny, didn't I tell you? We've cancelled the show because of last year.'

As Ruth from Ozark would say, 'What the absolute fucking fuck?!'

'Er, no you didn't tell me.' 450 miles for nothing! I told him I was at a police station, so I couldn't really say what I'd do if I saw him and told him I wouldn't be coming to his shitty show if he was going to run it again next year. He got my drift.

I thanked the policeman, walked out of the station, went to a garage to fill up with fuel and immediately drove back to Brighton. A 900-mile round trip, driving over sixteen hours for nothing! When I finally got back to Brighton, I was so stiff, I looked like the plastic driver from an Airfix model race car kit.

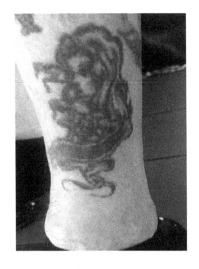

58. Photo of the world's most hastily covered tattoo!

15. A quick tattoo in Amsterdam and then back for a cover up

When I was with my second wife – my son's mum – our relationship was a bit up and down at times and she'd left me once or twice for no particular reason. Back then, I quite liked to go to Amsterdam sometimes for a smoke and to relax. I liked the whole place with the canals and the general atmosphere. She didn't like it so much, so one time I asked her if she minded if I went over with a friend of mine, just for a couple of days. She told me that it was fine. Excellent, I thought and we booked a flight over.

This was before mobile phones, so it was hard

to keep in touch like you can now, but I had promised to call her when I got the chance to let her know how we were doing. We booked to go for two nights, so we had an evening and a full day and then half a day before we flew back. It was just a quick break because I didn't want to be away for too long. I was grateful she'd let me go in the first place.

We had a good night when we arrived, visiting a load of coffee shops and bars and we walked past Henk Schiffmacher's tattoo studio, a very famous one. I thought to myself that as I was loved up, I'd go to his studio the next day and get a souvenir tattoo off the man himself. I planned to get a tattoo with my wife's name, as I was grateful she had trusted me to go to Amsterdam. I walked down to Henk's studio in the morning, as there was no booking system, and my mate happily went off and amused himself.

The studio was already busy when I got there, so I joined the queue. I looked through all the books of flash and found a really nice design that would be perfect. It was of a lady's head and shoulders with a scroll underneath. The lady looked a little like my partner so that was even better. I had promised to call her while I was there but I couldn't leave the studio because I'd have lost my place in the queue. So I ended up being in there until it was my turn. Most of the day. I had my tattoo done with her name in the scroll and I asked him to put a tiny rose on her shoulder for added realism because that's what she had on her shoulder. Oh, she was going to love it! I finally got to call home at about nine o'clock, but there was no answer so I thought she must have gone out. It didn't matter because I would be home by this time tomorrow and it would be a nice surprise to show her what I'd been doing all day.

I finally got home at about nine o'clock the next evening. It had been a long day and I hadn't seen a lot of Amsterdam as I'd been stuck in the tattoo studio for most of my break. But not to worry, I'd had a good time and I had my big surprise to show when I got back into the welcoming arms of my partner.

When I got home there were no lights on in the house. Strange. She knew I was due back. When I got inside, I turned the lights on and called out. No answer. Even stranger. I looked around and saw an envelope on the mantelpiece. There was a letter in it telling me she was really pissed off with me because I'd promised to call but hadn't. So, she thought I was up to all sorts and had left me to go and stay with a friend! Unbelievable! I'd been stuck in the tattoo studio for most of the time and she thought I'd been off misbehaving.

I was really annoyed. I have never been unfaithful in my life and if she thought I would take this opportunity then why let me go to Amsterdam in the first place if she didn't trust me? And I'd just had her fucking name tattooed on my leg!

It was about eleven o'clock at night by now, but I was so pissed off that I drove straight to the Blue Dragon, fired my machines up and covered her name in solid black ink. I didn't care that I'd only had it done the day before, if it hurt then that would teach me a lesson for being so stupid. So, I matched matey's record of the one day cover up, but I can claim a victory here because my partner never got to see her name on me! We eventually got back together and we did laugh because I think that was a hilarious tattoo story, it's one I've often told.

16. A spaced out mouse

Us Blue Dragon boys did like to party now and again after the working day. The King & Queen pub was a favourite haunt because it was just around the corner and was decked out like the inside of a Castle, which I particularly liked. One Saturday a customer of ours brought us in a little present. He'd made some space cakes and wanted us to try them. Sounded good, so after work that day we ate a cake each and went off to our favourite pub. There were a couple left so I thought I'd leave them hidden in the studio for a rainy day. I've got to admit, that evening was an absolute blast. I've never laughed so much in my life.

We ended up going to The Gloucester, which was a rock club on the junction of Old Gloucester Road and London Road, now closed sadly. I was a bit wasted the next day – Sunday – and so were the others, so I don't think you'd want to do those cakes every night for sure.

A few weeks went by and one afternoon all three of us were busy tattooing away, when the girl who was getting a tattoo screamed and shouted, 'There's a mouse!' I looked down and sure enough there was a tiny little mouse. He'd come out of our back room and was just walking along past everyone without a care in the world. Everyone watched in amazement as he walked through one guy's legs, into the waiting room and out of our open front door into North Road! I'd never seen anything like it, in fact I don't think I'd even seen a mouse before, not that close up anyway. Everyone had a good laugh at the audacity of the little fellow just walking past us all like that.

That Saturday we decided to have another night out on the remaining space cakes, as it had been a while and there were a couple left. I went out to get them from the back room where I had hidden them. They were in a cabinet under the sink. When I pulled them out, I was shocked: the cling film they were wrapped in had a big hole chewed in it and most of the cakes had been eaten! I brought out what was left and we looked disappointedly at our diminished cake supply. In all there was probably only

one cake's worth left, not enough to go around. There were also mouse droppings in with the crumbs, so we came to the conclusion that the little mouse must have eaten them. When he walked out in front of us, he must have been totally off his head and didn't know where he was or can't have even seen us! No one wanted to eat what was left with the mouse droppings in there, so we just threw them out. When I realised that we'd had a stoned mouse walk right through the studio one afternoon I did find it awfully funny, but I do think that taking a dump in what was left for us was a bit ungrateful.

17. Toilet paper is a bummer!

One afternoon, one of my regulars came into the Blue Dragon and said he wanted a tattoo on his arse cheeks. I wasn't keen on tattooing people there, for obvious reasons! Unfortunately, this guy wasn't the most hygienic customer I had ever worked on, so he usually smelt a bit unsavoury. But as he'd had plenty of pieces done by me in the past, I said okay. He wanted a cartoon piece of Roadrunner on his right cheek, being chased by Wile E Coyote on his left cheek, very funny but still a pain in the arse to do; pun intended! I did it for him and I must admit, it did look quite good.

He came back in a couple of days later looking a bit worried.

'Hello mate, everything alright?' I asked.

'No Dan,' he said. 'my arse is killing me.'

I said, 'Well, it's bound to be a bit sore, you only had your tatt done a couple of days ago.'

He said, 'It's not the tattoo, it's my arse.'

'What do you mean your arse?' I said, a bit lost by now.

'You know – in the middle – my ring piece.'

My work colleague and I burst out laughing, 'Whaaat?' I said. 'I never even touched it. Not YOUR arse that's for sure!'

He asked me if I could have a look because he thought it might have got infected or something. I must admit, having told you about his personal hygiene I wouldn't have been surprised!

Ugh! What a job. I don't remember signing up for this. I told him maybe the doctor should have a look at it, but he said he had a female doctor and didn't want to tell her he'd had his arse cheeks tattooed. So I thought, what the hell?

I said, 'Go on then drop your trousers and let's have a look.'

So there I was sitting in the Blue Dragon tattoo studio with a guy with his

trousers down and his arse stuck in my face, again. Does anyone still want to be a tattoo artist here?

I grimaced and took a look and saw immediately what the problem was. He'd obviously had a dump at some point and there was a small piece of dried-up toilet paper left stuck in between his arse cheeks. It was obviously pulling at the hairs when he moved and that was what was causing the pain! I burst out laughing again but louder this time and told him what I was looking at. I told him to go home, have a shower and learn to wipe his arse properly. He thanked me and off he went with his tail between his legs … along with a bit of dried-up toilet paper!

18. *Oh my God, I nearly kissed his back!*

One year before I went to the Mad Hatter's Tea Party in Portland, Maine, I asked my partner if I could do a back piece on her to enter into the Ladies Large Piece Tattoo Competition. She was all for it. So, over the months before the show – on most Sundays when we were closed – I worked on a large fantasy piece covering the whole of her back. She was very brave and didn't complain at all. It was a happy time and often while I was working on it, after doing a long segment and because she had to stay so still, I would lean forward and give her a little reassuring kiss on her back. How nice.

I think it took us about three months to do as there was a lot of work involved in a full back piece.

Sometime after I'd finished hers, I was working on a piece on a guy's back and it was going well and I was in the zone and miles away. All of a sudden, I leant forward and only just managed to stop myself planting a reassuring kiss on his back! I was so used to giving my partner a kiss that it must have become kind of a habit. Where was I – away with the fairies – I nearly did it to this big hairy guy! My nose literally stopped about a millimetre from his skin! He must have sensed me so close and he looked back and said, 'Everything alright?'

I said, 'Yep, just checking something.'

And that was how I nearly kissed a stranger's back. My God, that day could have ended so badly!

19. Ninteen ninty was a good year?

One of the guys I had working with me at the Red Dragon was sometimes prone to rush things a little when there was a big job involved. I'll leave it at that.

One afternoon in 2007, we were both merrily working away when a young lad came up the stairs closely followed by his mum. He was looking a bit sheepish and his mum did not look happy at all.

'Who did this one?' she asked, pointing to her son.

'That guy did', her son said, pointing to *guy sometimes prone to rush things*.

I already felt relieved.

'How's your Maths?' she asked him.

'I don't know, you tell me.' he replied.

'It's shit,' she said. 'What's two thousand and seven, minus one thousand nine hundred and ninety?' she asked, angrily.

I sort of guessed where this was going by now.

Before, *guy sometimes prone to rush things* could answer, she said, 'It's seventeen, isn't it?'

Oh my God, now I really knew where this was going.

She wasn't finished, 'He just had, *Since nineteen ninety* written right across his chest, so that makes him seventeen! Yeah?'

I just sat there helpless and watched. There was more.

'And to put the icing on the cake, you've spelt it wrong, you moron!' She was really, really angry now.

She lifted her son's t-shirt up and I could see this jet-black writing right across the lad's chest in about inch high letters. *Since NINTEEN NINTY* He'd left the E's out.

Oh my God, we're finished! You fucking twat. I think I just sat there and put my head in my hands. Tattooing someone underage is really not a good thing to do, and to spell it wrong as well! She could have pretty much taken us to the cleaners and had the Red Dragon closed down. I glared at my tattooist who was looking down at the floor not knowing what to say other than repeating, 'I'm sorry.' about fifty times.

I thought, fucking right you will be if we get closed down.

Fortunately, and I mean very, extremely, amazingly fortunately, angry lady wasn't the suing type. Perhaps she hadn't thought of it? I didn't care but I could have kissed her. I think seeing the devastated look on my tattooist's face she calmed down a bit. She told him she wanted him to cover the whole thing over free of charge with something else and my tattooist agreed immediately.

We'd had a few close shaves over the years but that was by far the closest. We weren't closed down and *guy sometimes prone to rush things* became, *guy not so*

often prone to rush things. He eventually left Red Dragon to go out on his own and I heard that he reverted back to *guy that often rushes things*. Well, good luck, but that sure ain't the way to do things.

I think the last of my stories should be another one about my brother Steve. To be honest, I haven't thought a lot about him over the nearly thirty years since he passed away. Writing this book has brought back so many memories and I hadn't realised how much I'd missed him. So, this one's for you my big brother and wherever you are I know you'll be having a drink and most certainly making everyone laugh!

20. Steve finds an ear stud!

In the late 80s, when I worked at Duke's Market with my brother Steve, piercing was only just starting to become popular, at least in tattoo studios. There wasn't body piercing as such, mainly earlobes that you pierced with a stud using a spring-loaded gun that pushed the stud straight through the skin with a snap.

I wasn't interested in piercing, I just wanted to tattoo people. But Steve saw an opportunity to make extra money and bought himself a kit. He did quite a few at around £3.50 a time. We both had our ears pierced. I had my left ear done about six times which was fashionable in those days and Steve just had one in his left lobe.

A guy came in one day wanting his ear pierced. I thought Steve had used the last of his studs up, because I knew that he'd recently ordered some more and was waiting for them to arrive, so I told the guy he'd have to come back.

'Nope. It's okay, I've got one left,' Steve jumped in with.

'Oh, well there you go mate,' I said. 'Lucky you. I thought we'd run out.'

'Nope still got some.' and Steve went behind the little partition where he kept his piercing gun and after a few minutes he re-emerged with it cocked and ready to go.

It was soon done, and after the guy had left, I said, 'Oh sorry, I thought all the studs were gone.' He looked at me with his eyes wide open and a huge devilish grin on his face, pointed to his left ear which now just had a pinkish glow around a little hole, but no stud!

I looked at him in horror, 'Oh my God! You didn't?'

'Well, it was £3.50!' he said, roaring with laughter.

Unbelievable then, but very funny now. I'm sure I had a nightmare about that not too long afterwards.

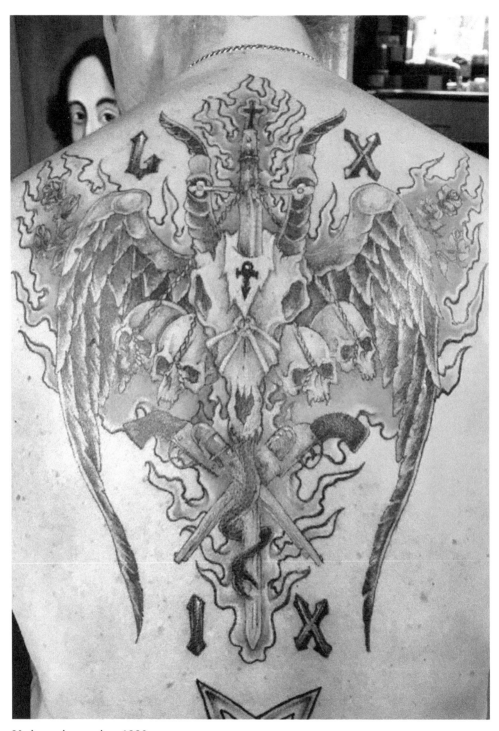

Various pieces, circa 1990s

Illustrations

Glossary

List of terms

Flaker	Someone who passes out during a tattoo
Flash	Examples of tattoo designs
Flesh tunnels	A flesh tunnel is a hollow, tube-shaped variety of body piercing jewellery. It is also sometimes referred to as a spool, fleshy, earlet, expander, or eyelet
Guns	Tattoo machines
Inked	Another term for tattoos
Iron	As in the phrase, Fuller family iron. It means group or collective
Labret	A labret is a form of body piercing. Literally, any type of adornment that is attached to the lip. Although, the piercing is usually below the bottom lip, and above the chin. It can also be referred to as a tongue pillar or a soul patch piercing
Māori tattoo designs	Māori tattooing usually began at adolescence and celebrated important events. So, the first tattoo marked the transition from childhood to adulthood and was created during a series of rites and rituals. Tattoo art was a crucial part of Māori culture, people without tattoos were considered to be without status or worth.
Marked	Another term for tattoos
Tatts	Abbreviation for tattoos
Trailer	An enormous caravan
Whitey	A whitey, sometimes called a white-out (or a green-out or greening) is a slang term for when a new or recreational drug user feels faint and vomits as a direct or indirect result of drug use (usually cannabis).

Index

Page numbers in bold refer to illustrations

Devilfish Collectibles

Handmade in England, UK

Devilfish Collectibles is a brand-new gaming and collectibles manufacturer from England, UK.

Founded by retired tattoo artist (40 years!) and lifelong modelling and gaming enthusiast, Danny Fuller in 2020. Devilfish's aim is to produce a range of exciting and unusual busts and full body sculpts. The first being the *Heroes of the Dungeon* range featuring brand new takes on your most popular fantasy heroes. There will also be a *one-off* category for rare and unusual standalone sculpts.

Plans are in development for a fun and exciting new board game, where you recruit then lead a handpicked band of adventurers through treacherous badlands in search of fortune and fame.

www.devilfishcollectibles.co.uk

Oh, and one last thing before you go …

I hope you've enjoyed *Marked for Life: Tattooing through the Golden Age* enough to give me a good review on Amazon, Goodreads and on your social media platforms.
Please share my book's cover with your social media review.

Thanks for reading my story.

All the best,

Danny Fuller

I hope you've enjoyed my story. If you'd like to get a Danny or Scarlett Fuller tattoo, then your luck is in!
We've just opened a studio in Worthing. We hope to see you there ...

For appointments: 07714 379249
Or email: thelionsdentattooshop@gmail.com

10 Coronation Buildings,
Brougham Road,
Worthing, BN11 2NW
UK

Follow us on Instagram:
www.instagram.com/thelionsdentattoo/
www.instagram.com/scarlettfullertattoo/
www.instagram.com/dannyfullerofficial/